FROM MUSEUMS, GALLERIES, AND STUDIOS

A Guide to Artists on Film and Tape

Compiled by SUSAN P. BESEMER
and CHRISTOPHER CROSMAN

D0209918

Art Reference Collection, Number 6

Greenwood Press
Westport, Connecticut • London, England

Library of Congress Cataloging in Publication Data

Main entry under title:

From Museums, galleries, and studios.

(Art reference collection, ISSN 0193-6867 ; no. 6)
Includes index.
1. Artists—United States—Interviews—Film catalogs.
2. Artists—United States—Interviews—Phonotape
catalogs. I. Besemer, Susan P. II. Crosman, Christopher.
III. Series.
N368.F76 1984 016.7′092′2 83-22710
ISBN 0-313-23881-2 (lib. bdg.)

Library of Congress Catalog Card Number: 83-22710
ISBN: 0-313-23881-2
ISSN: 0193-6867

First published in 1984

Greenwood Press
A division of Congressional Information Service, Inc.
88 Post Road West, Westport, Connecticut 06881

Printed in the United States of America

10 9 8 7 6 5 4 3 2 1

To Jenny and Janet,
True Survivors

CONTENTS

PREFACE

Rather than dwelling on the many possible reasons—philosophical, esthetic, sociological, or technological—that artists of the present century have been and are increasingly willing to talk about their work, we should simply and gratefully accept what is a fairly recent phenomenon. Although artists since the Renaissance have occasionally written or spoken about art (though not necessarily their own work), the context has usually been technical (*The Book of the Art of Cennino Cennini*), or theoretical (Joshua Reynolds's *Discourses on Painting and the Fine Arts, Delivered at the Royal Academy*), or polemical (the various Futurist manifestoes by Marinetti, Boccioni, and others).[1] Only in the past several decades (with notable exceptions) have artists discussed their own work, often in the form of recorded interviews for radio, television, and independent filmmakers. Some artists have even opened their studios to still and motion photography to record work in progress and the processes of art making, which is a vital part of the meaning of modern art. Many of these recent records have been produced by museum curators and educators, art historians, critics, librarians, and fellow artists. What some of these documents lack in sophisticated "production values," they more than make up for in sensitivity, spontaneity, and intimacy. Because of a certain informality, these documentary programs lend themselves to wide-ranging discussions beyond specific works or even art in general, offering interesting insights into the broader social history of our times through the eyes of individuals who know how to look. Moreover, the recorded interview or documentary sets up a kind of tension between the artist's solitary presence and private vision and the visibility of art in today's world of mass media including blockbuster museum exhibitions, record-breaking auction sales, cable television channels, and glossy magazines devoted to the arts.

Artists are both the source and the subject of their work in a way that is perhaps more direct and literal than at any time in the past history of art

before the rise of modernism in the mid-nineteenth century. It is probably erroneous and certainly a cliché to say that an artist is like his work. But as the noted art historian Leo Steinberg has stated in another context, clichés are based upon a core of power and truth. To speculate whether or not Nicolas Poussin had the demeanor of an idyllic landscape is a frivolous non sequitur. But there is abundant evidence and the artist's own statement to the effect that George Segal's plaster and bronze figures based on direct casts of live models also recapitulate Segal's own powerful physique, blunt gestures, and even his strongly metaphoric figures of speech.[2] To see Henry Moore turn and twist, knead and caress a small pebble is to know in part, at least, why his monumental sculpture looks the way it does. Certain forms of recent conceptual and performance art refer directly to the artist as subject and medium.

If much of contemporary art is self-referential in the sense of establishing an identity between the artist and the work of art, then the first-person narrative of audio, film, and video documentaries with artists talking about art is primary resource material of crucial importance. Such documentary materials do not exclude other forms of information and interpretation. Art historians and critics will continue to provide insights escaping even the most articulate and historically aware artists. It is also true that artists are not always objective, as, by definition, their task is to select, emphasize, reduce, manipulate, and otherwise transform different aspects of the world as they envision it.

There are important limitations for documentary evidence of this nature. Robert Motherwell, among the most widely quoted artists of our time, prefers that anyone citing his writings or interviews include the date and source for any particular statement.[3] Here Motherwell acknowledges that his own ideas and attitudes towards his work as well as to the work itself change over time. A recorded interview is only a tick of the artist's clock, a record of a moment in his or her life and work that is incomplete and fragmentary. To draw definitive conclusions about an artist from a single interview would be like characterizing all of French cuisine based on a single, possibly stale, croissant.

On another level it is well to remember that media documentaries, including those that are among the best, are very often a form of creative fiction. CBS's *Sixty Minutes* notwithstanding, there is also James Blue's powerful and moving record of the 1963 civil rights rally in Washington, D.C., led by Dr. Martin Luther King titled, *The March*; or Bruce Conner's avant garde film, *Report*, a highly personalized restructuring of preexisting film footage of the Kennedy assassination. While documentaries in whole or in part utilize "natural" footage of real events, places, and persons, such editing techniques as inter-cutting, sound over-dubbing, mixing, camera position and angle, framing, and program length all presuppose a point of view. If the program is essentially an interview, then

the interviewer's personality, approach, and line of questioning become extremely important factors; what is asked may be less revealing than what is not.

This book also has its errors of omission despite our best efforts. The vast majority of artists in this country and around the world have not been the subject of media documentation. In a few cases artists who have been approached simply prefer to let the work speak for itself. After all, as artists often point out, if the work could be explained in words, there would be no point in making it visual. More often, the artist has not yet received and perhaps never will receive sufficient critical attention in his or her lifetime to attract the potential documentation. Less frequently the considerable technological baggage accompanying anything but the most basic type of media documentation serves to exclude artists living and working away from urban population centers, though compact, battery-operated recording equipment has alleviated such logistical problems in recent years.

This book was compiled to provide increased access to filmed and taped interviews with artists. Just as the act of looking at a great work of art is never a finished event, so this reference book is only a first glimpse at what we know to be a continuously growing body of media material on artists and their works.

SCOPE

The book brings together more than six hundred films, videocassettes, and audiocassettes which document the work of contemporary artists. While other useful sources consider films about artists in a general sense, our compilation is unique in limiting its scope to productions in which artists are heard or seen with their work.

To derive the entries, primary source materials were used. Letters to producers and distributors solicited entries for items currently available from them. Those responding completed data entry forms on which information was organized in a standardized format. The annotations in this book are based upon these responses from producers and distributors. In only a small percentage of the interviews listed here did we resort to secondary sources. This was done to assure the accuracy of production and access information. The annotations given here are intended to be descriptive of the content, not evaluative of the artist's work or of the production, since it was impossible to preview the films and tapes that we list. The length of the entry was determined chiefly by the length of the annotation provided to us through the courtesy of the producers and distributors of the productions listed. While it was possible to use many annotations much as they were submitted, some were elaborated upon or edited for style or length.

In selecting works to be included in this listing we have limited our coverage to visual artists (painters, sculptors, photographers, architects, film and video artists, craft artisans, and folk artists). Every production listed here is available at the time of writing for purchase, rental, or loan from the distributor indicated. The productions listed are pieces of documentation that consist primarily of interviews produced by commercial or independent producers, museums, art galleries, universities, or other educational institutions. While almost all include the artist speaking "live," a few are wordless records of the artist at work, reconstructed voice-overs of the words of the artist recorded in letters and diaries, or interviews of the family members of the artist or members of the art world reflecting upon the works and life of the artist.

ARRANGEMENT

The book is divided into four sections: Entries for Individual Artists, Entries for Multiple Artists, the Directory, and the Index.

Entries

Entries for productions about an individual artist are arranged alphabetically by the artist's surname. In cases where more than one production is listed for an artist, the interviews are further arranged under the artist's name by title. Entries for productions interviewing more than one artist are arranged alphabetically by title. Access by personal name is provided through the index.

Each entry consists of a mediagraphic citation followed by a narrative annotation. For the convenience of the user, only a few abbreviations have been used in the citations. These abbreviations are explained below.

 ac = audiocassette
 allv = all videocassette formats are available
 avail = available
 b&w = the production is in black and white
 CA = available for rental from the University of California,
 Extension Media Service
 IU = Available for rental from Indiana University Audiovisual
 Center
 prev = preview is available
 16mm. = 16 millimeter motion picture film
 SUCB = available for rental from State University College at
 Buffalo, Film Library
 SY = available for rental from the Syracuse University Film
 Rental Center

vc:¾ = ¾ inch U-matic videocassette
vc:b = ½ inch Beta videocassette
vc:v = ½ inch VHS videocassette

In the citations, the following generalized format has been used.

CITATION NUMBER (alphanumeric with four places). Title. Audiovisual format. Producer. Distributor. Date. Running time (in minutes as expressed by the distributor). Sound or Silent. Color, or Black and White. Order number, or Order by title. Purchase price if available for purchase. Rental fee if available for rental. Preview conditions if available for preview. Series title if part of a series. Film Library Holdings symbol if held in one of the four film libraries whose holdings are indicated.

When elements of the mediagraphic description are absent from the citation, the missing data elements do not apply to this production. (For example, with audiocassettes, there is no indication of "color" or "black and white.")

Dates listed are as year-specific as possible. In some instances we were able to establish exact year dates. Sometimes we were forced to make an educated guess, indicated by a question mark following the year. Sometimes we could establish only a range of possible years or even a likely decade. For example, "1982?" indicates that 1982 is the likely, but not certain, date for the production. The indication "198?" suggests that the range of years between 1980 and 1983 (the year that this book was compiled) includes the date of production, while "197?" indicates that the production was made sometime during the decade of the 1970s.

Directory

Directory entries are listed alphabetically. The directory contains names, addresses, and phone numbers of sources for purchasing, renting, or borrowing the productions. Nearly all names are, therefore, distributors. However, listings in some cases include producers, if they distribute some formats of their own productions. For example, some filmmakers distribute their own videocassette copies of their productions. Producers are not, however, generally listed in the directory. The directory also lists four college or university film libraries. These four rental sources are: Syracuse University Film Rental Center; State University of New York, College at Buffalo, Film Library; Indiana University Audiovisual Center; and the University of California Extension Media Service. Geographically, these libraries span the country, making their films available nationwide. Films held by these four libraries, when other criteria for inclusion in the compilation were met, were marked here by a "holdings symbol" (see abbreviations). We intend, by listing holdings, merely to indicate that film libraries may be possible sources

for obtaining the cited production. In some instances, the film's original distributor has gone out of business or has dropped the film from its catalog, making it unavailable from commercial distributors. In these cases the film library serves as the primary "distributor" for the program, and we have given complete order information. When the film is also available from a commercial source, only a notation indicating holdings in one or more of the four above-mentioned film libraries is given. We suggest that borrowers consult film libraries in their locales before contacting one of the four libraries listed here.[4] In some cases, rental or purchase from the commercial distributors may be preferred. When holdings are indicated, they appear at the end of the mediagraphic citation (see above).

A few productions from Australia are included in our listings. While 16mm. films should present no problems for use on American equipment, potential purchasers or renters of videocassettes should be aware that the standards for Australian television are different from the American NTSC standard (525 lines, 60 hz.). Conversion here from PAL standard (625 lines) is possible in most metropolitan centers, but does suggest an additional cost factor.

In the directory, where company names or the names of individuals contain both given names and surnames, the listings are arranged by surname. (For example, Arthur Cantor, Inc., is arranged with the Cs.) Educational institutions are usually alphabetized under the place name. Cross-references are provided for alternate forms.

Index

The index refers the user from over four thousand access points including the names of persons, places, museums, galleries, works of art, artistic media and professions, and schools of art to the appropriate citation entry numbers in the text. Users wishing to show a film where, for example, **Guernica** is discussed, may look directly under the title of that work of art without searching also under the name of the artist. The typography of the section is also an attempt to assist the user in this comprehensive index. Boldfaced entries indicate the titles of works of art. Upper and lower case letters are used for names and for titles of productions and series titles, while upper case letters are used for "descriptors" or "subject headings." We hope that the index will prove an enhancement to the usefulness of the compilation.

The citation entry numbers provide a numbering system for each production listed in sequential order in the index. The first place in the number indicates the first letter of the surname of the artist when only one artist is interviewed by the production. When multiple artists are interviewed, the first place of the citation entry number is taken by the

Arabic numeral one (1), referring the user to the Multiple Artists section of the book. The next three places in the number are ordinal numbers that indicate the sequential arrangement within the chapters.

Other Sources

During the course of research for this book, we became aware of several additional sources for artist interview tapes. Unfortunately, these institutions cannot loan or copy their tapes for distribution. They are, however, available for consultation on-site by scholars or others interested in researching them. An important source for such tapes is Archives of American Art, which conducted its first Oral History interviews in 1959 with Charles Burchfield, Edward Hopper, Charles Sheeler, Abraham Walkowitz, and William Zorach. In the years since, 1,700 interview tapes have been prepared. The collection includes 400 interviews with artists and administrators who were active in government art programs of the 1930s and early 1940s. Tapes and transcripts are made available to researchers only on Archives' premises in any of the regional offices in Washington, Boston, New York, Detroit, San Francisco, and Los Angeles. The card catalog of the Archives' Oral History Collection will be published in November 1983. (For further information about the Archives of American Art Oral History Program, see Directory entry under "Archives of American Art.")

Additionally, other artist interview tapes may be found in the Oakland Museum, the Library of the University of California at Santa Cruz, the University of Washington Library, and the Port Washington, New York, Public Library.

The Port Washington Public Library is an informational and cultural center for the school district of Port Washington, New York. Its Media Services include video production workshops, a commercial videotape collection, and a local history archive containing hundreds of community produced tapes. The Library creates videotapes exhibiting video artists, photographers, and filmmakers presenting and discussing their work at the library, which are kept in the Library's collection for future study and viewing by local residents. (See the Directory for address and telephone number.)

Revisions

An attempt has been made to be as comprehensive as possible within the scope of our project. Any omissions or any future productions noted by users of this publication will be welcomed by the first author. (Name and address are listed in the Directory.) Any errors or changes in addresses, telephone numbers, or company names may also be referred to us for correction in future editions.

Thanks

Our research has been interesting and stimulating. It has also been time-consuming and demanding. The authors wish to extend their sincere appreciation to their respective institutions, the State University of New York, College at Buffalo and the Albright-Knox Art Gallery, for their support and encouragement. Many individuals also have been of tremendous assistance in tracking down information regarding films and tapes. Our thanks go especially to Mary Ann Chach, Liz Hager, Pat Ulmer, Pat Wetmore, and Janice Woo. Much-appreciated assistance in preparing the manuscript was given by Gretchen Baldauf, Jennifer Besemer, and Randy Gadikian. And to our editor, Mary Robinson Sive, and to our respective family members, our most sincere thanks for their patience, their help, their support, and their enthusiasm.

1. These are standard references that have been published in many editions over the years. We recommend that interested readers also consult the following works for further information:

Robert Goldwater and Marco Treves, eds., *Artists on Art, From the XIV to the XX Century,* 3d ed. (New York: Pantheon Books, 1974).
See pp. 7ff. for further discussions of the nature of artists' writings.

Sources for writings by twentieth century artists include:

Robert L. Herbert, ed., *Modern Artists on Art; Ten Unabridged Essays* (Englewood Cliffs, N.J.: Prentice-Hall, 1964).

Ellen H. Johnson, ed., *American Artists on Art from 1940 to 1980* (New York: Harper and Row, 1982).

Numerous other compilations and other artist interviews have appeared in print in recent years.

2. Nancy Miller, Christopher Crosman. Conversation with the artist, 1976.

3. Christopher Crosman. Conversation with the artist, September 1975.

4. An excellent source for checking the availability of 16mm. films held in college and university film libraries is the following publication, available in many large public libraries. Some of the productions listed in our compilation are held in the numerous noncommercial film libraries that are shown in the *Locator.*

Educational Film Locator of the Consortium of University Film Centers and R. R. Bowker Company, 2d ed. (New York: R. R. Bowker Company, 1980).

From Museums,
Galleries,
and Studios

ENTRIES FOR INDIVIDUAL ARTISTS

AA

ACCONCI, VITO

A001 A Visit to Soho. allv. Inner-Tube Video. 1980?. 30 min. sound. color. order #2. buy: $125. series: ART/New York: 1980-1 Art Season.

 This tape visits the following exhibitions: "Large Scale Works" at the Leo Castelli Gallery, Vito Acconci, Robert Morris, Dennis Oppenheim at the Sonnabend Gallery, Acconci at the Kitchen and Jenny Snider at Artists Space. Features an interview with Vito Acconci (4 min.).

A002 Vito Acconci. vc: 3/4. Jaime Davidovich. Artists Television Network. 1980. 28 min. sound. color. order by title. buy: request price. rent: request price. prev. series: Conversations.

 "Conversations" is a series of informal interviews featuring some members of the art world. Steven Poser interviews Les Levine, Laurie Anderson, Vito Acconci and others in half-hour sessions designed for television. In this tape Vito Acconci, sculptor, performance and video artist, is interviewed.

ADAMS, ANSEL

A003 Ansel Adams--Photographer. 16mm., allv. Larry Dawson. International Film Bureau. 1958. 20 min. sound. b&w. order by title. buy: 16mm./$300, vc/$250. rent: $20. 16mm. only.

prev. CA.

This film records the life and work of Ansel Adams and shows how he uses his zone system of control over exposure and development. Deals with his photography of parks and monuments and briefly touches on his work for Polaroid. Includes many of his photographs, among them the famous "Moonrise, Hernandez, New Mexico, 1941." Shows Adams to be a photographer, writer, philosopher, and mountaineer.

A004 Ansel Adams: Photographer. 16mm. FilmAmerica, Inc. Arthur Cantor Films. 1981. 60 min. sound. color. buy: $1200. rent: $150. prev.

This is a film portrait of the life and work of Ansel Adams, a twentieth century photographer. Adams, born in 1902, reflects on his life as an artist, first studying classical piano and "taking a while to get into photography in a big way." He is filmed in his workshop home in Carmel, California, where he discusses the theoretical and emotional aspects of photography. Adams talks about the development of photography as an art form and is seen teaching his annual photography workshop.

A005 Language of the Camera Eye. 16mm. KQED Educational Service. Indiana University Audiovisual Center. 1961. 29 min. sound. b&w. order #RS-518. buy: $250. rent: $9.50. prev. CA.

Ansel Adams and Beaumont Newhall, Director of Eastman House in Rochester, New York, analyze the photographs of Edward Weston, Cartier-Bresson, Edward Steichen, Alfred Stieglitz and others. Mr. Adams explains the development of his own philosophy in photo-poetry and how it has influenced his work.

A006 Photography as an Art. 16mm. KQED Educational Service. Indiana University Audiovisual Center. 1960. 29 min. sound. b&w. order #RS-514. buy: $250. rent: $9.50. prev. CA.

Presents Ansel Adams as he photographs Yosemite National Park. Explains how a sense of discovery and rediscovery is conveyed through his photography. Shows a collection of his photographs. Adams discusses his methods of teaching and his indebtedness to other photographers.

A007 Points of View. 16mm. KQED Educational Service. Indiana University Audiovisual Center. 1961. 29 min. sound. b&w. order #RS-515. buy: $250. rent: $9.50. prev.

Shows Ansel Adams as he photographs an old house and its inhabitants. Explains his "point of view" as he photographs from many different perspectives to suit many purposes. Tells how sensitive photographers can become "photo-poets."

A008 <u>Professional</u> <u>Photography.</u> 16mm. KQED Educational Service. Indiana University Audiovisual Center. 1961. 29 min. sound. b&w. order #RS-517. buy: $250. rent: $9.50. prev. CA.

Ansel Adams and Milton Halberstadt, commercial photographer, discuss photography as a profession. Mr. Adams applies his imagination and techniques to industrial, promotional, and portrait photography.

A009 <u>Technique.</u> 16mm. KQED Educational Service. Indiana University Audiovisual Center. 1961. 29 min. sound. b&w. order #RS-516. buy: $250. rent: $9.50. prev. CA.

Ansel Adams discusses the techniques of photography. Illustrates from his collection the use of light, filters, exposure, magnification and interpretation. Demonstrates the use of these techniques to achieve given effects.

AGAM, YAACOV

A010 <u>Agam</u> and... 16mm. Forma Art Associates. 1980. 29.5 min. sound. color. order #8308. buy: $600. rent: $60 per 3 days, $20 per addl. day. (rental fee may be applied toward purchase if used for preview). series: Artists at Work.

Yaacov Agam, filmed in his Paris studio at work for his Guggenheim Museum retrospective, explains his "participatory" painting and sculptures. He demonstrates his art in the Agam Salon of the Pompidou Museum, a permanent, total environment of his work. He is shown explaining his huge "Hundred Gates," and speaking with educators and small children. Viewers also see the artist at work on stained glass windows.

A011 <u>The</u> <u>Possibilities</u> <u>of</u> <u>Agam.</u> 16mm. Forma Art Associates. 1967. 28 min. sound. color. order #8307. buy: $450. rent: $55 per 3 days (rental fee may be applied to purchase if used for preview). prev.

Early work of the internationally recognized Israeli kinetic pioneer. His work depends on the participation of the spectator. Agam explains his

"contrapuntal" art as the camera dollies across the work, colors and forms constantly changing with the movements. As Agam's "sound tactile" paintings quiver, images emerge and change while the tone produced provides an aural equivalent.

A012 The World of Yaacov Agam. 16mm. Arthur Cantor Films. 1976. 60 min. sound. color. buy: $950. rent: $120. prev.

Agam was born in 1928 and grew up in Israel, where he was exposed at an early age to the mysticism and philosophy of Jewish Cabalistic thought. He went to Paris in 1951 and has lived there since. The film shows the artist working on sculptures that create sounds, paintings that change shape and color, and a many-hued carpet, woven for the French Presidential Residence. The film also includes a panoramic look at Israel and its culture, which have an enormous influence on Agam's work.

ALBERS, JOSEF

A013 Josef Albers: Homage to the Square. 16mm. Paul Falkenberg and Hans Namuth. Museum at Large. 1969. 25 min. sound. color. order by title. buy: $600 (plus handling). rent: $60 (plus handling). prev. SY.

Albers discusses the ambiguities of color and visual perception, taking the role of the teacher with the viewer as pupil. Two of his former students, Richard Anuszkiewicz and Robert Rauschenberg, reflect upon his theories and his influence on their work.

ALECHINSKY, PIERRE

A014 Alechinsky. 16mm., allv. Luc de Heusch for Albina Productions with the cooperation of the Belgian Radio-TV Network and the Belgian Ministry of Culture. International Film Bureau, Inc. 1972. 20 min. sound. color. order by title. buy: 16mm./$350, vc/$275. rent: $25 (16mm. only). prev.

A unique opportunity to watch the award-winning Belgian artist Pierre Alechinsky as he designs "Les Gilles de Binches," an immense ink-drawing that is his interpretation of a folkloristic ballet of medieval origin. With very little narration, the production conveys his creativity by using unusual sound effects, music, and further examples of his work.

ALEXANDER, PETER

A015 <u>Peter Alexander.</u> 16mm. KCET. Indiana University Audiovisual Center. 1971. 30 min. sound. color. order #RSC-785. rent: $12.50. series: Artists in America.

 Examines the work and the philosophy of Peter Alexander. This sculptor who was first an architect found that his drawings were not as original as he would have liked. He decided to explore the effects of light on plastic cubes, wedges and other forms.

ANDERSON, LAURIE

A016 <u>Laurie Anderson.</u> ac. Audio Arts. 1981. 30 min. sound. order by title. buy: ℔3 (plus ℔1.50 for handling). series: Audio Arts Magazine Supplement.

 An interview recorded at Riverside Studios, London, concerning her work "United States."

A017 <u>Laurie Anderson.</u> vc:3/4. Jaime Davidovich. Artists Television Network. 1980. 28 min. sound. color. order by title. buy: request price. rent: request price. prev. series: Conversations.

 "Conversations" is a series of informal interviews featuring some articulate members of the art world. Steven Poser interviews Les Levine, Laurie Anderson, Vito Acconci and others in half-hour sessions, designed for television. This tape interviews Laurie Anderson, musician, composer, poet and visual artist who has been performing and exhibiting for over a decade.

A018 <u>Laurie Anderson.</u> vc:3/4. Video Data Bank. 1977. 47 min. sound. b&w. order by title. buy: $275. rent: $50.

 Anderson works with words, language, sound, film and other elements in her performances. Her work is both intensely personal and reflective of the art and the world in which she lives.

ANDRE, CARL

A019 <u>Carl Andre.</u> ac. Audio Arts. 1975. 40?. min. sound. order by title. buy: ℔3.5 (plus ℔1.10 for handling). series: Audio Arts Magazine.

 An interview with the sculptor while in London for his exhibition at the Lisson Gallery in June 1975.

Andre moves through the gallery space describing the works, their references, and his links as an artist with American culture and its history.

A020 Carl Andre. vc:3/4. The Buffalo Fine Arts Academy/Albright-Knox Art Gallery. SUCB Film Library. 1978. 25 min. sound. color and b&w. order by title. buy: $100. rent: $40. prev. tape with excerpts from several programs avail. on request.

"My sculpture and my poetry are made by the same person which is not as frivolous as it sounds, because they are both informed by the same sensibility..." With directness and a powerful presence Carl Andre discusses his early art training, influences on his works, and his views on art in contemporary society.

ANDREWS, CHRIS

A021 The Room With a View. vc:3/4. Chris Andrews. Art Metropole. 1982. 11 min. sound. color. order by title. buy: $250. rent: $50 single play, per half-hour; $200 multiple play, per half-hour.

This is the first section of a series of videotapes which make use of "documentary evidence" of a personal past (photographs, films and recollections) to construct a self-portrait of the artist.

ANNIGONI, PIETRO

A022 The Artist and The Saint. 16mm. Frank Brittain. St. Jude Chapel. 1980. 25 min. sound. color. order by title. buy: $500. rent: request price.

We first meet Annigoni on the street in Ponte Buggianese, a small town in Central Italy. He takes us into the church of San Michele Arcangelo where he shows three of his works. Then to the South and the Abbey of Monte Cassino, the dome of which pictures four events in the life of St. Benedict. Annigoni and Brittain discuss the works.

A023 The Glory of St. Benedict. 16mm. Frank Brittain. St. Jude Chapel. 1979. 32 min. sound. color. order by title. buy: $500. rent: request price.

Pietro Annigoni painted this fresco for the commemoration of the 1500th anniversary of the birth of St. Benedict. The film documents the actual painting which took a year and one-half. The fresco

pictures Abraham and Moses as well as some of the
followers of St. Benedict. The narrative includes
the history of the Abbey and Annigoni's comments
about his characterizations.

A024 Pietro Annigoni, An Individual. 16mm. Frank Brittain.
St. Jude Chapel. 1978. 35 min. sound. color. order by title.
buy: $500. rent: request price.

In this film Annigoni discusses several of his
works, among which are "Vita," "The Healing of the
Paralytic," and two versions of "The "Raising of
Lazarus" which were done thirty years apart. One of
these two versions, an oil, now hangs in the Vatican
Museum.

ANTIN, ELEANOR

A025 Eleanor Antin. vc:3/4. Video Data Bank. 1980. 28 min.
sound. color. order by title. buy: $175. rent: $50.

Interviewed by Nancy Bowen, Antin discusses the
characters she creates on video and in performance
which blur fiction and history. She avoids "good
taste" and discloses concealed intentions,
attempting to force the viewer to stretch all
possible associations to the breaking point.

A026 100 Boots Conversation with Eleanor Antin. ac.
Pacifica Tape Library. 1974. 62 min. sound. order #BC1848.
buy: $17.

Arlene Raven, Ruth Iskin, and Clare Spark talk with
the conceptual artist.

APPEL, KAREL

A027 The Reality of Karel Appel. 16mm. Jan Vrijman.
Consulate General of the Netherlands. 1962. 15 min. sound.
color. order by title. rent: free loan. prev.

Karel Appel is the best-known Dutch abstract painter
living. The passion with which he paints has been
caught by the camera and set to music.

ARDIZZONE, EDWARD

A028 Edward Ardizzone. 16mm. John Phillips for Penguin
Books. Weston Woods. 1978. 13 min. sound. color. order
#MP429. buy: $225. rent: $15. prev.

This live-action film probes the world of Edward Ardizzone, creator of the Little Tim books, in his studio in Kent, England. He talks with and swaps drawings with children on the village green. Commentary accompanies the showing of many of the artist's sketches, highlighting Ardizzone's ability to capture personality in his characters.

ARMAN

A029 Arman. vc:3/4. The Buffalo Fine Arts Academy/Albright-Knox Art Gallery. SUCB Film Library. 1975. 23 min. sound. b&w. order by title. buy: $100. rent: $40. prev. tape with excerpts from several programs avail. on request.

Arman is interviewed in his lower Manhattan loft apartment. Tracing the sources and influences on his art from Duchamp and the Dada movement to aspects of Oriental philosophy and popular culture, Arman reveals a sensuous and intellectual temperament that is uniquely his own.

A030 Arman: Conscious Vandalism. vc:3/4. The Buffalo Fine Arts Academy/Albright-Knox Art Gallery. SUCB Film Library. 1978. 16 min. sound. b&w. order by title. buy: $100. rent: $40. prev. tape with excerpts from several programs avail. on request.

This program consists of excerpts from an "Action" or "Conscious Vandalism" staged at the John Gibson Gallery, New York City, on April 5, 1975. Sequences of Arman destroying an apartment setting (built by the artist for this purpose) are included with eyewitness accounts by Arman and his dealer, Susan Gibson. Action sequences were taped by Andy Mann.

ARMITAGE, KENNETH

A031 Kenneth Armitage. vc:3/4. The Buffalo Fine Arts Academy/Albright-Knox Art Gallery. SUCB Film Library. 1976. 40 min. sound. b&w. order by title. buy: $100. rent: $40. prev. tape with excerpts from several programs avail. on request.

From his London carriage house studio Armitage talks about his relationship to the development of post-World War II British sculpture, describing continuities and changes in his own work through the course of the past twenty-five years.

ARTSCHWAGER, RICHARD

A032 <u>Richard Artschwager</u>. vc:3/4. Christopher Crosman and
Linda Cathcart for The Buffalo Fine Arts Academy/Albright-
Knox Art Gallery. SUCB Film Library. 1979. 16 min. sound.
color. order by title. buy: $100. rent: $40. prev. tape
with excerpts from several programs avail. on request.

> This tape documents the first comprehensive
> exhibition of Richard Artschwager's work organized
> jointly by the Albright-Knox Art Gallery, the La
> Jolla Museum of Contemporary Art, and the
> Institute of Contemporary Art, University of
> Pennsylvania. Artschwager who anticipated many of
> the forms and concerns of Post-modernism emerged
> from a Duchapian esthetic which creates new thoughts
> for familiar-looking objects. His work confuses
> and blends the usual distinctions between
> abstraction and representation and always contains a
> detatched irony and wit. The tape includes views of
> the exhibition and the artist working on the
> installation with comments by Artschwager and
> exhibit co-curator, Linda Cathcart.

ATCHLEY, DANA

A033 <u>Travelling With Ace Space</u>. vc:3/4. Dana Atchley. Art
Metropole. 1977. 8 min. sound. color. order by title. buy:
$250. rent: $50 single play, per half-hour; $200 multiple
play, per half-hour.

> A short piece for KDIX News about travelling video
> artist and documentarian Dana Atchley.

ATGET, EUGENE

A034 <u>Atget</u>. 16mm. WNET/13, New York. Indiana University
Audiovisual Center. 1967. 30 min. sound. b&w. order #RS-704.
buy: $250. rent: $9.50. prev. CA.

> A look at the work of Eugene Atget whose photographs
> depict turn-of-the-century Paris. Narrator Berenice
> Abbott, photographer and protege of Atget, analyzes
> some sixty photographs including portraits, still
> life photographs and street scenes. She describes
> Atget's meager equipment, painstaking methods and
> traces his influence on other photographers and
> painters.

AVERY, MILTON

A035 <u>Milton Avery (Discussed by Sally Avery and March Avery
Cavanaugh)</u>. vc:3/4. Catherine Green and Sharon Blume for The
Buffalo Fine Arts Academy/Albright-Knox Art Gallery. SUCB

Film Library. 1983. 16 min. sound. color. order by title. buy: $100. rent: $40. prev. tape with excerpts from several programs avail. on request.

Milton Avery has always been highly regarded by his fellow artists including Mark Rothko and Adolph Gottlieb who were his close friends. This tape which accompanied the Milton Avery retrospective exhibition organized by the Whitney Museum of American Art is also about Avery's widow, Sally, whose strength, intelligence and good humor sustained them and made the work of Avery possible. The interview also contains comments by Avery's daughter, March, the model for numerous paintings. Interview by Catherine Green.

AYCOCK, ALICE

A036 Alice Aycock. vc:3/4. Video Data Bank. 1977. 37 min. sound. b&w. order by title. buy: $275. rent: $50.

Kate Horsfield discusses with Aycock her large environmental sculpture. Although she uses primitive rite and architecture as sources, her use of contemporary materials removes those specific connotations while creating intense psychological atmospheres.

BB

BALDESSARI, JOHN

B001 John Baldessari. vc:3/4. Sharon Blume and Charlotta Kotik for The Buffalo Fine Arts Academy/Albright-Knox Art Gallery. SUCB Film Library. 1981. 23 min. sound. color. order by title. buy: $100. rent: $40. prev. tape with excerpts from several programs avail. on request.

Baldessari, before deciding to become an artist in his late twenties spent several years studying philopophy and literature. Words, literary allegories and linguistics in general still fascinate him and have deeply influenced the structure of his art, so that most of his work, in which photography is the primary medium, could be described as visual poems. Taped in conjuntion with the exhibition at the Albright-Knox, "John Baldessari: Selected Works." Scheduled for 1984 release.

B002 John Baldessari. vc:3/4. Video Data Bank. 1979. 28 min. sound. b&w. order by title. buy: $175. rent: $50.

Interviewed by Nancy Bowen, Baldessari discusses his films, videotapes, photographs and books. These encompass a wide range of ideas that have to do with the gathering, sorting and re-organizing of information. He uses common images and words, treating them with humor in a conceptual structure.

BARTLETT, JENNIFER

B003 Jennifer Bartlett. vc:3/4. Video Data Bank. 1976. 52 min. sound. b&w. order by title. buy: $275. rent: $50.

Bartlett is a writer and painter who makes large paintings with enamels on fabricated panels. She uses an overall grid structure upon which she uses and repeats the images in a variety of styles, ranging from lyric abstraction to childlike represention. Near the end of the interview by Kate Horsfield, Bartlett reads the chapter 'Dreaming' from her book, The History of the Universe.

BASKIN, LEONARD

B004 Images of Leonard Baskin. 16mm. Forma Art Associates. 1968. 28 min. sound. color. order #8305. buy: $450. rent: $55. (per 3 days, $15 per additional day; rental fee applicable to purchase price if used for preview). prev. series: Artists at Work Series.

Shows sculptor Leonard Baskin at home and at work in North Hampton, Massachusetts. Focuses on wood engraving, sculpture, and graphic arts.

BASS, SAUL

B005 Bass on Titles. 16mm., vc:3/4. Saul Bass. Pyramid Film & Video. 1977. 32 min. sound. color. order by title. buy: $450. rent: $55. prev. by arrangement.

The work of Academy Award winner Saul Bass, who produced the classic film Why Man Creates, covers the full range of the design spectrum. Bass discusses his thematic title sequences that open and close many well-known feature films. Shows ten of the more than forty main titles that Bass created, accompanied by his comments on the background and approach to each. Among those included are: The Man with the Golden Arm, Grand Prix, West Side Story and A Walk on the Wild Side.

BATEMAN, ROBERT

B006 <u>Images</u> <u>of</u> <u>the</u> <u>Wild.</u> 16mm. National Film Board of Canada. Benchmark Films, Inc. 1980. 22 min. sound. color. buy:$435. rent:$45. prev.

> Seeking out wild animals in their own natural environment, and painting them with much detail has taken the Canadian artist, Robert Bateman, into the Canadian wilderness as well as on safari in East Africa. While Bateman collects rocks, branches, even elephant dung with which to later reconstruct an animal's environment, he explains what his artist's eye perceives in such objects. The photographs, preliminary sketches, and clay models he makes of the animals are also part of his exacting preparation before beginning a painting.

BEARDEN, ROMARE

B007 <u>Bearden</u> <u>Plays</u> <u>Bearden.</u> 16mm. Modern Talking Picture Service. 1981. 28 min. sound. color. order #15395. rent: free loan. prev.

> Shows how black artist Romare Bearden's Southern roots and years in Harlem have influenced his paintings and collages. In depicting the black experience in America he has been compared to such blues and jazz artists as Bessie Smith. An award winning film. Sponsored by the Seven-Up Company. Available only to senior high schools.

B008 <u>The</u> <u>Unknown</u> <u>American</u> <u>Negro</u> <u>Artist.</u> ac. Pacifica Tape Library. 1967. 42 min. sound. order #BB3415. buy: $15.

> Painter Romare Bearden is interviewed by Jeanne Siegel.

BELL, LARRY

B009 <u>Larry</u> <u>Bell:</u> <u>A</u> <u>Video</u> <u>Portrait.</u> allv. John Hunt and International Enviromnmental Communications. Independents Network. 1976. 2 parts. Part I: 25 min.; Part II: 30 min. sound. color. order by title. buy: $100. each part. prev. for libraries only.

> This tape documents the creation of Bell's giant glass sculpture, "Iceberg," first shown at the Fort Worth Art Museum in 1975. In the second part of the tape, the artist discusses his life and art. He also explains "Solar Fountain."

BENDER, RUDI

B010 <u>Rudi Bender.</u> ac. Pacifica Tape Library. 1971. 23 min. sound. order #BC0170. buy: $13.

> Photographer Rudi Bender discusses his exhibit at the San Francisco Museum of Modern Art with Michael Bry.

BENGLIS, LYNDA

B011 <u>New Art.</u> allv. Inner-Tube Video. 1980?. 30 min. sound. color. order #3. buy: $125. series: ART/New York: 1980-1 Art Season.

> This tape visits the following exhibitions: "Illustration and Allegory" at the Brooke Alexander Gallery, Jim Sullivan at the Nancy Hoffman Gallery, Claes Oldenburg at the Whitney Museum and the Leo Castelli Gallery and Lynda Benglis at the the Paula Cooper Gallery. Includes a 3.5 minute interview with Lynda Benglis.

BERNSTEIN, JUDITH

B012 <u>Hyphenated Expletives Need Not Apply.</u> ac. Pacifica Tape Library. 1974. 56 min. sound. order #BC1881. buy: $15.

> Artist Judith Bernstein talks with art historian Carl Baldwin and Clare Spark about censorship.

BETAUDIER, PATRICK

B013 <u>Artist in Exile: Patrick Betaudier.</u> ac. Amina Hassan. Pacifica Tape Library. 1980. 30 min. order #AZ0375. $10. prev.

> Patrick Betaudier, a native of Trinidad, lives and paints in Paris. He talks about his life in a foreign land, his teaching and his art.

BETTS, EDWARD

B014 <u>Abstract Designs from Nature with Edward Betts.</u> 16mm., allv. Electrographic Corporation. Perspective Films. 1973. 19 min. sound. color. order #3570/16mm., #3570V/vc. (specify format). buy: 16mm./$389, vc/$233. prev. (16mm. only). series: Watercolor Painting. IU, SY.

> A stone quarry, where Betts finds inspiration for many of his paintings, is the subject of his semi-abstract acrylic watercolor. The viewer sees how the Maine artist maintains a true graphic affinity

for the bulk, weight, color, and texture of high
blocks of mined stone.

B015 <u>Creative</u> <u>Color</u> <u>Collage</u> <u>with</u> <u>Edward</u> <u>Betts.</u> 16mm., allv.
Electrographic Corporation. Perspective Films. 1973. 18 min.
sound. color. order #3571/16mm., #3571V/vc. (specify
format). buy: 16mm./$389, vc/$233. prev. (16mm. only).
series: Watercolor Painting. IU, SY.

Betts creates a painting of monoliths of stone using
successive overlays of paint applied by brush and
knife. His final expression is semi-abstract. Betts
comments upon his style which is spontaneous and
accepting of "accidents."

BEUYS, JOSEPH

B016 <u>Current</u> <u>Exhibitions.</u> allv. Inner-Tube Video. 1980?. 30
min. sound. color. order #1. buy: $125. series: ART/New
York: 1980-1 Art Season.

This tape visits the following exhibitions: Andy
Warhol at the Whitney Museum, Ned Smyth and Thomas
Lanaghan-Schmidt at the Holly Solomon Gallery, Mel
Bochner at the Sonnabend Gallery and Joseph Beuys at
the Ronald Feldman Gallery. Included is an interview
with Joseph Beuys (4 min.).

B017 <u>Joseph</u> <u>Beuys.</u> vc:3/4. Video Data Bank. 1980. 55 min.
sound. color. order by title. buy: $275. rent: $50.

Kate Horsfield speaks with Beuys about his
methodology which embodies a spirit of provocation
and controversy. His work concerns the creation of
new cultural horizons through the incorporation of
political/economic aspects into his art.

B018 <u>Joseph</u> <u>Beuys</u> <u>at</u> <u>the</u> <u>Institute</u> <u>of</u> <u>Contemporary</u> <u>Art.</u> ac.
Audio Arts. 1974. 30? min. sound. order #Volume 2 Number 1.
buy: ₺3.50 (plus ₺1.10 handling). series: Audio Arts
Magazine.

Beuys spoke in London in November 1974 on the
following topics: the existing world social and
political system, structuring society by individual
creativity, education as a strategy for bringing
about change, the evolution from drawings to action
art to environment art and social sculpture, the
structure of his proposed "Free International School
for Creativity and Interdisciplinary Research," and
moving to a more effective positon as artists within
society. On the tape with: "R. Buckminster Fuller."

B019 Joseph Beuys at the School of the Art Institute of
Chicago. vc:3/4. Horsfield and Blumenthal. Ronald Feldman
Fine Arts. 1974. 55 min. sound. b&w. order by title. buy:
$275. rent: $50 single play, per half-hour; $200 multiple
play, per half-hour. prev. on premises only.

 An early interview with Beuys done by Kate Horsfield
 and Lyn Blumenthal.

B020 Joseph Beuys: Interviewed by Willoughby Sharp. vc:3/4.
Willoughby Sharp. Ronald Feldman Fine Arts. 1972. 39 min.
sound. b&w. order by title. buy: $175. rent: $50. prev. on
premises only.

 The well-known German artist discusses his sculpture
 and performances at his Dusseldorf studio. Camera
 by Andy Mann.

B021 Public Dialogue at The New School. vc:3/4. Ronald
Feldman Fine Arts. 1974. 150 min. sound. b&w. order by
title. buy: $275. rent: $100. prev. on premises only.

 This dialogue took place during Joseph Beuys' first
 trip to the United States.

BINDER, ERWIN

B022 Binder: The Sculptor's Art. 16mm., allv. Gerald Schil-
ler. S-L Film Productions. 1983. 30 min. sound. color. buy:
$450. rent: $35. prev.

 The life and career of Erwin Binder are traced in
 this film. We hear Binder's comments about his
 philosophy and his work, influenced by Mexican
 masters. The film documents the evolution of one of
 his bronze pieces from conception through the steps
 of clay, mold, wax, and finally bronze. The film
 concludes with a survey of some of his best known
 works in marble, onyx, and bronze.

BISHOP, ISABEL

B023 Isabel Bishop: Portrait of an Artist. 16mm. vc:3/4,
vc:v. Pat Depew. Films Incorporated. 1979. 29 min. sound.
color. order #523-0001. buy: 16mm./$470, vc/$235. rent: $50.
prev.

 Master of Romantic Realism, Isabel Bishop's
 preoccupation with the ordinary has produced a style
 uniquely her own. She has been drawing, painting

and making etchings of the people of New York City
for almost half a century. Scenes from her
paintings and from her life portray the personality
of this highly individual woman and expand the
viewer's understanding of her work.

BLACK, CALVIN

B024 Possum Trot. 16mm. Allie Light and Irving Saraf. Light-
Saraf Films. 1977. 28:45 min. sound. color. order by title.
buy: $370. rent: $40. prev. with intent to purchase. series:
Visions of Paradise.

Calvin Black was a folk artist of the Mojave desert
who created over eighty wooden, nearly life-size
dolls. He built the Bird Cage Theater where the
dolls perform and sing in voices recorded by Calvin.
This film is the only filmed document of the lives
of Calvin Black and his wife Ruby who died in 1972
and 1980, respectively.

BLANTON, BILL

B025 Bill Blanton: Photographer. vc:3/4. Appalshop, Inc.
1982. 29 min. sound. color. order by title. buy: $150. prev.
restricted to segments of the program. series: Headwaters.

Bill Blanton is staff photographer with a small
weekly newspaper in Norton, Virginia. He has been
photographing the people and events of southwestern
Virginia in several different photographic modes.
He discusses how each of his roles causes him to
bring a different approach to the work.

BOISE, RON

B026 The Sculpture of Ron Boise. 16mm. Canyon Cinema. 197?.
9 min. sound. color. order by title. rent: $15.

Documents Boise working on one of the last pieces of
sculpture which he created before his death. He
collects, cuts, shapes and welds cast-off materials
into a human figure. The sound track includes sounds
and rhythms played by Boise on unique musical
sculptures which he called "Space Flowers."

BOLOTOWSKY, ILYA

B027 Ilya Bolotowsky. vc:3/4. Sharon Blume and Mary Wayne
Fritzsche for The Buffalo Fine Arts Academy/Albright-Knox
Art Gallery. SUCB Film Library. 1980. 16 min. sound. color.
order by title. buy: $100. rent: $40. prev. tape with

excerpts from several programs avail. on request.

Bolotowsky who died in 1982 at the age of 75 was a
native of Russia who emigrated from his native land
during the Russian Revolution and became one of the
co-founders of the American Abstract Artists
Association. His work is closely related to the
ideals and methods of Mondrian and the European De
Stijl artists who emphasized pure abstraction based
on right angles and strong primary colors. He
taught at Black Mountain College from 1946-48,
influencing many younger artists. Taped at
Bolotowsky's lower Manhattan studio. Scheduled for
1984 release.

BOROFSKY, JONATHAN

B028 Sculpture Today. allv. Inner-Tube Video. 1980?. 30 min.
sound. color. order #4. buy: $125. series: ART/New York:
1980-1 Art Season.

This tape visits the following exhibitions: Duane
Hanson at O.K. Harris Gallery, Anthony Caro at
Acquavella Gallery, Alain Kirili at the Sonnabend
Gallery and Jonathan Borofsky at the Paula Cooper
Gallery. The tape includes an interview with
Jonathan Borofsky (4 min.).

BOURAS, HARRY

B029 Points of View. vc:3/4. Peter Weiner. 1983?. in two
parts: 20 min. each. sound. color. order by title. buy:
$350. rent: $30.

This two-part tape discusses relationships,
esthetics and philosophy. The discussions are
presented by the Chicago-based artist, teacher, and
critic Harry Bouras. Mr. Bouras has a regularly
scheduled radio program in Chicago and appears
nationally in print. His art work is widely shown
and represented in many collections. Scheduled for
1983 release.

BOYLE, JOHN

B030 John Boyle's Canadian Heroes. 16mm., allv. Film Arts.
Kinetic Film Enterprises. 1981. 14 min. sound. color. order
#4077/0625. buy: $325. rent: $50. prev.

A documentary about the young Canadian artist John
Boyle, whose work is devoted to creating a Canadian
mythology through the events and personalities of
the nation's history. Boyle uses such figures as
Tom Thomson, the Black Donnellys, Emily Carr, Louis

Riel and scenes of the Metis uprising in his work.

BRAKHAGE, STAN

B031 Stan Brakhage. vc:3/4. Video Data Bank. 1976. 38 min.
sound. b&w. order by title. buy: $275. rent: $50.

B. Ruby Rich interviews this major figure among
independent filmmakers, whose works have transformed
the idea of film making for many contemporary
artists.

BRISLEY, STUART

B032 Conversations. ac. Audio Arts. 1981. 60? min. sound.
order #Volume 4 Number 4. buy: ₤4 (plus ₤1.10 for handling).
series: Audio Arts Magazine.

This tape is edited from a nine-hour interview with
Brisley where he discusses eleven works carried out
since 1972. Brisley talks extensively about his
attitudes and concerns as an artist and of the
issues surrounding live work. Publication of this
issue coincided with Brisley's retrospective
exhibition at the Institute of Contemporary Arts,
May 1981.

BUFANO, BENJAMINO

B033 Art, Gandhi, Revolution, Mammon. ac. Pacifica Tape
Library. 1957. 41 min. sound. order #B1983. buy: $15.

Benjamino Bufano is interviewed by Bryon Bryant.

BUFFEY, URVE

B034 Apple Dolls. 16mm., allv. Labyrinth Films. Wombat
Productions. 1978. 19 min. sound. color. order by title.
buy: 16mm./$330, vc/$230. rent: $33. prev. (16mm. only). CA.

Urve Buffey discusses and demonstrates the practice
of the traditional folk art of apple-doll making.

BURDEN, CHRIS

B035 Car Nut. vc:3/4. Art Tapes. Ronald Feldman Fine Arts.
1975. 25 min. sound. b&w. order by title. buy: $175. rent:
$50. prev. on premises only.

Chris Burden, with Alexis Smith, fondly remembers
the fifteen to twenty cars that he has lived with

and known. He tells anecdotes about the automobiles
and discusses how they have affected his life.

B036 Chris Burden: "The Big Wheel." vc:3/4. Sharpcom
Productions. Ronald Feldman Fine Arts. 1980. 29 min. sound.
color. order by title. buy: $175. rent: $50. prev. on
premises only.

> Taped at the Ronald Feldman Gallery during the
> exhibition of Burden's "Big Wheel," this video is an
> interview by Willoughby Sharp of Ronald Feldman and
> Chris Burden. The Big Wheel, a cast iron flywheel,
> eight feet in diameter and weighing six-thousand
> pounds is shown.

B037 Chris Burden Videoviewed by Willoughby Sharp. vc:3/4.
Willoughby Sharp. Ronald Feldman Fine Arts. 1975. 30 min.
sound. b&w. order by title. buy: $175. rent: $50. prev. on
premises only.

> Willoughby Sharp interviews Chris Burden who talks
> about his early work.

B038 No Place to Hide Down There: An Interview With Chris
Burden. ac. Pacifica Tape Library. 1974. 57 min. sound.
order #BC1853. buy: $15.

> This tape is a psychological self-portrait of the
> conceptual artist, Chris Burden, interviewed by
> Clare Spark.

B039 Selections 1971-1974. vc:3/4. Chris Burden. Ronald
Feldman Fine Arts. 1975. 36 min. sound. color and b&w. order
by title. buy: $275. rent: $125. prev. on premises only.

> Burden has attracted international attention for his
> investigation of psychological experience peculiar
> to risk. In "Shoot" a bullet is fired through his
> left arm; in "Icarus" he balances two six foot
> sheets of glass splashed with flaming gasoline; in
> "Velvet Water" he almost drowns himself.

B040 T.V. Interviews. vc:3/4. Chris Burden. Ronald Feldman
Fine Arts. 1974. 30 min. sound. color. order by title. buy:
$175. rent: $50. prev. on premises only.

> An off-air copy of an interview with Chris Burden on
> a morning talk show in California.

B041 T.V. Tapes. vc:3/4. Chris Burden. Ronald Feldman Fine

Arts. 1977. 5 min. sound. color. order by title. buy: $175. rent: $50. prev. on premises only.

Three commercials made by Chris Burden: "Through the Night Softly," "Poem for L.A.," and "Chris Burden Promo," 1976. Accompanied by an explanation by the artist.

BURTON, JOHN

B042 John Burton. 16mm. WNET/13, New York. Indiana University Audiovisual Center. 1966. 30 min. sound. color. order #RSC-696. rent: $12.50.

Introduces the glass sculpture of John Burton. The artist discusses his philosophy of life and of art and offers the viewer a tour of his studio, home, and surrounding gardens.

BUSH, JACK

B043 Jack Bush. 16mm., allv. National Film Board of Canada. 1979. 56:50 min. sound. color. order #106C 0179 004. buy: 16mm./$775, vc/$450. rent: $80. prev.

A Canadian abstract painter, Bush exhibited and sold his works in New York, London and Europe. In an interview he gave before his death, he talks about his life, his work, and the development of art in Canada. A retrospective of his work is shown in which Clement Greenberg comments upon his paintings.

BYARS, JAMES

B044 James Byars. ac. Pacifica Tape Library. 1971?. 45 min. sound. order #BV4458.02. buy: $13. series: Art and Technology.

James Byars, while resident at the Hudson Institute, describes his project.

cc

CALDER, ALEXANDER

C001 Alexander Calder: Calder's Universe. 16mm. Paul Falkenberg and Hans Namuth. Museum at Large. 1977?. 26 min. sound. color. order by title. buy: $750 (plus handling). rent: $75 (plus handling). prev.

Directed by Louisa Calder and Tom Armstrong, this
film displays the mobiles and animated wire
sculpture that Calder exhibited in 1976 and 1977 at
the Whitney Museum. He playfully integrates an old
spoon into one of his delicate mobiles, showing his
lighthearted approach to creation.

C002 Mobile by Alexander Calder. 16mm. allv. National
Gallery of Art. National AudioVisual Center. 1980. 24 min.
sound. color. order #AO3683/GD(16mm.), AO3684/GD(vc). buy:
16mm./$230, vc/$80. prev.

Alexander Calder's mobile at the National Gallery of
Art's East Wing was the first piece of art installed
in the new building and the last major work of its
creator. The work shows whimsy, color, balance and
movement. This film traces the story of the
innovator of the mobile and the record of the
collaboration of artist, museum staff, and craftsmen
in the giant structure's creation.

CALLAHAN, HARRY

C003 Harry Callahan: A Need to See and Express. allv.
Silver Productions. Video Gallery. 1982. 23 min. sound.
color. order by title. buy: vc:3/4/$175, vc:b/$125,
vc:v/$125. prev. $50. charge waived if purchased. series:
Masters on Photography.

Interviews Callahan, an artist-photographer-teacher
for over forty years at the Institute of Design and
the Rhode Island School of Design. Shows many of
his photographs in color and black and white, plus
rare footage of his films.

C004 Harry Callahan: Eleanor and Barbara. 16mm. Checker-
board Foundation, Inc. 1983. 18 min. sound. color. order by
title. buy: request price. rent: request price.

Callahan's photographs of his wife and daughter,
taken over a period of approximately twenty-five
years, provide an important insight into his
creativity.

CAMPOLI, COSMO

C005 Conversations with Cosmo. vc:3/4. Peter Weiner. 1983?.
60 min. sound. color. order by title. buy: $500. rent: $50.

The basis of this tape is an interview with sculptor
Cosmo Campoli, whose work has been widely shown and
is represented in many collections. He has also

taught at the Institute of Design. Scheduled for
1983 release.

CARO, ANTHONY

C006 Anthony Caro. vc:3/4. The Buffalo Fine Arts Academy/
Albright-Knox Art Gallery. SUCB Film Library. 1976. 55 min.
sound. b&w. order by title. buy: $100. rent: $40. prev. tape
with excerpts from several programs avail. on request.

Caro speaks about his work and its development, his
views on modern art criticism and his relationship
to contemporary British and American painting and
sculpture. The tape includes a look at Caro's
Georgiana Street studio in London.

CARTER, FRED

C007 Fred Carter and the Cumberland Museum. vc:3/4.
Appalshop, Inc. 1980. 28 min. sound. color. order by title.
buy: $150. prev. restricted to segments of the program.
series: Headwaters.

Fred Carter is a wood sculptor from Dickenson
County, Virginia whose work is collected in the
Cumberland Museum. He has operated the museum in
Clintwood for many years. Fred talks about his art,
which is not only exhibited in the Museum, but also
carved into its structure. The scale of his
sculptures range from a seven-foot Indian and
fourteen-foot totems to miniatures.

CASSON, A.J.

C008 A.J. Casson...The Only Critic Is Time. 16mm., allv.
Film Arts/Morningstar. Kinetic Film Enterprises. 1982. 28
min. sound. color. order #4116/0625. buy: $495. rent: $75.
prev.

A.J. Casson is the youngest and last surviving
member of Canada's most famous school of painters:
the Group of Seven. As a working artist approaching
his eighth decade, he is in a unique position to
speak about an art movement that specialized in
wilderness landscapes, especially from the Far
North, which Canadians felt captured the strong
spirit of their land. Samples of his work display
his style in development to the present.

CASTELLI, LEO

C009 Leo Castelli. vc:3/4. The Buffalo Fine Arts Academy/Al-

bright-Knox Art Gallery. SUCB Film Library. 1976. 20 min. sound. b&w. order by title. buy: $100. rent: $40. prev. tape with excerpts from several programs avail. on request.

Since the late nineteenth-century certain dealers have been instrumental in presenting new art to the general public. None has been more successful in recent years than Leo Castelli who has represented or still represents such artists as Andy Warhol, Frank Stella, Roy Lichtenstein and Jasper Johns. Frank Stella also reflects on this extraordinary art dealer.

CASTLE, WENDELL

C010 Transitions: Conversations with Wendell Castle. 16mm. Public Television Library. Indiana University Audiovisual Center. 1971. 30 min. sound. color. order #RSC-790. buy: $360. rent: $12.50. prev. CA.

A sculptor who likes rugged woods and plastic better than materials which are traditionally valued more highly, Wendell Castle creates forms which are beautiful, functional, and relatively inexpensive. Castle designs pieces to fit with each other in a total environment. He believes that artists must continually change because they are never satisfied with the status quo.

CAUDILL, OAKSIE

C011 Oaksie. 16mm., allv. Anthony Stone. Appalshop, Inc. 1979. 22 min. sound. color. order by title. buy: 16mm./$350, vc/apply for prices. rent: $40. (16mm. only). prev. with intent to purchase ($10 handling).

A portrait of basketmaker, fiddler and harp player Oaksie Caudill. The film seeks to capture the spirit of a man who has spent his life surrounded by beauty that he has created in his baskets and in his music.

CHADWICK, LYNN

C012 Lynn Chadwick. vc:3/4. The Buffalo Fine Arts Academy/Albright-Knox Art Gallery. SUCB Film Library. 1976. 45 min. sound. b&w. order by title. buy: $100. rent: $40. prev. tape with excerpts from several programs avail. on request.

Chadwick's spectacular fifteenth-century castle in the rolling Cotswolds region of England provides the setting for his solitary sculpture. Chadwick discusses his work and ideas from his early days as

an architectural draftsman to his present place in modern sculpture.

CHAGALL, MARC

C013 Homage to Chagall. 16mm. Harry Rasky. Kino International Corporation. 1977. 90 min. sound. color. order by title. buy: $1100. rent: $150.

Interviews the artist at the age of ninety, and explores the productivity that has encompassed everything from primitive mysticism to cubist intellectuality. Through on-location photography and old documentary footage, the film investigates various influences on his art and on his life.

C014 Marc Chagall: The Colours of Passion. 16mm., allv. Charles Harris. International Film Bureau, Inc. 1979. 24 min. sound. color. order by title. buy: 16mm./$425, vc/$310. rent: $35. (16mm. only). prev. IU, SY.

An exploration of the major influences on the artist's creative life as well as his preoccupation with color, form and the role of emotion in art. Considers his etchings, mosaics, oils, and gouaches, culminating with his stained-glass windows.

CHAMBERS, WENDY

C015 The Music of Wendy Chambers. vc:3/4. Wendy Chambers. Artmusic, Inc. 1981. 29 min. sound. color. order #01. buy: request price. prev.

This tape documents the performance art of Wendy Chambers, who uses traditional instruments, kitchen utensils and other found objects to create works which are "only incidentally noisy." One work takes place performed from boats on Central Park Lake in New York City.

CHANDLER, GLEN

C016 Glen Chandler: Designer Woodworker. allv. Film Victoria. Tasmanian Film Corporation. 1979. 5 min. sound. color. order by title. buy: (series). Australian $813. rent: Australian $50 per screening, plus freight. prev. series: Craft as a Livelihood.

Part of a series produced for the Victorian Crafts Council, these productions cover a wide range of craft occupations and are intended for teaching appreciation of the skills required in the various

careers. In this segment Glen shows how machine
tools are used in woodworking from planning to the
finished product.

CHASE, DORIS

C017 Circles II. 16mm., allv. Doris Chase. Perspective
Films. 1974. 7.5 min. sound. color. order #3664/16mm.,
#3664V/vc. (specify format). buy: 16mm./$170, vc/$107. prev.
(16mm. only).

This film demonstrates kinetic sculptures made
specifically for dancers. Mary Statton, who
choreographed the dancers, calls this an exciting
experience for her dancers and for the audience. An
award-winning film.

C018 Doris Chase: A Life in Art. vc. 1983. Doris Chase.
Global Village. 30 min. sound. color. order by title. buy:
$275. rent: $75. prev.

Film and video artist, Doris Chase, traces her
journey from sculpture through dance to her work
with film and television. Excerpts are included
from the Chase Dance Series and the Concept Series.

C019 Full Circle. 16mm. allv. Elizabeth Wood. Perspective
Films. 1974. 9.5 min. sound. color. order #3688/16mm.,
#3688v/vc. buy: 16mm./$199, vc/$119. prev. (16mm. only). IU.

Doris Chase discusses her transition from painting
to sculpture to dance. She explains how her art
evolved to enable her to explore more of the
qualities of space and form through dance and
eventually through film/video.

CHICAGO, JUDY

C020 The Dinner Party. ac. Karla Tonella. Pacifica Tape
Library. 1979. 33 min. order #AZ0295. buy: $12. prev.

Judy Chicago talks about "The Dinner Party," a major
piece of sculpture in the making for five years. It
encompasses the history of western women from the
beginning of time using traditional crafts and
symbols as well as new technology and feminist
ideas.

C021 An Evening With Judy Chicago. ac. Pacifica Tape
Library. 1972. 81 min. sound. order #BC1224. buy: $17.

Judy Chicago is interviewed by Arlene Raven.

C022 <u>Judy Chicago in 1976.</u> allv. Sheila Ruth. Independents Network. 1980. 22 min. sound. color. order by title. buy: $100. prev. for libraries only.

> Los Angeles artist Judy Chicago discusses her controversial installation, "The Dinner Party," which was in the initial stages of development during the the taping of this production, begun in 1976 as part of a larger program produced by Sheila Ruth and Jan Zimmerman. In this interview with Hajore Canton, Chicago addresses issues of feminist art, women in history, and the sources of her own work.

C023 <u>Right Out of History: The Making of Judy Chicago's Dinner Party.</u> 16mm. Johanna Demetrakas. Picture Start. 1980. 75 min. sound. color. order by title. buy: $850. rent: $85. CA.

> This film is a document of the over four hundred people working together under the leadership of Judy Chicago to create the huge artwork "The Dinner Party." The filming spanned four of the five years that were needed for the completion of "The Dinner Party" and shows the community of artists who sought to make a socio/esthetic statement through the project.

C024 <u>Women in Art History.</u> ac. Pacifica Tape Library. 1972. 56 min. sound. order #BC1226. buy: $15. series: Women in the Arts.

> Judy Chicago is interviewed by Arlene Raven about the nature and function of women in the arts.

CHRISTO

C025 <u>Christo: Ten Works in Progress.</u> 16mm., allv. Blackwood Productions. 1979. 52 min. sound. color. order by title. buy: $775. rent: $90. prev. with intent to purchase.

> Documents Christo's projects over a period of fifteen years. He is seen at work wrapping a woman in plastic material, unfurling his celebrated orange curtain between two mountains in Colorado, installing his long fabric "fence" in California, and creating other temporary structures around public landmarks.

C026 <u>Christo:</u> <u>Wrapped Coast.</u> 16mm., allv. Blackwood
Productions. 1977. 28 min. sound. color. order by title.
buy: $550. rent: $60. prev. with intent to purchase.

Filmed as the project was executed, the wrapping of
Little Bay, outside of Sydney, Australia in 1969 was
a dramatic project, one of the most memorable
achievements of the dedicated and enthusiastic
Christo.

C027 <u>Christo:</u> <u>Wrapped Walk Ways.</u> 16mm., allv. Blackwood
Productions. 1979. 25 min. sound. color. order by title.
buy: $550. rent: $60. prev. with intent to purchase.

Narrated by the artist, this film is a cinematic
record of the installation of "Wrappeed Walk Ways,"
a project which covered in golden yellow fabric
nearly three miles of public walkways in Loose Park
in Kansas City, Missouri. The installation took
place in fall of 1977.

C028 <u>The Christo Kid.</u> ac. Pacifica Tape Library. 1975. 47
min. order #BC2483. buy: $13.

The controversial artist Christo is interviewed in
the Oakland California Museum at an exhibition of
his work. Christo created a 1,300 foot orange nylon
curtain which was stretched across a valley in
Colorado. He discusses his theories of art, and
some of his planned future projects.

C029 <u>Running Fence Project for Sonoma & Marin,</u>
<u>California, 1976.</u> allv. Gerry Jarocki & Michael Asciutto.
Independents Network. 1976?. 24 min. sound. color. order by
title. buy: $100. prev. for libraries only.

This tape documents the installation of Christo's
mammoth work, an environmental sculpture running 24
miles. Christo narrates the tape, offering his
insights and intentions. City officials, ranchers,
construction workers, and local townspeople are all
recorded on the tape, documenting the public's
reaction to the project.

CLARK, LEON

C030 <u>Leon "Peck" Clark, Basketmaker.</u> 16mm. Center for
Southern Folklore. 1979. 15 min. sound. color. order by
title. buy: $235. rent: $25. prev.

Featuring a day in the life of Leon and Ada Clark,
the film follows the patient development of a white

oak basket from tree to finished product. Detailed
scenes of basketmaking blend with the couple's fond
reminiscences of their long life together.

CLARK, PARAS KEVA

C031 Portrait of the Artist as an Old Lady. 16mm., allv.
National Film Board of Canada. 1982. 27:03 min. sound.
color. order #106C 0182 059. buy: 16mm./$500, vc/$300. rent:
$50. prev.

Paras Keva Clark, now in her eighties, lives in
Toronto. She is an artist, socialist, feminist, and
always her own woman. This film is a biographical
interview of a Russian-Canadian artist whose
paintings are examples of the social-political art
that came out of the nineteen-thirties and forties.

CLARK, ROBERT

C032 Robert Clark: An American Realist. 16mm., vc:3/4.
University of California Extension Media Center. 1974. 19
min. sound. color. order #8962. buy: 16mm./$270, vc/$190.
rent: $29. prev. with intent to purchase.

This film is a study of the American landscape
painter, featuring a demonstration of the methods of
working with egg tempera, a difficult and little-
used medium.

COLEMAN, JAMES

C033 "Box" James Coleman. ac. Audio Arts. 1977. 30 min.
sound. order by title. buy: ₤3 (plus ₤1.10 handling).
series: Audio Arts Magazine Supplement.

The cassette starts with a recording of Coleman's
installation "Box" at ROSC, an international
exhibition of contemporary art held in Dublin in
1977. The artist then describes the work and its
references.

COPPOLA, FRANCIS FORD

C034 Filmmaker: A Diary by George Lucas. 16mm., vc:3/4.
Lucasfilm Ltd. Direct Cinema Limited. 1968, revised 1982. 33
min. sound. color. order by title. buy: $495. rent: $45.
prev.

An on-the-spot record of the making of "The Rain
People." Lucas records the passion, intensity, and
humor of the filmmaker, Coppola, at work. Lucas'

camera follows the cast and crew on a cross-country
automobile caravan, providing viewers with a look
inside moviemaking.

C035 Francis Ford Coppola at the National Press Club. ac.
Warren Kozak. NPR Publishing. 1982. 59 min. sound. order
#NP-82-02-09. buy: $10. series: National Press Club.

Coppola speaks about his concerns for the future of
motion pictures as well as for society as a whole.
He comments on the society's profit orientation and
how this value conflicts with creativity and
artistic values.

CORBETT, JOHN

C036 John Corbett: Textile Teacher. allv. Film Victoria.
Tasmanian Film Corporation. 1979. 5 min. sound. color. order
by title. buy: (series) Australian $813. rent: Australian
$50 per screening, plus freight. prev. series: Craft as a
Livelihood.

Part of a series produced for the Victorian Crafts
Council, these productions cover a wide range of
craft occupations and are intended for teaching
appreciation of the skills required in the various
careers. In this segment John shows the directions
which weaving and textile creation are taking.

CORNELL, JOSEPH

C037 Cornell, 1965. 16mm. Canyon Cinema. 1978. 9 min. sound.
color. order by title. rent: $20.

The only existing film footage of Joseph Cornell.
Included are close-up interiors of many Cornell
boxes, some collage, and some views of Cornell. An
award-winning film.

CORNETT, CHESTER

C038 Hand Carved. vc:3/4. Appalshop, Inc. 1981. 88 min.
sound. color. order by title. buy: $1350. (plus $10
handling). rent: $150 (plus $10 handling). prev. with
intent to purchase.

Documents both the beauty of the designs and the
cold economic reality of marketing the work of this
expert hand-carved chairmaker. Focusing on
Chester's fine craftsmanship and original designs,
the film explores the economic situation of folk
artists today.

CORPRON, CARLOTTA

C039 Carlotta Corpron. vc:3/4. Amon Carter Museum. 1980. 9:50 min. sound. color. order by title. buy: $150. prev.

A 1980 exhibition at Amon Carter Museum celebrated the rediscovery of Carlotta Corpron, a photographer who has lived and worked in Denton, Texas for many years. The subject of her work is light. She captures, modulates and reflects it, both to illuminate real objects and to create form from light itself. Corpron describes her inspiration and experimentation in this interview.

COSINDAS, MARIE

C040 Art of Marie Cosindas. 16mm. WNET/13, New York. Indiana University Audiovisual Center. 1967. 29 min. sound. color. order #RSC-720. buy: $360. rent: $12.50. prev.

Many of Marie Cosindas' color photographs are presented along with comments of museum visitors, art critics, and persons who have posed for her. Reactions of individuals at an exhibition of her Polaroid color photographs are candidly shown. Cosindas discusses her photographs and later creates a still life. She is also shown at work during two portrait sittings. Several of her subjects describe her quiet competency. An experimental filmclip is included.

COTTRELL, JAMES

C041 All Hand Work. 16mm., vc:3/4. University of California Extension Media Center. 1976. 15 min. sound. color. order #9418. buy: 16mm./$215, vc/$150. rent: $26. prev. with intent to purchase.

This production is a portrait of James Cottrell, a well-known 73-year-old mountain artist who plays his banjo and sells his homemade whistles, decorative toadstools, billy clubs, bull roarers, and rolling pins at music festivals and craft fairs throughout West Virginia.

CRANSTON, TOLLER

C042 "Toller." 16mm., allv. Insight Productions. Wombat Productions. 1976. 26 min. sound. color. order by title. buy: 16mm./$440, vc/$310. rent: $44. prev. (16mm. only).

A profile of Toller Cranston, world figure skating champion, showing him on ice and also describing his unique approach to painting.

CRUXENT, JOSE M.

C043 Moire. 16mm., allv. Museum of Modern Art of Latin America. 1970. 8 min. sound. color. order #14. buy: 16mm./$80, vc/$24. prev. on premises only.

Considers the kinetic works of Venezuelan artist J.M. Cruxent. The works move in two ways: the work itself moves, or the spectator must move to vibrate or change the optic plane. The artist uses metallic canvas enclosed in a box form with lights behind parallel layers of colored mesh-work that creates a watery quality like the fabric, moire. Narration in English and Spanish.

CUEVAS, JOSE LUIS

C044 Reality and Hallucinations. 16mm., allv. Museum of Modern Art of Latin America. 1978. 23 min. sound. color. order #26. buy: 16mm./$230, vc/$69. prev. on premises only.

Explores the life and works of the Mexican graphic artist Jose Luis Cuevas. Filmed in Mexico and Paris. English and Spanish narration by Jose Ferrer.

DDD

DAHLBERG, EDWIN

D001 Working on Location with Edwin Dahlberg. 16mm., allv. Electrographic Corporation. Perspective Films. 1973. 19.5 min. sound. color. order #3569/16mm., #3569V/vc. (specify format). buy: 16mm./$389, vc/$233. prev. (16mm. only.) series: Watercolor Painting.

Dahlberg paints an abandoned railway station on location in Sparkill, New York. After making a few compositional sketches, the artist completes his watercolor with spontaneity, stressing textures and contrasts.

DASH, ROBERT

D002 Family Landscape. 16mm., vc:3/4. The Glyn Group, Inc. 1979. 17 min. sound. color. order by title. buy: request

price. rent: request price.

For the celebration of their one-hundredth anniversary, Chesebrough Ponds, Inc. commissioned Robert Dash to create three paintings of the family as part of the American landscape. "Family Landscape" chronicles the artist's process. The film accompanied the paintings on a cross-country museum tour.

DATER, JUDY

D003 The Woman Behind the Image: Photographer Judy Dater. 16mm. John A. Stewart Productions. 1982. 27 min. sound. color. order by title. buy: $450. rent: $45. (plus $5. handling).

A film portrait of a young photographer who wants to do artistically serious work, while maintaining her sense of herself in a profound personal relationship. Her struggle for a balanced life becomes representative of the modern woman's dilemma. An award-winning film.

DAUGHERTY, JAMES

D004 James Daugherty. 16mm. Morton Schindel. Weston Woods. 1972. 19 min. sound. color. buy: $275. rent: $20.

A visit to the home and studio of the noted author-illustrator and historian. Mr. Daugherty's comments contribute to an understanding of the relationship between the artist and the great Americans he portrays, among which are Lincoln, Thoreau and Daniel Boone.

DAVIS, DOUGLAS

D005 Douglas Davis: Video Against Video. vc:3/4. WNET/13, New York. Ronald Feldman Fine Arts. 1975. 30 min. sound. color. order by title. buy: request price. rent: request price. prev. on premises only.

Narrated by Russell Connor, this tape is a conversation with the artist intercut with excerpts from his video work from 1970-75. Telecast in New York on PBS.

D006 Fragments for a New Art. vc:3/4. Douglas Davis. Ronald Feldman Fine Arts. 1975. 35 min. sound. color. order by title. buy: $175. rent: $100. prev. on premises only.

Douglas Davis types out a manifesto for the
seventies in real-time, while the clock moves in
front of him. He declares the end of gesture and
reminds the viewer that Duchamp finally is dead.
This work is also available in book form, with the
same content typed out on the flat page, with
illustrations.

D007 <u>Studies in Myself.</u> vc:3/4. Everson Museum. Ronald
Feldman Fine Arts. 1973. 30 min. sound. color. order by
title. buy: $175. rent: $100. prev. on premises only.

Real-time exploration of the self, Douglas Davis
typing out spontaneous thoughts and intimate
revelations about himself, others, sex, death,
politics, art and video seen on the screen.

DAWSON, DIANA

D008 <u>Claysong.</u> 16mm., allv. Harry Dawson. The Media Project.
1977. 12 min. sound. b&w. order by title. buy: 16mm./$180,
vc/$135. rent: $21.

Harry Dawson documents a clay artisan, his sister
Diana, practicing the careful steps of her craft.
Shows the texture, sensuality and fluidity of this
artistic medium.

DAY, MARY NASH

D009 <u>A Telephone Interview with Mary Nash Day, April 27,
1981.</u> ac. Arthur Oakes. Department of Art. The University
of Alabama. 1981. 55 min. sound. order by title. buy: $15.
series: University of Alabama Artists' Telephone Conference.

Mary Nash Day discusses her philosophy and approach
to her paintings and drawings. She explains that
her works are personal statements about her life and
also symbolic narrative images which reflect her
broad interests from Egyptian tomb paintings, to Van
Gogh, to the Chicago Imagists. This tape includes a
short introductory statement by the artist plus a
forty-five minute interview.

DE HIRSCH, STORM

D010 <u>Storm DeHirsch: Portrait of a Renaissance Woman.</u>
16mm., allv. Mark J. Grossman. Loma Communications. 1980. 14
min. sound. color. order by title. buy: 16mm./$225, vc/$100.
rent: $45 per day (can be applied to purchase price). prev.

Explores the life and work of poet, painter, and
filmmaker, Storm DeHirsch. She discusses her
poetry, The Twilight Massacre, her films, among them
Third Eye Butterfly, and her work in the Film Makers
Cooperative in New York City on their publication
Film Culture. The film includes excerpts from her
various works and current and historical interviews
with the artist.

DEITCH, GENE

D011 Gene Deitch: The Picture Book Animated. 16mm. Morton
Schindel. Weston Woods. 1977. 25 min. sound. color. order
#MP427. buy: $325. rent: $25. prev.

Gene Deitch, whose film animations for Weston Woods
have been award-winners at film festivals on three
continents, turns his camera on himself to reveal
the insight that he brings to animating children's
books. He shares with his audience the excitement
of filmmaking and the dimension that animation
brings to picture books.

DE KOONING, WILLEM

D012 De Kooning on de Kooning. 16mm., vc. Courtney Sale.
Direct Cinema Limited. 1982. 58 min. sound. color. order by
title. buy: $895. rent: $100. prev. series: The American
Artists.

In this portrait of Willem de Kooning, the artist,
the filmmakers, and Elaine de Kooning discuss the
people, events and ideas that formed de Kooning's
artistic vision. The final sequence shows the
artist painting in his studio.

D013 Willem de Kooning at the Modern. 16mm. Paul Falkenberg
and Hans Namuth. Museum at Large. 1960. 26 min. sound.
color. order by title. buy: $600 (plus handling). rent: $60
(plus handling). prev.

This film documents the development of de Kooning's
style over thirty-five years from the late 1930's
until the sixties. The viewer sees him at his
retrospective held at the Museum of Modern Art in
1969 and at work in his studio in 1972.

D014 Willem de Kooning the Painter. Paul Falkenberg and Hans
Namuth. Museum at Large. 1965?. 16 min. sound. color. order
by title. buy: $375 (plus handling). rent: $45 (plus

handling). prev.

Shows de Kooning at work in New York and East Hampton over a two-year period during the mid-1960's. As de Kooning paints he comments on the challenges posed by each new project. By integrating his comments with the action of his brushwork, this film offers an insight into the balance between intellect and gesture that is typical of de Kooning. The narration is extracted from an interview by David Sylvester recorded in 1960.

DELAUNAY, SONIA

D015 Interview with Sonia Delaunay. vc:3/4. The Buffalo Fine Arts Academy/Albright-Knox Art Gallery. SUCB Film Library. 1977. 18 min. sound. b&w. order by title. buy: $100. rent: $40. prev. tape with excerpts from several programs avail. on request.

This tape consists of an edited interview with Sonia Delaunay by Daniel Abadie, Curator, Musee de l'Art Moderne, Centre Georges Pompidou, Paris. Interview was shot on location at Madame Delaunay's Paris studio/residence. Produced and edited by Nancy Miller and Christopher Crosman through a grant from the National Endowment for the Arts.

DEL VALLE, JULIO ROSADO

D016 Julio Rosado del Valle. 16mm., allv. Museum of Modern Art of Latin America. 1967. 13 min. sound. color. order #10. buy: 16mm./$130, vc/$39. prev. on premises only.

This Puerto Rican abstract painter paints a picture in his studio in San Juan. The film gives biographical information, and discusses the influences from the artist's country on his life and art. Spanish narration by Luis Vivas.

DELVAUX, PAUL

D017 Paul Delvaux in His Studio. 16mm., allv. Henri Storck. American Version by International Film Bureau, Inc. International Film Bureau, Inc. 1969. 8 min. sound. color. order by title. buy: 16mm./$150, vc/$150. rent: $10. (16mm. only). prev.

The painter is seen at work while he explains his viewpoint on how sketches relate to a painting. He also reflects about how the objects in his studio

recall childhood memories. The film is also available in French.

DEUTCH, STEPHEN

D018 PISTA: The Many Faces of Stephen Deutch. 16mm., vc:3/4. Katherine Deutch Tatlock. The Rear Window. 1979. 27.5 min. sound. color. order by title. buy: $450. (plus $8 handling). rent: $45. per day. (plus $8 handling).

A portrait of sculptor and photographer Deutch, featuring his wife Helene, also an artist, along with writers Studs Terkel and Nelson Algren. Violinist Leonard Sorkin of the Fine Arts Quartet appears on the soundtrack. As well as showing Deutch's artwork, this film raises questions regarding personal and artistic choices.

DIEBENKORN, RICHARD

D019 Richard Diebenkorn. allv. Tom McGuire for TVTV and the Los Angeles County Museum of Art. Independents Network. 1977. 30 min. sound. color. order by title. buy: $100. prev. for libraries only.

Recorded in his studio in Ocean Park, he talks about his exhibition at the LA County Museum of Art and what it means to him, his recent work and the effects of the environment on his painting. Then the production visits the museum where all aspects of the art world are represented: dealers, curators, other artists, the historians, and the public.

DIMITRIJEVIC, BRACO

D020 "Interview: Interview" Braco Dimitrijevic. ac. Audio Arts. 1978. 60 min. sound. order by title. buy: ₺4. (plus ₺1.10 handling). series: Audio Arts Magazine Supplement.

This cassette includes a reading of Dimitrijevic's work "Interview" and a series of interviews, the first of which was recorded in 1975, the last of which in 1978. The artist talks about the process of becoming historically important and about themes in his work.

DINE, JIM

D021 Jim Dine. 16mm. WNET/13, New York. Indiana University Audiovisual Center. 1966. 30 min. sound. b&w. order #RS-653.

buy: $250. rent: $9.50. prev. series: Artists. SY.

Jim Dine discusses his works and explains how they represent his co-action with his environment. Examples of typical paintings from various periods in his artistic life are shown. He comments on the change in his work from painting to sculpture, to happenings, to a new style of work involving sprayed enamel backgrounds upon which real objects are arranged.

D022 Jim Dine, London. 16mm., allv. Blackwood Productions. 1973. 28 min. sound. color. order by title. buy: $550. rent: $60. prev. with intent to purchase.

Narrated by the artist, this film visits Dine during a four-year self-imposed exile in London. This early Pop artist is shown working in his studio on several large charcoal and collage drawings, and on a series of grease drawings on a lithography stone for posters. The artist talks about his connections to literature and reads some of his own poetry. He also attends a performance of the living sculptures, Gilbert and George, who are seen in the film as they perform their tableau "Underneath The Arches."

DOBELL, WILLIAM

D023 Portrait of Dame Mary Gilmore. 16mm., allv. Film Australia. Tasmanian Film Corporation. 1979. 9 min. sound. color. order by title. buy: 16mm./Australian $135. vc/Australian $68. rent: Australian $50 per screening, plus freight. prev. series: Australian Eye.

This film, which is built around recordings of the voice of William Dobell, Dame Mary Gilmore and James Gleeson (the artist's friend and biographer), evokes very strongly and personally the way in which a portrait painter approaches his or her subject.

DORAZIO, PIERO

D024 Piero Dorazio. vc:3/4. Christopher Crosman and Sharon Blume for The Buffalo Fine Arts Academy/Albright-Knox Art Gallery. SUCB Film Library. 1979. 20 min. sound. color. order by title. buy: $100. rent: $40. prev. tape with excerpts from several programs avail. on request.

Piero Dorazio is a member of the generation of Italian artists who emerged following the devastation of World War II. His highly refined and sophisticated sense of color and structure place him

well within the tradition of European modernism
stemming from Picasso and Matisse. Yet there are
surprising connections as well with the American
Abstract Expressionists, particularly Mark Rothko
and Clyfford Still, whose concern for expressing
universals he shares. The tape was produced in
conjunction with the exhibition organized by the
Albright-Knox, "Piero Dorazio: A Retropsective."
Interview by Serena Rattazzi.

DREISBACH, C. FRITZ

D025 Blow Glass. 16mm. Canyon Cinema. 1970. 8.5 min. sound.
color. order by title. rent: $6.

Considers the work of C. Fritz Dreisbach, a former
glass-blowing instructor at the Toledo Museum of
Art. Mr. Dreisbach discusses his own manner of
work, designing his own art glass pieces rather than
producing company-designed work.

DUCHAMP, MARCEL

D026 Marcel Duchamp. ac. Audio Arts. 1974. 45? min. sound.
order #Volume 2 Number 4. buy: ₤4. (plus ₤1.10 handling).
series: Audio Arts Magazine.

In this recording, made in 1959 of an interview by
George Heard Hamilton in New York and Richard
Hamilton in London, the artist answers questions
about his work, his motivation as an artist, and
offers views in retrospect on many works. Duchamp
articulates complex issues surrounding his work with
clarity and simplicity. On tape with: "Hermann
Nitche."

D027 The Marcel Duchamp Interview. ac. Jeanne Siegel.
Pacifica Tape Library. 1968. 32 min. order #3894. buy: $12.
prev.

In this interview, Duchamp talks about his work and
other aspects of his career. An articulate and keen
reviewer of contemporary art movements, he provides
thoughtful observations.

DUKS, LLAISA

D028 Llaisa Duks: Weaver. allv. Film Victoria. Tasmanian
Film Corporation. 1979. 5 min. sound. color. order by title.
buy: (series) Australian $813. rent: Australian $50 per
screening, plus freight. prev. series: Craft as a
Livelihood.

Part of a series produced for the Victorian Crafts
Council, these productions cover a wide range of
craft occupations and are intended for teaching
appreciation of the skills required in the various
careers. In this segment Ms. Duks shows her
weaving. Although she had been weaving for many
years before emigrating to Australia, twenty-six
additional years passed there before she became
recognized.

EE

EAVES, WINSLOW

E001 The World and Work of Winslow Eaves. 16mm. Public
Television Library. Indiana University Audiovisual Center.
1970. 29 min. sound. color. order #RSC-751. buy: $360. rent:
$12.50. prev. series: World of the American Craftsman.

Winslow Eaves, a sculptor who works in wood, bronze,
and steel, believes that the most important aspect
of his work is how a piece of sculpture affects the
person looking at it. Eaves shows the exciting but
physically dangerous and emotionally exhausting work
of bronze casting. He also works in wood, through
which, Eaves says, he finds his identity with
nature.

EDELSON, MARY BETH

E002 Mary Beth Edelson. vc:3/4. Sharon Blume and Susan Krane
for The Buffalo Fine Arts Academy/Albright-Knox Art Gallery.
SUCB Film Library. 1980. 12 min. sound. color. order by
title. buy: $100. rent: $40. prev. tape with excerpts from
several programs avail. on request.

Edelson's work derives from a personal and poetic
feminism that suggest dark, druid-like rituals and
deep recesses of the human imagination where
sorceresses and goddesses reside in a hooded,
forgotten past. Her raw material is what she
considers to be the primitive and timeless essence
of female consciousness. This program was taped on
the occasion of the exhibition, "Mary Beth Edelson:
Recent Works" at the Albright-Knox Art Gallery.
Interview by Susan Krane, exhibition curator.

EIDLITZ, FRANK

E003 The Metaphysical Man. allv. Eidlitz Design Associates.

Tasmanian Film Corporation Pty. Ltd. 1982. 25 min. sound. color. order by title. buy: Australian $322. rent: Australian $50. per screening plus freight. prev.

This film is about the Hungarian-Australian painter Frank Eidlitz. It details in the form of interview the exhibitions Eidlitz had in Australia and the Metaphysical Nymphs exhibitions he had in New York and Berlin. As the first artist to receive the Winston Churchill Fellowship he talks about how working with George Kepes influenced his art. He talks about his large environmental installation in North Sydney and about nine large painted wool hangings done recently. He speaks also about the influence of Yoga in his life.

EISENSTAEDT, ALFRED

E004 Eisenstaedt: Germany. 16mm., allv. Varied Directions, Inc. Perspective Films. 1982. 29 min. sound. color. order #4279/16mm., #4279V/vc. (specify format). buy: 16mm./$489, vc/$293. prev. (16mm. only).

This documentary joins Eisenstaedt, the photojournalist, as he returns to Germany for the first time since his leaving it in 1935. He photographs prominent German film director Rainer Werner Fassbinder and the actress Hanna Shygulla, among others. He explains how he photographed these celebrities. An award-winning film.

ELIAS, SHEILA

E005 Homage to the Street People. allv. Sheila Elias. 1981. 12 min. sound. color. order #8. buy: $45. Rescue Mission Project II.

The tape documents the installation of a string of eight huge (6-square-foot) shopping bags splashed with big black Xs and glitter dust over a street in Los Angeles' Skid Row area. San Pedro Street, where Ms. Elias rents studio space, is shared by numerous street people who live on the street and in roominghouses in the area. Elias uses the X to connote the connections and crossings of all kinds of people in the world.

ESCHER, M.C.

E006 Adventures in Perception. 16mm. BFA Educational Media. 20 3/4 min. sound. color. order #11118. buy: $360. rent: $43.

M.C. Escher's approach to the world is a visual one. His complex and interesting paintings are shown, illustrating his unusual perspectives on the world.

E007 <u>Maurits</u> <u>Escher:</u> <u>Painter</u> <u>of</u> <u>Fantasies.</u> 16mm., allv. Document Associates, Inc. Coronet Films. 1970. 26.5 min. sound. color. order #3146/16mm., #3146V/vc (specify format). buy: 16mm./$521., vc/$365. prev. (16mm. only). CA, IU, SY.

The works of this Dutch graphic artist are a curious blend of fact and fantasy, with mirror images, and interlocking figures flowing from symmetrical shapes. He discusses his art and philosophy and the camera explores such works as "Day and Night" and "Ascending and Descending." An award-winning film.

ESTES, RICHARD

E008 <u>Richard</u> <u>Estes.</u> vc:3/4. The Buffalo Fine Arts Academy/Albright-Knox Art Gallery. SUCB Film Library. 1976. 30 min. sound. b&w. order by title. buy: $100. rent: $40. prev. tape with excerpts from several programs avail. on request.

Estes talks about Super-Realism and the seventies pointing out some of the critical differences between his own meticulous brand of representation and the photographic image including his personal motivations and speculation on the role of reality and illusion in the history of American painting.

EVANS, MINNIE

E009 <u>The</u> <u>Angel</u> <u>that</u> <u>Stands</u> <u>by</u> <u>Me:</u> <u>Minnie</u> <u>Evans'</u> <u>Paintings.</u> 16mm. Allie Light and Irving Saraf. Light-Saraf Films. 1983. 28:45 min. sound. color. order by title. buy: $370. rent: $40. prev. with intent to purchase. series: Visions of Paradise.

Minnie Evans is the embodiment of the visionary artist. She is a 90-year-old black painter of Wilmington, N.C. The film captures the connection between her visions, her religious fervor and her art. It traces her slave ancestry and her life as an impoverished gate-keeper at the Arlie Gardens, where we see her painting. It contains scenes from her church, showing her 103-year-old mother, and scenes of the Evans family reunion of six generations. Minnie Evans had a number of one person shows, among them one at the Whitney Museum.

FF

FAFARD, JOE

F001 I Don't Have to Work That Big. 16mm., allv. National
Film Board of Canada. 1973. 27:20 min. sound. color. order
#106C 0173 143. buy: 16mm./$500, vc/$300. rent: $50. prev.

> Joe Fafard knows cows. He sculpts them and the
> people who own them. A native of Pense,
> Saskatchewan, he has exhibited his clay miniatures
> in Western Canada, Paris and New York.

FASANELLA, RALPH

F002 Ralph Fasanella: Song of the City. 16mm. Jack Ofield.
Bowling Green Films, Inc. 1981. 25 min. sound. color. order
#RF21. buy: $390. rent: $40 (for two days). prev. with
intent to purchase. series: Three American Folk Painters.

> Documents the life and art of former union organi-
> zer and manual laborer turned creative artist.
> Fasanella paints within the tradition of social
> primitivism, but his esthetic vision is his own. On
> camera, he works at and discusses his huge, complex
> canvases that interweave labor history, cityscapes,
> and social issues with his own life.

FEIFFER, JULES

F003 Jules Feiffer at the School of Visual Arts. ac.
Pacifica Tape Library. 1972. 90 min. sound. order #BB5339.
buy: $17.

> The noted satirical cartoonist, playwright and
> screenwriter discusses the advantages and
> disadvantages of "going Hollywood," as well as the
> state of cinema.

FERBER, HERBERT

F004 Herbert Ferber. vc:3/4. The Buffalo Fine Arts Acade-
my/Albright-Knox Art Gallery. SUCB Film Library. 1975. 30
min. sound. b&w. order by title. buy: $100. rent: $40. prev.
tape with excerpts from several programs avail. on request.

> Ferber speaks of his involvement with members of the
> Abstract Expressionist group in New York City
> following World War II. Taped at his western
> Massachusetts summer residence, Ferber discusses his
> sculpture as well as his recent paintings.

FERRER, RAFAEL

F005 <u>Rafael Ferrer.</u> vc:3/4. The Buffalo Fine Arts Academy/Albright-Knox Art Gallery. SUCB Film Library. 1977.10 min. sound. b&w. order by title. buy: $100. rent: $40. prev. tape with excerpts from several programs avail. on request.

> Installation views and comments by Ferrer on the exhibition, "Rafael Ferrer: SUR," organized jointly by the Albright-Knox Art Gallery and HALLWALLS, Buffalo, New York. Exhibition Curator, Linda L. Cathcart.

FLEISCHNER, BOB

F006 Bob <u>Fleischner.</u> vc:3/4. Jaime Davidovich. Artists Television Network. 1980. 28 min. sound. color. order by title. buy: request price. rent: request price. prev. series: Conversations.

> "Conversations" is a series of informal interviews which feature some members of the art world. Steven Poser interviews Les Levine, Laurie Anderson, Vito Acconci, Annette Michelson and others in half-hour sessions, designed for television. Bob Fleischner is interviewed in this tape.

FRANCIS, SAM

F007 <u>Sam Francis.</u> 16mm., allv. Blackwood Productions. 1975. 52 min. sound. color. order by title. buy: $690. rent: $90. prev. with intent to purchase.

> Narrated by the artist, the Abstract Expressionist painter, Sam Francis. He explores how his travels to Paris and Japan and his life in California have influenced his work, as well as his psychological point of view.

FRANKENTHALER, HELEN

F008 <u>Frankenthaler: Toward a New Climate.</u> 16mm., vc:3/4, vc:v. WNET/13, New York. Films Incorporated. 1977. 30 min. sound. color. order #405-0028. buy: 16mm./$490, vc/$245. rent: $65. prev. series: The Originals: Women in Art Series. SY.

> At the precocious age of twenty-four, Helen Frankenthaler invented the stained canvas which influenced a whole generation of Color Field painters. The film traces the background and

evolution of her work. The highlight of the film is a sequence in which we see the actual creation of a painting from the mixing of the paint to the completion of the canvas.

F009 Helen Frankenthaler. vc:3/4. The Buffalo Fine Arts Academy/Albright-Knox Art Gallery. SUCB Film Library. 1977. 25 min. sound. b&w. order by title. buy: $100. rent: $40. prev. tape with excerpts from several programs avail. on request.

Focusing on two of her major works, "Round Trip," 1956, and "Tutti Frutti," 1966, (both in the collection of the Albright-Knox Art Gallery), Frankenthaler traces the development of various expressive and technical concerns. This tape is available subject to Ms. Frankenthaler's permission.

FRIRSZ, MAX

F010 One Generation is Not Enough. 16mm. Tony De Nonno. Direct Cinema Limited. 1980. 24 min. sound. color. order by title. buy: $395. rent: $30. prev.

In the New York workshop of violin maker, Max Frirsz, the art of making violins is passed from one generation to the next. Frirsz's son, Nicholas, an apprentice, assembles a new violin, showing the struggle to live up to the family's tradition of excellence which spans four generations.

FULFIT, GEORGE

F011 Steady as She Goes. 16mm., allv. National Film Board of Canada. 1981. 26:30 min. sound. color. order #106 C 081 049/16mm., #116C 0181 049/vc. buy: 16mm./$500, vc/$300. rent: $50. prev. with intent to purchase.

George Fulfit, retired, illustrates with humor and optimism the delicate craft of putting ships into bottles. The film documents the contruction of the largest ship he has ever built.

FULLER, R. BUCKMINSTER

F012 Buckminster Fuller. ac. Robert Malesky. NPR Publishing. 1977. 59 min. sound. order #VW-77-05-15. buy: $10. series: Voices in the Wind.

Buckminster Fuller's friend and admirer Norman Cousins discusses Fuller's genius at synthesizing science and art. Fuller then discusses his unique

perspectives on art and creativity.

F013 <u>R. Buckminster Fuller at Art Net, November 1974.</u> ac.
Audio Arts. 1974. 30 min. sound. order #Volume 2 Number 1.
buy: ℔3.50 (plus ℔1.10 handling). series: Audio Arts Maga-
zine.

> This edited tape serves both as an introduction to
> some of the fundamental concepts behind
> Fuller's arguments and as a unique opportunity to
> witness the development of his ideas as he speaks.
> On tape with: "Joseph Beuys at the Institute of
> Contemporary Art."

F014 <u>Synergetics.</u> ac. Pacifica Tape Library. 1975. 54 min.
sound. order #BC2247. buy: $15.

> Buckminster Fuller talks about his book and
> reminisces about his early housing designs.
> Fuller's work perceives human society and nature as
> whole systems, and "synergy" is the study of the
> behavior of whole systems predicted by the behavior
> of their parts.

F015 <u>The World of Buckminster Fuller.</u> 16mm. Arthur Cantor.
197?. 90 min. sound. color. buy: $1450. rent: $130.

> A comprehensive visual close-up of Fuller,
> architect, inventor, scientist, teacher and
> philosopher. He is seen at home and at work, in his
> three-wheeled Dymaxion car and portable residence.
> Fuller's ideas of reachable utopias are discussed.

GGG

GALLO, FRANK

G001 <u>Frank Gallo.</u> 16mm. WILL-TV, Champaign, Illinois.
Indiana University Audiovisual Center. 1971. 30 min. sound.
b&w. order #RSC-776. rent: $12.50. CA.

> Shows Gallo, sculptor turned printmaker, as he works
> with students and makes prints in his studio. Gallo
> comments upon the frustrations imposed by galleries
> and how printmaking has resolved some of his
> conflicts over the situation.

GARRETT, CARLTON

G002 <u>Carlton</u> <u>Garrett.</u> vc:3/4. Bill Brown for Atlanta Video. The <u>High</u> <u>Museum</u> of <u>Art</u>, Adult Extension Services. 1981. 13 min. sound. color. order by title. buy: $50. rent: $5.

> This program focuses on the world of Georgia folk artist Carlton Garrett and his ingenious mechanical wood sculptures.

GEHRY, FRANK

G003 <u>Problems</u> <u>of</u> <u>Architecture</u> <u>in</u> <u>L.A.</u> ac. Pacifica Tape Library. 1970. 60 min. sound. order #BB5222. buy: $15.

> Architect Frank Gehry talks with John Pastier of the <u>L.A.</u> <u>Times.</u>

GIGLIOTTI, DAVIDSON

G004 <u>The</u> <u>Whitney</u> <u>Biennial:</u> <u>Part</u> <u>II.</u> allv. Inner-Tube Video. 1981?. 30 min. sound. color. order #7. buy: $125. series: ART/New York: 1980-1 Art Season.

> This tape is a comprehensive visual survey of the photography, film and video at the Whitney Biennial Exhibition. Included is a four-minute interview with Davidson Gigliotti.

GILLEY, WENDELL

G005 <u>Gilley:</u> <u>Portrait</u> <u>of</u> <u>a</u> <u>Bird</u> <u>Carver.</u> 16mm., vc:b, vc:v. Wendell Gilley Museum. 1981. 25 min. sound. color. order by title. buy: request price. rent: $15.00 (plus handling).

> During the construction of a museum in his honor in his home town, bird carver Wendell Gilley recounts the evolution of his "whittling" hobby into a full-time profession. Gilley is filmed at work and discussing his craft. He relates his experiences as a hunter, amateur taxidermist, and professional plumber to his art work. Pieces are shown from his career of more than fifty years.

GIZYN, LOUIE

G006 <u>As</u> <u>If</u> <u>By</u> <u>Magic.</u> 16mm., allv. Jan Baross. The Media Project. 1981. 11 min. sound. color. order by title. buy: 16mm./$200, vc/$150. rent: $21.

> This documentary follows puppeteer Louie Gizyn as she designs a cast of handcrafted puppets which then perform the opera "Carmen." Music by the Portland

Opera Association with effects by Billy Scream.
Winner of CINE Golden Eagle.

GLEIZES, ALBERT

G007 Albert Gleizes. 16mm. Les Films du Cypres. Indiana
University Audiovisual Center. 1971. 15 min. sound. color.
order #RSC-1044. rent: $13.40.

Considers Gleizes's development from Impressionism
to Cubism. Illustrates many of the points made with
examples from Gleizes's work.

GORKY, ARSHILE

G008 Arshile Gorky. 16mm., allv. Courtney Sale. Direct
Cinema Limited. 1982. 29 min. sound. color. order by title.
buy: $495. rent: $45. prev. series: The American Artists.

An intimate portrait of the American abstract
artist, Arshile Gorky, is revealed with the
utilization of archival footage and extensive
interviews with his wife, sister, and close
associates.

GOTTLIEB, ADOLPH

G009 Adolph Gottlieb. ac. Pacifica Tape Library. 1967. 32
min. sound. order #BC0424.02. buy: $15. series: Great
Artists in America Today.

New York artist Adolph Gottlieb talks with Jeanne
Siegel.

G010 An Interview with Adolph Gottlieb. ac. Pacifica Tape
Library. 1968. 39 min. sound. order #BB3434. buy: $15.

Adolph Gottlieb is interviewed at the Whitney Museum
by Lawrence Alloway.

GRAVES, NANCY

G011 Nancy Graves. vc:3/4. Christopher Crosman, Sharon
Blume, and Catherine Green for The Buffalo Fine Arts Acade-
my/Albright-Knox Art Gallery. SUCB Film Library. 1980. 18
min. sound. color. order by title. buy: $100. rent: $40.
prev. tape with excerpts from several programs avail. on
request.

Painter, sculptor and filmmaker, Nancy Graves has
long drawn inspiration from such science-related

fields as natural history, archeology, oceanography, and NASA space missions. Her work, though, summarizes and celebrates the random, indeterminate patterns, rhythms, and textures of nature in ways that paradoxically connect with contemporary esthetics from Minimalism to Photo-Realism to Neo-Expressionism. Graves is interviewed in her Manhattan studio and discusses the various phases of her work from 1969 to 1980.

GREEN, ALAN

G012 Alan Green. vc:3/4. The Buffalo Fine Arts Academy/Albright-Knox Art Gallery. SUCB Film Library. 1978. 45 min. sound. b&w. order by title. buy: $100. rent: $40. prev. tape with excerpts from several programs avail. on request.

British artist Alan Green discusses his reductive, subtly nuanced paintings and prints. Taped at the Nina Freudenheim Gallery, Buffalo, New York.

GREEN, AUSTIN

G013 Slim Green: Master Saddlemaker. 16mm., vc:3/4. Public Media, Inc. 1982. 25 min. sound. color. order by title. buy: 16mm./$450, vc/$275. rent: $50. prev.

From his first saddle assembled during the Depression from scraps of leather to his latest made of the finest imported cowhide, Austin "Slim" Green has endeavored to do his best to learn his skill in traditional ways yet to be a real artist by giving expresssion to his own feelings about life.

GREENAWAY, VIC

G014 Vic Greenaway: Production Potter. allv. Film Victoria. Tasmanian Film Corporation. 1979. 5 min. sound. color. order by title. buy: (series) Australian $813. rent: Australian $50 per screening, plus freight. prev. series: Craft as a Livelihood.

Part of a series produced for the Victorian Crafts Council, these productions cover a wide range of craft occupations and are intended for teaching appreciation of the skills required in the various careers. In this segment viewers see the handmade mass-produced pottery which is Mr. Greenaway's livelihood.

GUSTON, PHILIP

G015 <u>Philip Guston</u>: A <u>Life Lived</u>. 16mm., allv. Blackwood
Productions. 1982. 58 min. sound. color. order by title.
buy: $690. rent: $90. prev. with intent to purchase.

 Filmed during the last ten years of his life, this
 film documents the evolution of Guston's figurative
 style, beginning in 1970 when he abandoned the hard-
 won success and public image of an Abstract
 Expressionist for that of a figurative painter.
 Guston discusses his philosophy and the psychologi-
 cal motivation for his work.

HH

HALL, SUSAN

H001 <u>Susan Hall</u>. vc:3/4. Video Data Bank. 1982. 35 min.
sound. color. order by title. buy: $275. rent: $50. series:
New Narrative.

 The paintings of this prolific artist challenge the
 positive and negative charges that exist in human
 and environmental relationships. Dramatic and
 energetic, Hall brings to these works an instantly
 accessible, yet complex essence which expresses a
 synthesis in levels of consciousness which are not
 rationally apparent, but which can mesmerize Hall's
 viewers.

HAMBLETT, THEORA

H002 <u>Art of Theora Hamblett</u>. 16mm. Division of Continuing
Education, University of Mississippi. 1965. 22 min. sound.
color. buy: $300. rent: $40. prev.

 Depicts Theora Hamblett, the Mississippi artist most
 frequently classified as a primitive, along with her
 works. In her own words she describes her early
 love of color as well as the sources of inspiration
 for individual paintings. The film includes
 canvases of her memories of a by-gone era and those
 which have been inspired by her visions and dreams.

HAMELCOURT, JULIETTE

H003 <u>Juliette Hamelcourt</u>: <u>Tapestry Artist</u>. allv. Doris
Chase. 1980. 20 min. sound. color. order by title. buy:
$275. rent: $100. prev.

 Shows tapestries, drawings and slides of the

artist's work, interspersed with a conversation with
Juliette Hamelcourt, master tapestry-maker and
craftsperson.

HARRISON, NEWTON

H004 <u>Newton Harrison.</u> ac. Pacifica Tape Library. 1971. 51
min. sound. order #BB4458.08. buy: $15. series: Art and
Technology.

Newton Harrison discusses a project at the Los
Angeles County Museum of Art.

HARRISON, TED

H005 <u>Harrison's Yukon.</u> 16mm., allv. National Film Board of
Canada. Wombat Productions, Inc. 1980. 23 min. sound. color.
order by title. buy: 16mm./$390, vc/$275. rent: $39. prev.
(16mm. only).

When artist Ted Harrison moved to the Yukon, he felt
the need to change his style of painting to respond
to the boldness of his new surroundings.

HARTIGAN, GRACE

H006 <u>Grace Hartigan.</u> vc:3/4. Sharon Blume and Mary Wayne
Fritzsche for The Buffalo Fine Arts Academy/Albright-Knox
Art Gallery. SUCB Film Library. 1980. 23 min. sound. color.
order by title. buy: $100. rent: $40. prev. tape with
excerpts from several programs avail. on request.

Grace Hartigan who is often linked with the Abstract
Expressionist painters of the 1950's has always
retained a quasi-representational style based on the
forms, colors and textures of landscape which she
freely translates into emotional equivalents or
states of feeling. In recent years her work has
turned more toward flowing linear forms and a more
limited palette. Hartigan discusses her work in her
Maryland home and studio with Mary Wayne Fritzche of
the Albright-Knox Art Gallery. Scheduled for 1984
release.

HARTUNG, HANS

H007 <u>Hans Hartung.</u> vc:3/4. The Buffalo Fine Arts
Academy/Albright-Knox Art Gallery. SUCB Film Library. 1976.
45 min. sound. b&w. order by title. buy: $100. rent: $40.
prev. tape with excerpts from several programs avail. on
request.

Interviewed at his home-studio complex in the south
of France, Hartung illuminates the European vision
of gestural abstraction as he and others practiced
it during the years following World War II.
Available in French with accompanying English
transcript. Interview by Daniel Abadie, Curator,
Centre Georges Pompidou, Paris.

HAYTER, STANLEY WILLIAM

H008 Hayter. 16mm., vc:3/4. Peter Weiner. 1982. 28 min.
sound. color. order by title. buy: 16mm./$500, vc/$350.
rent: $60.

Stanley William Hayter was born and educated in
England. He studied earth sciences at Kent, and
after his graduation he began work for a middle-
eastern oil company. Shortly thereafter, he moved
to Paris to study and practice art where he
established a workshop which is now world-famous.
Chagall, Giacometti, Miro and others have worked
there. An innovator, he used his scientific
knowledge to develop new techniques, processes and
approaches to printmaking.

HEINO, VIVIKA

H009 The World and Work of Vivika Heino. 16mm. Public
Television Library. Indiana University Audiovisual Center.
1969. 30 min. sound. color. order #RSC-739. buy: $360. rent:
$12.50. prev. series: World of the American Craftsman.

The artists, Vivika and Otto Heino, express their
interpretation of life through their craft, pottery
making. Much of the stimulus for shaping the clay
as it turns upon the wheel comes from the scenic
setting of the artists' home in New Hampshire.

HERMS, GEORGE

H010 A Los Angeles Artist: George Herms. ac. Pacifica Tape
Library. Paul Vangelisti. 1977. 98 min. sound. order
#KZ0295. buy: $19.

Paul Vangelisti interviews Herms, an artist of the
Constructivist school, in his studio.

HICKS, MARK

H011 Gravity is My Enemy. 16mm. John Joseph and Jan Stussy.
Indiana University Audiovisual Center. 1977. 27 min. sound.

color. order #RSC-1021. rent: $17.75. CA, SY.

> This award-winning film shows how quadraplegic Mark Hicks expresses his personal outlook through art. Provides interviews with Hicks and his family, in addition to numerous photographs of his artwork, exhibited in a one-man show in San Francisco.

HOCKNEY, DAVID

H012 David Hockney's Diaries. 16mm., allv. Blackwood Productions. 1973. 28 min. sound. color. order by title. buy: $550. rent: $60. prev. with intent to purchase.

> Narrated by the artist, this film documents the work and outlook of English painter, David Hockney. He discusses how his diaries, which include hundreds of snapshots taken by him over the years provide him with compositional elements upon which his paintings and graphic works are based. The photographs in his diaries clarify for the viewer the motivation and the point of view behind his unique style of realism.

HOLLIS, DOUGLAS

H013 Douglas Hollis. vc:3/4. Sharon Blume and Susan Krane for The Buffalo Fine Arts Academy/Albright-Knox Art Gallery. SUCB Film Library. 1980. 10 min. sound. color. order by title. buy: $100. rent: $40. prev. tape with excerpts from several programs avail. on request.

> Taped during Hollis' installation, "A Venue," in Buffalo's Delaware Park, the artist talks about nature, the physics and metaphysics of sound and sensory perception. The program includes views of the construction and installation of "A Venue," which was a kind of wind harp (since dismanteled) consisting of a one-hundred foot walkway jutting out into Delaware Park Lake activated by the movement of visitors and the natural elements of wind and water. Interview by Susan Krane.

HOLWICK, WAYNE

H014 Wayne Holwick: Almost 32; Saturday and Sunday. allv. John Hunt. Independents Network. 197?. 2 parts, 20 min. each. sound. color. order by title. buy: $200. ($100 each part). prev. for libraries only.

> In "Saturday" Holwick is seen at work in his studio, drawing on canvas the design for "Homage to Cortez."

This work is a mural located in Malibu, California, on a slab of concrete in the hillside. He reproduced two figures taken from a Chumash Indian cave painting. In "Sunday" the artist creates a mask on camera which is evocative of the native peoples of Peru.

HOOPER, JOHN

H015 John Hooper's Way With Wood. 16mm., allv. National Film Board of Canada. 1977. 17:43 min. sound. color. order #106C 0177 281. buy: 16mm./$410, vc/$300. rent: $50. prev. SY.

The woodworking of John Hooper is highlighted as the film follows the progress of one of his projects. Numerous aspects of his work are discussed, from the selection of seasoned woods to the variety of techniques used.

HOSOE, EIKOH

H016 Eikoh Hosoe Reflects on Photographs 1960-1980. allv. James E. Lyle. 1982. 22 min. sound. color. order by title. buy: $350. rent: $40. prev.

This tape was made during Mr. Hosoe's visit to Rochester, New York which coincided with his retrospective shows at the International Museum of Photography at the George Eastman House, Rochester Institute of Technology and Visual Studies Workshop. Included are over seventy examples of his work and a clip of his film "Navel and A-Bomb." The interview includes his especially poignant remembrances of Yukio Mishima and their relationship while photographing "Ordeal by Roses."

HOWE, OSCAR

H017 Oscar Howe: The Sioux Painter. 16mm., allv. Telecommunications Center, University of South Dakota. Centron Films. 1974. 27 min. sound. color. order #74529/16mm., #74529V/vc. (specify format). buy: 16mm./$475, vc/$333. prev. (16mm. only).

Mr. Howe designs and executes the painting, "Sioux Eagle Dancer" from the concept to the completed work. The artist and Vincent Price comment upon his subject matter, technique and philosoply of art. The film explores the development of his style by reviewing seventeen paintings completed throughout his career.

HOWLETT, VICTORIA

H018 Victoria Howlett: Art Potter. allv. Film Victoria. Tasmanian Film Corporation. 1979. 5 min. sound. color. order by title. buy: (series) Australian $813. rent: Australian $50 per screening, plus freight. prev. series: Craft as a Livelihood.

Part of a series produced for the Victorian Crafts Council, these productions cover a wide range of craft occupations and are intended for teaching appreciation of the skills required in the various careers. In this segment Ms. Howlett shows how her pots are similar to both paintings and sculptures.

HOYLAND, JOHN

H019 John Hoyland. vc:3/4. The Buffalo Fine Arts Academy/Albright-Knox Art Gallery. SUCB Film Library. 1976. 60 min. sound. b&w. order by title. buy: $100. rent: $40. prev. tape with excerpts from several programs avail. on request.

Discussing Color Field abstract painting of the sixties and seventies, Hoyland reveals his relationship to and independence from recent American painting. Taped in Hoyland's London studio.

HUGHAN, HAROLD

H020 Busy Sort of Bloke: Harold Hughan. 16mm., allv. Crafts Resource Productions. Tasmanian Film Corporation Pty. Ltd. 1979. 23 min. sound. color. order by title. buy: 16mm./Australian $506, vc/Australian $322. rent: Australian $50. per screening plus freight. prev.

This film is about the Australian potter Harold Hughan who is shown at work in his studio and at home. The film goes through the various stages of his pottery: his wheel technique, art and glazing techniques, firing, the finished project and exhibiton. Throughout the film Harold Hughan discusses his objectives in his art and life.

HUNT, RICHARD

H021 Richard Hunt: Sculptor. 16mm., allv. Encyclopaedia Britannica Educational Corporation. 1970. 14 min. sound. color. order #2981. buy: $155. rent: $20. prev. CA, SY.

Eyesores of the junkyards, discarded metal,

abandoned cars, and scraps change into fantastic
sculptures under the creative hands of this American
black artist. The camera follows Hunt as he
collects junk, welds, sketches, and works on a
sculpture of John Jones, the first black man to be
elected to public office in Illinois. This film,
which was collaborated upon by Louise Dunn Yochim,
is a study of an artist who utilizes the resources
of an urban environment to create sculptures which,
in turn, enrich urban settings.

HURD, PETER

H022 Painters of America: Peter Hurd. 16mm., allv. MFC Film
Productions, Inc. Coronet Films. 1969. 16 min. sound. color.
#3034/16mm., #3034V/vc. (specify format). buy: 16mm./$335,
vc/$235. prev. (16mm. only). IU.

Interviews portrait painter Peter Hurd in his New
Mexico home. The artist discusses why he paints,
how he develops a painting, what motivates him, and
how color and light enter into his approach to the
art of painting portraits.

II

INDIANA, ROBERT

I001 Robert Indiana Portrait. 16mm. FilmAmerica, Inc.
Arthur Cantor. 1974. 25 min. sound. color. buy: $400. rent:
$75. prev.

A documentary about Indiana, "the Gertrude Stein of
Pop Artists."

IRWIN, ROBERT

I002 Bob Irwin Raps. allv. Dan Mangus and Steve Daly for
California State College, Humbolt. Independents Network.
1973. 30 min. sound. b&w. order by title. buy: $100. prev.
for libraries only.

Speaking informally before a large audience at
Humbolt State, Irwin talks about a wide range of
topics, from art and information to his theory of
art and society. He goes beyond esthetics into the
realm of communications theory and human
consciousness.

JJJ

JAWORSKA, TAMARA

J001 Tamara's Tapestries. 16mm., allv. Film Arts. Kinetic Film Enterprises. 1981. 8 min. sound. color. order #4435/0625. buy: $295. rent: $40. prev.

The tapestries of Toronto artist Tamara Jaworska have won international awards. The "Gobelin" technique used by Jawarska to produce painting-like tapestries is a method of weaving which originated in sixteenth-century France.

JEKYLL, ROBERT

J002 Painting With Light. 16mm., allv. Black Elk Films. Kinetic Film Enterprises. 1981. 15 min. sound. color. order #4223/0200. buy: $350. rent: $50. prev.

The craft and art of stained glass, from the early stages of the design, through the choice of glass are detailed through the expression of Robert Jekyll. Explores many examples of Jekyll's stained glass windows.

JENSEN, ALFRED

J003 Alfred Jensen. vc:3/4. The Buffalo Fine Arts Academy/Albright-Knox Art Gallery. SUCB Film Library. 1978. 12 min. sound. b&w. order by title. buy: $100. rent: $40. prev. tape with excerpts from several programs avail. on request.

"There are many facets of truth -- it is like a many-faceted diamond. There is no such thing as a truth. You must know all the facets before you can present the diamond." Jensen's own multi-faceted life and work have been a source of inspiration for younger artists.

JOHNS, JASPER

J004 Jasper Johns. 16mm. WNET/13, New York. Indiana University Audiovisual Center. 1966. 30 min. sound. b&w. order #RS-665. buy: $250. rent: $9.50. prev. series: Artists.

A series of filmed interviews with pop artist Jasper Johns during which he discusses his ideas about art. These comments are alternated with scenes of the artist at work in his South Carolina studio and the lithographic workshop of Tatyana Grosman of New

York.

J005 <u>Jasper</u> Johns: <u>Decoy.</u> 16mm., allv. Blackwood
Productions. 1973. 18 min. sound. color. order by title.
buy: $400. rent: $50. prev. with intent to purchase.

 Johns continues to investigate the relationship
between popular culture and fine art, using the
offset printing process in creating the work
"Decoy." "Decoy" combines photographic images with
painted surfaces, mixing the objective and the
subjective. Its intricate network of layers and
surfaces, representation and reproduction, conveys
the sense of hidden meaning and irony that
characterize Johns. Barbara Rose narrates.

JOHNSON, CECILE

J006 <u>Creating</u> <u>with</u> <u>Watercolor.</u> 16mm., allv. Crystal
Productions. 1976. 20 min. sound. color. order #F-103/16mm.,
V-103/vc. buy: 16mm./$295, vc/$195. rent: $30 (3 days).
prev.

 Watercolor painter Cecile Johnson discusses her
philosophy of watercolor as she demonstrates by
painting scenes from across the country. A variety
of her other paintings are shown.

JOHNSTON, RANDOLPH

J007 A <u>Sculptor's</u> <u>Dream.</u> ac. Donna Limerick. NPR Publishing.
1980. 29 min. sound. order #HO-80-01-16. buy: $9. series:
Horizons.

 Seventy-five-year-old artist Randolph Johnston
discusses Little Harbor, a paradise island in the
Northern Bahamas. Mr. Johnston, a bronze sculptor
explains how changing social values led him to his
tropical island, describes his sculpting technique
and reflects upon his life as an older person.

JONES, ALLEN

J008 <u>Allen</u> <u>Jones.</u> vc:3/4. The Buffalo Fine Arts Academy/Al-
bright-Knox Art Gallery. SUCB Film Library. 1976. 40 min.
sound. b&w. order by title. buy: $100. rent: $40. prev. tape
with excerpts from several programs avail. on request.

 One of the founders of the British Pop Art movement,
Jones' art has evolved into a personal style. His
recent work has ranged from painting to furniture
design and stage sets to costumes for "Oh, Calcutta"

and "A Clockwork Orange." Taped in Jones' Chelsea
studio in London.

J009 <u>Scenes</u> <u>Seen</u> <u>With</u> <u>Allen</u> <u>Jones.</u> 16mm., allv. Blackwood
Productions. 1973. 28 min. sound. color. order by title.
buy: $550. rent: $60. prev. with intent to purchase.

> British Pop Artist Allen Jones is introduced in his
> London studio where he is developing an idea for a
> new painting. This one, like many other of his
> works, has erotic overtones. He explains his use of
> pin-up postcards to "get to know anatomy,"
> discusses his costume designs for films (among them
> "A Clockwork Orange") and theater shows and makes an
> excursion to a lithography studio where he signs a
> new edition of prints.

JONES, HOWARD

J010 <u>Howard</u> <u>Jones.</u> 16mm. KETC-TV, Saint Louis, for Public
Television Library. Indiana University Audiovisual Center.
1971. 30 min. sound. color. order #RSC-778. rent: $12.50.
series: Artists in America.

> Explores the sound and light artworks of Howard
> Jones, a professor at Washington University in St.
> Louis. Some of Jones' art responds to viewers by
> electronic sensing devices which alter the pitch or
> intensity of the sound or light. While Jones' work
> has been criticized as lacking human qualities,
> Jones contends that it, like nature, has a life of
> its own.

JONIK, JOHN

J011 <u>John</u> <u>Jonik:</u> A <u>Miniography.</u> 16mm. Bill Stein and Pat
Jonik. Picture Start. 1979. 15 min. sound. color. order by
title. buy: $250. rent: $25.

> An documentary portrait of an off-beat cartoonist
> and artist whose lifestyle and philosophy stress the
> importance of using everything, wasting nothing.

JORDAN, LARRY

J012 <u>Cut-Out</u> Animation: <u>Larry</u> <u>Jordan.</u> 16mm. Larry Jordan.
Canyon Cinema. 1977. 28 min. sound. b&w. order by title.
rent: $25.

> The artist discusses and works on an animated film,
> "The Rime of the Ancient Mariner." Also included
> are clips from earlier films and from "The Mariner"

tracing its development from concept to completion.

KKK

KAEP, LOUIS

K001 Working with Sketches with Louis Kaep. 16mm., allv.
Electrographic Corp., Perspective Films. 1973. 19.5 min.
sound. color. order #3567/16mm., 3567V/vc. (specify format).
buy: 16mm./$389, vc/$233. prev. (16mm. only). series:
Watercolor Painting. SY.

 This film demonstrates the process of moving through
 pencil drafts to the completed watercolor painting
 using a Chinese sampan as the subject.

KAHLO, FRIDA

K002 The Life and Death of Frida Kahlo. 16mm. Karen and
David Crommie. Serious Business Co. n.d. 40 min. sound.
color. order by title. buy: $600. rent: $75. prev.

 Filmed in Mexico, this film traces the life of Frida
 Kahlo, a Mexican painter who expressed herself in
 both social concerns and art. Her relationship with
 Diego Rivera is also discussed.

KAHN, LOUIS

K003 Form and Design. ac. Pacifica Tape Library. 1961. 79
min. sound. order #BB1977. buy: $17.

 A speech by the architect Louis I. Kahn.

K004 Louis Kahn: Architect. 16mm. Paul Falkenberg and Hans
Namuth. Museum at Large. 1974. 28 min. sound. color. order
by title. buy: $640 (plus handling). rent: $60 (plus
handling). prev.

 Made shortly before Kahn's death, this film
 describes both his rebellion against the Bauhaus and
 the classical clarity of his later works. Considers
 the development of his mastery of interior light
 effects as he discusses the concept of the "slice of
 the sun." Several important projects are shown:
 the Yale University Art Gallery, the Salk Institute
 in San Diego, the Olivetti plant in Pennsylvania and
 the Kimball Art Museum in Texas.

KAINEN, JACOB

K005 Jacob Kainen: Five Decades as an Artist. 16mm. Alison Abelson. National Museum of American Art, Smithsonian Institution. 1982. 26 min. sound. color. order by title. buy: request price. rent: request price.

Kainen is known as a painter and printmaker, and as a critic for the liberal art journal of the thirties, Art Front.

KANTOR, TADEUSZ

K006 Interview: Tadeusz Kantor. ac. Audio Arts. 1980?. 90? min. sound. order by title. buy: ₤4.50 (plus ₤1.10 handling). series: Audio Arts Magazine Supplement.

This interview with the artist and theater director Tadeusz Kantor is conducted in French. He discusses his work "Wielopole-Wielopole." With accompanying English translation booklet, by Cyril Barrett.

KEATS, EZRA JACK

K007 Ezra Jack Keats. 16mm. Morton Schindel. Weston Woods. 1970. 17 min. sound. color. order #MP410. buy: $275. rent: $20. prev. SY.

In his New York studio Ezra Jack Keats discusses the experiences which have influenced his work as a children's book illustrator. The film concludes with the motion picture adaptation of "A Letter to Amy," demonstrating how the artist puts the sights and sounds of the city, its colors and moods into his stories for children.

KEMP, ROGER

K008 Tapestry Workshop. 16mm., allv. Film Victoria. Tasmanian Film Corporation. 1979. 9:20 min. sound. color. order by title. buy: 16mm./Australian $180, vc/Australian $113. rent: Australian $50 per screening, plus freight. prev.

This film is about the making of a tapestry from a painting by a leading Australian artist, Roger Kemp. Shows steps through to a completed tapestry.

KENT, ROCKWELL

K009 Art in the Soviet Union. ac. Pacifica Tape Library. 1958. 59 min. sound. order #BB1982. buy: $15.

Rockwell Kent discusses his visit to the USSR with artist Emmy Lou Packard, professors Victor Arnautoff and Glenn Wessells, and Elsa Knight Thompson.

KING, PHILLIP

K010 Phillip King. vc:3/4. The Buffalo Fine Arts Academy/Albright-Knox Art Gallery. SUCB Film Library. 1976. 60 min. sound. b&w. order by title. buy: $100. rent: $40. prev. tape with excerpts from several programs avail. on request.

King, who studied with Anthony Caro, continues to advance the long tradition of modern British sculpture. Taped in his Dunstable studio outside London, King reflects on his work and discusses such issues as the problem of patronage of the arts in Britain.

KING, STAN

K011 Stan King: Bookbinder. allv. Film Victoria. Tasmanian Film Corporation. 1979. 5 min. sound. color. order by title. buy: (series) Australian $813. rent: Australian $50 per screening, plus freight. prev. series: Craft as a Livelihood.

Part of a series produced for the Victorian Crafts Council, these productions cover a wide range of craft occupations and are intended for teaching appreciation of the skills required in the various careers. In this segment the viewer is introduced to the vanishing craft of hand-bookbinding. This craft was originally taught in apprenticeship.

KLINE, FRANZ

K012 Franz Kline Remembered. 16mm. Courtney Sale. Direct Cinema Ltd. 1982. 29 min. sound. color. order by title. buy: $495. rent: $45. classroom use rental. prev. series: American Artists.

One of America's best-known Abstract Expressionists, Franz Kline, who died in 1962 at the age of 51 years, is presented through the recollections of his friends and colleagues. During the 1940's and 1950's Kline painted with an immediacy which gave solidity to line and form in black and white through broad brushstrokes and sweeping gestures. This production examines the artist and his contemporaries including Willem and Elaine de Kooning and Sidney Janis.

KOHN, MISCH

K013 A Portrait: Misch Kohn. 16mm., vc:3/4. Peter Weiner.
1967-68. 27 min. sound. b&w. order by title. buy:
16mm./$350, vc/$250. rent: $40.

> Misch Kohn is a graphic artist and teacher. The
> film reveals him as a person and as an artist. It
> discusses how his experiences growing up in the
> Midwest and his later environment have influenced
> his work. C.I.N.E. Golden Eagle winner.

KRASNER, LEE

K014 Lee Krasner. vc:3/4. The Buffalo Fine Arts Academy/Al-
bright-Knox Art Gallery. SUCB Film Library. 1976. 30 min.
sound. b&w. order by title. buy: $100. rent: $40. prev.
tape with excerpts from several programs avail. on request.

> "No, I would never call Jackson Pollock a
> 'liberated' husband..." Krasner's work, long
> overshadowed by the mythic figure of Pollock, is
> considered in this interview. She speaks about
> Abstract Expressionism, modern criticism, Jackson
> Pollock and especially her own work.

KRUGER, BARBARA

K015 Barbara Kruger. vc:3/4. Video Data Bank. 1980. 30 min.
sound. b&w. order by title. buy: $175. rent: $50.

> In this interview with Kate Horsfield, Kruger
> explores her viewpoint of art, life, and art in
> life. This theme runs through her photography,
> readings, poetry, criticism, collages and
> conversation. Strong and immediate, her attitude is
> ironic even to her own art.

KURELEK, WILLIAM

K016 Kurelek: The Ukranian Pioneers. 16mm., allv. Film
Arts. Kinetic Film Enterprises. 1980. 14 min. sound. color.
order #4016/0625. buy: $325. rent: $50. prev.

> Canadian artist William Kurelek is seen in his
> studio creating a history of his parents' arrival
> from the Ukraine. He describes in his paintings and
> drawings the new land which they worked, and his
> memories of growing up in Canada.

LL

LABISSE, FELIX

L001 The Happiness of Being Loved: Paintings by Felix
Labisse. 16mm., allv. Henri Storck, American version by
International Film Bureau, Inc. 1962. 11.5 min. sound.
color. order by title. buy: 16mm./$225, vc/$195. rent: $15.
(16mm. only). prev.

> The concern for transformation and metamorphosis in
> the personality of Labisse is seen in his surre-
> alistic paintings. In this film his models, Claude
> Bessy and Jean-Louis Barrault, pose as they did for
> his portraits of them. Others of the painter's
> friends appear in the film. These include Man Ray
> and Eugene Ionesco.

LACEY, BRUCE

L002 Bruce Lacey. 16mm., allv. Tripe Film Productions.
Perspective Films. 1975. 23.5 min. sound. color. order
#3722/16mm., #3722V/vc. (specify format). buy: 16mm./$469,
vc/$281. prev. (16mm. only). IU, SY.

> A documentary about Lacey, whose creative output and
> lifestyle as an artist, inventor, musician and
> actor are explored. Considers the relationships of
> individuality and eccentricity to standardization
> and conformity.

LALIBERTE, NORMAN

L003 Bannerfilm. 16mm., allv. National Film Board of Canada.
1972. 9:44 min. sound. color. order #106C 0172 058. buy:
$16mm./$275, vc/$250. rent: $40. prev.

> Norman Laliberte, a designer of banners, is shown in
> his workroom, piecing and stitching together, from
> bits of bright cloth, the figures and symbols that
> call to mind ancient ceremony.

LANGE, DOROTHEA

L004 Dorothea Lange: The Closer for Me. 16mm. WNET/13, New
York. Indiana University Audiovisual Center. 1965. 30 min.
sound. b&w. order #RS-642. buy: $250. rent: $9.50. prev.
series: Photography. CA.

> Provides an opportunity for the viewer to compare
> the personality of Dorothea Lange with her work.
> Many of her photographs of various historical

periods such as the Depression, World War II, and
the growth of urban sprawl in California are shown.
Lange comments about the photographs and proposes a
project to photograph the cities of America on a
large scale.

L005 Dorothea Lange: Under the Trees. 16mm. WNET/13, New
York. Indiana University Audiovisual Center. 1965. 30 min.
sound. b&w. order #RS-641. buy: $250. rent: $9.50. prev.
series: Photography. CA.

Provides an intimate view of Dorothea Lange and her
photographs. Giving exposure to her philosophy as a
photographer, the camera views Lange in her home as
she prepares a show of her work covering the past
fifty years. She comments upon the reasons and
emotions that have moved her to photograph
particular scenes. Lange died in 1965, not long
after the completion of the series.

LASSAW, IBRAM

L006 Ibram Lassaw. vc:3/4. The Buffalo Fine Arts Academy/Al-
bright-Knox Art Gallery. SUCB Film Library. 1976. 15 min.
sound. b&w. order by title. buy: $100. rent: $40. prev. tape
with excerpts from several programs avail. on request.

Along with Herbert Ferber and a handful of others,
Lassaw struggled to bring an international
perspective to American sculpture. Lassaw comments
on his career as he conducts a tour of his Long
Island studio, housing examples of his work from the
thirties to the present.

LENHARDT, ART

L007 Art Lenhardt: Light On Rock. 16mm. Allen Moore.
Picture Start. 1977. 8 min. sound. b&w. order by title. buy:
$150. rent: $15.

This film is a portrait of a seventy-eight-year-old
stone mason who builds old-fashioned granite walls,
using irregularly shaped pieces of rock fitted
together like a jigsaw puzzle. An award-winning
film.

LEVINE, LES

L008 Artistic. vc:3/4. Les Levine. Ronald Feldman Fine Arts,
Inc. 1974. 30 min. sound. color. order by title. buy: $300.
rent: $150. prev. on premises only.

A videotape performance by Les Levine. On the
audiotrack, the artist's voice is heard explaining
his own conceptual position vis à vis the audience,
his own work, and the nature of the performance.

L009 Fortune Cookie. vc:3/4. Les Levine. Ronald Feldman Fine
Arts. 1975. 30 min. sound. color. order by title. buy: $300.
rent: $150. prev. on premises only.

A videotape performance produced at Fanshawe College
in Ontario. The artist tells of small events in his
life that have a phenomenal relationship to his
views of art. Occasionally the video image of the
artist is transposed by a network broadcast image.
Much of what is said appears to have a symbolic
connection with the network broadcast image.

L010 I Am an Artist. vc:3/4. Les Levine. Ronald Feldman Fine
Arts. 1975. 30 min. sound. color. order by title. buy: $300.
rent: $150. prev. on premises only.

The camera follows the artist around New York's
Bowery while he explains why he wishes to remain
uninvolved in the problems of society. From time to
time a derelict attempts to involve the artist, but
he resists.

L011 The Last Sculpture Show. vc:3/4. Les Levine. Ronald
Feldman Fine Arts. 1971. 25 min. sound. color. order by
title. buy: $300. rent: $150. prev. on premises only.

Five people discuss art and society while the artist
creates simple visual and energy forms.

L012 Mott Art Hearings. vc:3/4. Les Levine. Ronald Feldman
Fine Arts. 1970. 60 min. sound. b&w. order by title. buy:
$470. rent: $150. prev. on premises only.

Previous Mott Art Hearings from 1970 taken at the
Rhode Island School of Design, Chicago Institute,
and the Corcoran in Washington.

L013 Mr. Abstract. vc:3/4. Les Levine. Ronald Feldman Fine
Arts, Inc. 1975. 30 min. sound. color. order by title. buy:
$300. rent: $150. prev. on premises only.

An empty screen gradually develops an abstract
pattern as flowers are thrown in front of the
camera. On the sound track the artist can be heard
talking about himself as an abstract artist and
eventually becoming an abstract bully.

L014 <u>Portrait</u> <u>of</u> <u>Les</u> <u>Levine.</u> vc:3/4. Les Levine. Ronald Feldman Fine Arts. 1974. 30 min. sound. color. order by title. buy: $300. rent: $150. prev. on premises only.

Three cameras focus upon various features of the artist's face while Levine responds to biographical questions about his personal life.

L015 <u>The</u> <u>Selling</u> <u>of</u> <u>a</u> <u>Video</u> <u>Artist.</u> vc:3/4. Les Levine. Ronald Feldman Fine Arts. 1976. 4 min. sound. color. order by title. buy: $300. rent: $150. prev. on premises only.

This is a four-minute commercial for video art in which the artist explains the difference between television and video art and uses the concept of a commercial to sell his own image.

L016 <u>Space</u> <u>Walk.</u> vc:3/4. Les Levine. Ronald Feldman Fine Arts, Inc. 1972. 30 min. sound. color. order by title. buy: $250. rent: $100. prev. on premises only.

The artist walks through the space in which he lives with the camera on a dolly attempting to get as close as possible to objects in the space without hitting anything. The audio is the artist describing the experience of the space.

L017 <u>The</u> <u>Troubles:</u> <u>An</u> <u>Artist's</u> <u>Document</u> <u>of</u> <u>Ulster.</u> vc:3/4. Les Levine. Ronald Feldman Fine Arts, Inc. 1972. 55 min. sound. color. order by title. buy: $470. rent: $170. prev. on premises only.

A document on the war in Ireland. Produced from an eye-witness view by the artist.

L018 <u>Video</u> <u>Lecture.</u> vc:3/4. Les Levine. Ronald Feldman Fine Arts. 1975. 60 min. sound. color. order by title. buy: $470. rent: $170. prev. on premises only.

A single camera focuses on a blackboard while the artist draws various diagrams describing how television works and why artists want to use it.

L019 <u>Visiting</u> <u>Artist.</u> vc:3/4. Les Levine. Ronald Feldman Fine Arts. 1974. 30 min. sound. color. order by title. buy: $300. rent: $150. prev. on premises only.

The artist performs a lecture about the concept of visiting artists. Three cameras switch back and

forth on the artist while the time of the
performance is counted down on a digital clock
chromakeyed on the center of the screen.

LEWIS, JOHN

L020 Designs in Glass. 16mm. Warren Bass. Canyon Cinema.
1971. 11 min. sound. color. order by title. rent: $18.

This award-winning film explores the contradictions
and discrepancies of glassblower John Lewis at work.
It is a study of the relationship between an artist
and his material. In particular, the discrepancy
between the crude industrial environment in which
Lewis works and the delicate glasswork that he
creates there is studied.

LIBERMAN, ALEXANDER

L021 Alexander Liberman: A Lifetime Burning. 16mm. Modern
Talking Picture Service. 1982. 26:20 min. sound. color.
order #15855. rent: free-loan. prev.

Alexander Liberman, the world-renowned sculptor who
appears in this program, describes his sculptures as
"a procession of life, a penetration of space."
Highlighted are many of Liberman's massive outdoor
creations, including "The Way," considered to be his
masterwork. Sponsored by the Seven-Up Company. (Not
avail. in the state of MO).

LICHTENSTEIN, ROY

L022 The Artist and the New Media. ac. Pacifica Tape
Library. 1968. 29 min. sound. order #BB4048. buy: $13.

Roy Lichtenstein is interviewed by Jeanne Siegel.

L023 Roy Lichtenstein. 16mm., allv. Blackwood Productions.
1975. 52 min. sound. color. order by title. buy: $690. rent:
$90. prev. with intent to purchase.

Narrated by the artist, the film visits Roy
Lichtenstein as he works on a major series of
paintings on the theme "The Artist's Studio." With
painstaking attention to detail, Lichtenstein
enlarges excerpts from works of artists such as
Picasso, Matisse and Leger. The film concludes with
the opening of the Pop Art exhibition at New York's
Whitney Museum, where Lichtenstein is joined by
other pioneers of the movement including Oldenburg,
Rauchenberg, Rivers and Rosenquist.

L024 <u>Roy</u> <u>Lichtenstein.</u> vc:3/4. The Buffalo Fine Arts Academy/Albright-Knox Art Gallery. SUCB Film Library. 1976. 30 min. sound. b&w. order by title. buy: $100. rent: $40. prev. tape with excerpts from several programs avail. on request.

Lichtenstein's work addresses the nature of "style" in art itself with references to such diverse modern masters as Monet, Picasso and Van Doesburg among others. Lichtenstein talks about his work and reflects upon American art and culture in general.

LIEBERMAN, HARRY

L025 <u>Hundred</u> <u>and</u> <u>Two</u> <u>Mature:</u> <u>The</u> <u>Art</u> <u>of</u> <u>Harry</u> <u>Lieberman.</u> 16mm. Allie Light and Irving Saraf. Light-Saraf Films. 1980. 28:30 min. sound. color. order by title. buy: $370. rent: $40. prev. with intent to purchase. series: Visions of Paradise.

Harry Lieberman, at age 102, shares his art and philosophy of life in this documentary which describes his transformation from a retired businessman to an artist. He is seen painting, sculpting and meeting with other senior citizens at the Golden Age Club of Great Neck, New York, where he started painting at the age of eighty and as an "artist in residence" at the Fairfax High School in Los Angeles.

LIPCHITZ, JACQUES

L026 <u>The</u> <u>Artist</u> <u>at</u> <u>Work:</u> <u>Jacques</u> <u>Lipchitz,</u> <u>Master</u> <u>Sculptor.</u> 16mm., allv. Encyclopaedia Britannica Education Corporation. 1968. 12 min. sound. color. order #2479. buy: $195. rent: $20. prev. SY.

A vivid color portrait of sculptor Jacques Lipchitz. This film, collaborated on by James D. Breckenridge, shows the artist at work. His own comments give added meaning to his works, help viewers see how he molds his sculpture to reflect the present times. The film also shows the wide range of his works, from a statue of Prometheus to a bronze portrait of John F. Kennedy. A Spanish version of this film is available.

L027 <u>Birth</u> <u>of</u> <u>a</u> <u>Bronze</u> <u>(With</u> <u>Jacques</u> <u>Lipchitz).</u> 16mm., allv. Walter P. Lewisohn under the auspices of the Americana Foundation, Inc. Coronet Films. 1966. 17.5 min. sound. color. order #1803/16mm., #1803V/vc. (specify format). buy: 16mm./$368, vc/$257. prev. (16mm. only). IU, SY.

The sculptor speaks intimately of his approach to
art and to life as we see his one-man show. He then
takes the viewer from the original idea for his
famous Madonna, commissioned for a French church
through clay-sculpting, plaster-casting, form-
making, waxing, bronze-pouring and polishing to the
finished work of art.

LIPKIN, JACOB

L028 New Materials for Art: Personal Credo of and by Jacob
Lipkin. ac. Pacifica Tape Library. 1963. 16 min. sound.
order #BB3654. buy: $13.

The sculptor speaks about his philosophy of art and
life. He reads his essay on art and society in
which he laments the loss of craftsmanship that new
art materials have induced and comments on the
influence of gallery economics.

LIPPOLD, RICHARD

L029 The Sun and Richard Lippold. 16mm. National Educational
Television. Indiana University Audiovisual Center. 1966. 30
min. sound. b&w. order #RS-655. rent: $9.50. series:
Artists.

Explores the relationship of the artist to his
experience. Lippold, who is a musician as well as a
sculptor, plays the organ and discusses his interest
in natural subjects as inspirations for his
sculptures.

LITTLE, JOHN

L030 John Little: Image from the Sea. 16mm. Paul Falkenberg
and Hans Namuth. Museum at Large. 1950. 14 min. sound.
color. order by title. buy: $120 (plus handling). rent: $15
(plus handling). prev.

This film, narrated by the artist, follows the
creation of a collage from the collecting of
driftwood and other materials along the beach at
Montauk to the finished work in the studio of the
artist on Long Island.

LYNAS, GERRY

L031 Sandsong. 16mm., allv. Stuart Goldman. Wombat
Productions, Inc. 1980. 18 min. sound. color. order by
title. buy: 16mm./$340, vc/$240. rent: $24 (16mm. only).

prev. (16mm. only).

Using the most basic of tools, artist Gerry Lynas creates a sculpture on the beach of Fire Island, only to watch it dissolve to the incoming tide.

MM M

MABE, MANABU

M001 Manabu Mabe Paints a Picture. 16mm., allv. Museum of Modern Art of Latin America. 1964. 13 min. sound. color. order #1. buy: 16mm./$13, vc/#39. prev. on premises only.

Japanese-Brazilian artist Mabe creates an abstract painting.

MCBAIN, JOE

M002 Joe McBain: Blacksmith. allv. Film Victoria. Tasmanian Film Corporation. 1979. 5 min. sound. color. order by title. buy: (series) Australian $813. rent: Australian $50 per screening, plus freight. prev. series: Craft as a Livelihood.

Part of a series produced for the Victorian Crafts Council, these productions cover a wide range of craft occupations and are intended for teaching appreciation of the skills required in the various careers. In this segment the blacksmith speaks of his life while making a horseshoe and repairing a pick.

MCCLOSKEY, ROBERT

M003 Robert McCloskey. 16mm. Morton Schindel. Weston Woods. 1964. 18 min. sound. color. order #MP403. buy: $275. rent: $20. prev. SY.

Robert McCloskey is filmed in his studio on an island in Maine where he discusses the various experiences which have shaped his work. The viewer sees many of the people and places that McCloskey has drawn into his books as the film explores the relationship of craftsmanship to inspiration.

MCCLURE, TOM

M004 The Art of Metal Sculpture. 16mm. McGraw Hill. Indiana University Audiovisual Center. 1958. 22 min. sound. color. order #RSC-585. rent: $8.75.

Shows sculptor Tom McClure creating a sculpture for
a suburban shopping center. Follows the progress of
the sculpture from idea through completion. Makes
the point that by placing sculpture in public
places, artists may reach larger audiences.

MCLAREN, NORMAN

M005 The Eye Hears, The Ear Sees. 16mm., allv. British
Broadcasting Company with the National Film Board of Canada.
International Film Bureau, Inc. 1970. 59 min. sound. color.
order by title. buy: 16mm./$750, vc/$475. rent: $60. (16mm.
only). prev. CA, SY.

Shows how McLaren created the many innovative films
that have become examples of film art. He talks of
what brought him to filmmaking and why he is
unsatisfied with conventional methods. In his
workroom at the National Film Board of Canada,
McLaren demonstrates and explains his methods of
animating live actors, called "pixillation." As
McLaren discusses his experiences and methods,
excerpts from his films appear including "Hen Hop,"
"La Poulette Grise," "Neighbors" and others.

MCMAHON, FRANKLIN

M006 The Artist as a Reporter. 16mm., allv. Bill Hare.
Phoenix/BFA Educational Media. 1978. 29 min. sound. color.
order #21202. buy: 16mm./$420, vc/$275. rent: 16mm./$38.50.
prev. CA.

Artist/reporter Franklin McMahon discusses the
interests which led him to take up the unique line
of work which has taken him all over the world. As
a reporter with a drawing pad, he is allowed access
to courts and other places where photographs have
been forbidden. His drawings and paintings have
appeared in almost every national magazine in the
United States. McMahon offers insights into what he
calls the "personal qualities of drawing."

MANZUR, DAVID

M007 David Manzur Paints a Picture. 16mm., allv. Museum of
Modern Art of Latin America. 1965. 13 min. sound. color.
order #2. buy: 16mm./$130, vc/$39. prev. on premises only.

Columbian painter Manzur works in his studios.

MARTINEZ, MARIA

M008 Indian Pottery of San Ildefonso. National Park Service. National AudioVisual Center. 16mm., allv. 1972. 28 min. sound. color. order #O10097/CH(16mm.), A00628/CH(vc). buy: 16mm./$265, vc/$80. rent: $25 (16mm. only). prev.

Maria Martinez, noted Indian pottery maker, demonstrates the traditional Indian ways of making pottery. Before she begins gathering her clay, she spreads sacred corn. Also shown are the mixing of clay, construction of the pottery, hand decorating, and building of the firing mound.

MARIN, JOHN

M009 John Marin. 16mm., allv. Radio-TV Bureau, University of Arizona. International Film Bureau, Inc. 1966. 20.5 min. sound. color. order by title. buy: 16mm./$350, vc/$275. rent: $25 (16mm. only). prev.

Surveys this twentieth-century artist's work and two important influences on his style: four years of study in Paris, and the subtle tones of Cubism. Marin's observations on his life and work are included in the narration.

MAYER, ALBERT

M010 Culture for the Subcities. ac. Pacifica Tape Library. 1963. 62 min. sound. order #BB3058. buy: $15.

Albert Mayer, design architect who built the East Harlem Plaza, discusses the need for the humane re-development of neighborhood dwellings and social resources. He criticizes projects like Lincoln Center and is in favor of the development of "focal centers" for urban societies.

MERCER, BARBARA ELIZABETH

M011 The View from Vinegar Hill. 16mm., allv. Film Arts. Kinetic Film Enterprises. 1981. 14 min. sound. color. order #4351/0625. buy: $325. rent: $50. prev.

Features the paintings of Barbara Elizabeth Mercer and explores her influences and inspirations. Filmed at her home and studio in Markham, Ontario, the film shows Mercer at work on some of her paintings.

MERZ, MARIO

M012 Mario Merz at the Whitechapel Art Gallery. ac. Audio
Arts. 1982?. 60? min. sound. order #Volume 5 Number 1. buy:
ь4 (plus ь1.10 handling). series: Audio Arts Magazine.

Mario Merz spent five days installing his exhibition
at the Whitechapel Art Gallery in January 1980.
After the work was finished he talked about it with
Mark Francis, William Furlong, and Martin Rewcastle.
Works discussed on the cassette include: "The Double
Igloo," "Two Lances," and others. On tape with:
"The Visual Arts in Tower Hamlets."

MESSMER, OTTO

M013 Otto Messmer and Felix the Cat. 16mm., allv. John
Canemaker. Phoenix Films & Video, Inc. 1977. 25 min. sound.
color and b&w. order by title. buy: $405. rent: $40. prev.

A double portrait of the first cartoon superstar,
Felix the Cat, and his shy unknown creator, Otto
Messmer. In this tribute, Messmer (filmed when he
was 84 years old) talks about how he developed
Felix's remarkable personality and style. Excerpts
from five vintage shorts demonstrate the cartoon
cat's expressive comic skills.

METCALFE, ERIC

M014 Spots Before Your Eyes. Dana Atchley, Eric Metcalfe and
Western Front Video. Video Out. vc:3/4. 1977?. 22 min.
sound. color. buy: $350 for life of tape. rent: $50 single
play, $200 multiple plays. prev.

A video portrait of Eric Metcalfe and his character
aliases: Ruby the Fop, Dr. Brute, and Howard Huge
who appear throughout the tape. Performance and
interviews are intercut with visual art works and
props relating to the portrait. This tape, a year
in the making, covers seven years of Metcalfe's
works.

MEYEROWITZ, PATRICIA

M015 Simply Making Jewelry. 16mm. International Film
Foundation, Inc. 1977. 18 min. sound. color. buy: $300.
prev.

Patricia Meyerowitz of New York City shows how she
creates unique items of jewelry using inexpensive
objects found in hardware stores, art and garment
supply shops.

MICHALS, DUANE

M016 Duane Michals (1939-1997). 16mm. Gerrit and Sydie
Lansing. Checkerboard Foundation, Inc. 1978. 15 min.
sound. b&w and color. order by title. buy: request price.
rent: request price.

> This film shows the photographer, portrayed through
> his work; his vision turned on himself, creating
> reflections of the artist.

MICHELSON, ANNETTE

M017 Annette Michelson. vc:3/4. Jaime Davidovich. Artists
Television Network. 1980. 28 min. sound. color. order by
title. buy: request price. rent: request price. prev.
Series: Conversations.

> "Conversations" is a series of informal interviews
> featuring some articulate members of the art world.
> Steven Poser interviews Michelson in this segment.
> She is an editor of October magazine and a professor
> of film at New York University.

MILLER, JOE

M018 THE Joe Miller Painting a Painting for a Film FILM.
(sic) 16mm. Rodger Darbonne. Canyon Cinema, Inc. Purchase
direct from producer. 1977. 8 min. sound. color. order by
title. buy: 16mm./$195. rent: $15 (Rental applies to
purchase price).

> Joe Miller, artist in residence at several National
> Parks in southern Utah's desert canyons, talks
> about his art while depicted at work in his studio.
> The film ends with a stop-motion creation of a
> painting made for this film.

MIRO, JOAN

M019 Femme/Woman--A Tapestry by Joan Miro. 16mm., allv.
National Gallery of Art. Natioal Audiovisual Center. 1980.
15 min. sound. color. order #A03814/16mm., #A03815/vc buy:
16mm./$145, vc/$70. prev.

> In the East Wing of the National Gallery of Art
> hangs a mammoth tapestry weighing more than a ton.
> "Femme/Woman" represents the mastery of painter Joan
> Miro and weaver Josep Royo. Filmmakers followed the
> progress of the work through the years, giving
> viewers a first-hand look at the elaborate weaving
> process, shipment of the massive tapestry from
> Spain, and its display in the East Wing.

MONTOYA, JOSE

M020 El Pachuco: From Zootsuits to Low Rides. 16mm.,
vc:3/4. J.R. Camacho. 1983. 50 min. sound. color. order by
title. buy: 16mm./$1000. rent: $100. prev. on videocas-
sette.

> Documents the work and life of Jose Montoya, Chicano
> artist and poet. The film details the personal
> involvement of Jose Montoya with the romantic figure
> of the Pachuco and shows how this interest is
> reflected in Montoya's work.

MOORE, HENRY

M021 Conversation with Henry Moore: Elephant Skull
Etchings. 16mm. Modern Talking Picture Service. 1982. 11
min. sound. color. order #12599. rent: free loan. prev.

> A conversation on film revealing Moore's fascination
> with the forms of an elephant's skull.
> Extraordinary close-up shots show a series of
> etchings and the fine, intricate patterns of his
> strokes. Sponsored by Gould, Inc.

M022 Henry Moore. vc:3/4. The Buffalo Fine Arts Academy/Al-
bright Knox Art Gallery. SUCB Film Library. 1976. 23 min.
sound. b&w. order by title. buy: $100. rent: $40. prev. tape
with excerpts from several programs avail. on request.

> Moore is seen working in his studio and discussing
> his restricted though inexhaustible vocabulary of
> forms. "If a young artist responds more to a brick
> than, say, to a woman's leg, then there is no hope
> for him." Taped at Moore's Much Hadham, England
> residence and studios.

M023 Henry Moore. 16mm. Modern Talking Picture Service.
1982. 58 min. sound. color. order #12597. rent: free loan.
prev.

> Sponsored by Gould, Inc, this film was two years in
> the making. The artist's hands at the moment of
> creating, his ideas as he speaks intimately of art,
> his drawings and sculptures, his family life and
> business transactions are considered in this
> portrait.

M024 Henry Moore. 16mm. John Read. British Information
Service. Indiana University Audiovisual Center. 1952. 28

min. sound. b&w. order #RS-327. rent: $8.75.

Considers Moore's notion of truthfulness to material
when creating sculpture. He discusses his education
and training as well as those ancient works which
influenced his art. Exhibits several of his works.

M025 Henry Moore: Master Sculptor. 16mm., allv. Centron
Films. 1976. 15.5 min. sound. color. order #75508/16mm.,
#75508V/vc. (specify format). buy: 16mm./$280, vc/$196.
prev. (16mm. only).

This award-winning film acquaints the audience with
one of the world's foremost sculptors on a personal
level. Mr. Moore discusses his life, his art, and
his philosophy. Traces the creative process from
the initial idea to the finished product.

M026 Henry Moore: The Sculptor. 16mm., allv. Sobany
Productions. Encyclopaedia Britannica Education Corporation.
1969. 24 min. sound. color. order #2336. buy: $405. rent:
$40.50. prev. CA, SY.

"The sculptor is a person who has found that his
obsession in life is the shape of something."
Sitting in his studio, Henry Moore discusses his own
obsession. He shows how small objects influence
him. A stick, a pebble, a shell may be the
springboard for a piece whose bulk requires an
enormous amount of space to set it off. He
demonstrates how he works with small "maquettes" to
envision his larger works. Close-ups of these models
in the studio contrast with views of his finished
massive sculptures.

M027 Henry Moore: A Sculptor's Landscape. 16mm. National
Educational Television. Indiana University Audiovisual
Center. 1959. 29 min. sound. b&w. order #RS-520. rent:
$9.50.

This film uses scenes of the artist at work on his
sculpture projects to show how Moore makes his work
relevant to the modern world and to his own life.
Discusses tehniques used by Moore in his sculpture.

MORGAN, BARBARA

M028 Barbara Morgan: Everything Is Dancing. vc:3/4.
Checkerboard Foundation, Inc. 1983. 18 min. sound. color.
order by title. buy: request price. rent: request price.

In this videotape interview, Barbara Morgan recalls

why movement and dance became important themes in
her photography.

MORGAN, MAUD

M029 <u>Light</u> <u>Coming</u> <u>Through:</u> <u>A</u> <u>Portrait</u> <u>of</u> <u>Maud</u> <u>Morgan.</u> 16mm.
Nancy V. Raine. 1981. 22.21 min. sound. color. order by
title. buy: $450. rent: $40. prev.

This film is an impressionistic portrait of seventy-
seven-year-old Maud Morgan, whose work has served as
a model for other younger artists. She narrates the
production, which is not merely biographical but is
instead indicative of Morgan's point of view and
artistic philosophy today. She comments about
getting older, about being a woman artist, and about
coping creatively with change.

MOSES, GRANDMA

M030 <u>Grandma</u> <u>Moses.</u> 16mm. Falcon Films. Indiana University
Audiovisual Center. 1950. 22 min. sound. color. order #RSC-
231. rent: $9.25. CA.

Archibald Macleish describes the artist's earlier
life, illustrating his comments with her work. The
production also shows Grandma Moses at work in her
mature years as she demonstrates her technique of
applying paint.

MOTHERWELL, ROBERT

M031 <u>Robert</u> <u>Motherwell.</u> 16mm., allv. Blackwood Productions.
1973. 28 min. sound. color. order by title. buy: $550. rent:
$60. prev. with intent to purchase.

Motherwell works in this Provincetown studio,
painting on several large canvases. He reflects on
the development of painting over the last three
decades from the 1940's when collage became a part
of his repertoire. Throughout the film, Motherwell
offers his interpretations of earlier artistic
styles and his response to the new, more objective
painting that developed in the 1960's.

M032 <u>Robert</u> <u>Motherwell,</u> <u>Part</u> <u>I.</u> vc:3/4. The Buffalo Fine
Arts Academy/Albright-Knox Art Gallery. SUCB Film Library.
1975. 70 min. sound. b&w. order by title. buy: $100. rent:
$40. prev. tape with excerpts from several programs avail.
on request.

Motherwell explains Abstract Expressionism

discussing some of the "subjects of the artist" seen in abstract painting. Taped at Motherwell's Provincetown, Massachusetts, summer residence and studio.

M033 <u>Robert Motherwell, Part II.</u> vc:3/4. Sharon Blume, Catherine Green and Stephanie Terenzio for The Buffalo Fine Arts Academy/Albright-Knox Art Gallery. SUCB Film Library. 1983. ca. 20 min. sound. color. order by title. buy: $100. rent: $40. prev. tape with excerpts from several programs avail. on request.

This interview by Motherwell's associate Stephanie Terenzio is an update of an earlier interview (1975). Taped at the artist's Cape Cod studio, Motherwell discusses his life and work, including the "Elegies," "Opens" and collages. The interview was produced in conjunction with the Robert Motherwell retrospective exhibition organized by the Albright-Knox Art Gallery. Scheduled for 1983 release.

MOUNT, NICK

M034 <u>Nick Mount: Glass Blower.</u> allv. Film Victoria. Tasmanian Film Corporation. 1979. 5 min. sound. color. order by title. buy: (series) Australian $813. rent: Australian $50 per screening, plus freight. prev. series: Craft as a Livelihood.

Part of a series produced for the Victorian Crafts Council, these productions cover a wide range of craft occupations and are intended for teaching appreciation of the skills required in the various careers. In this segment the craftsman discusses his goal to make the best piece of handblown glass possible for himself at that time.

MOURIS, FRANK

M035 <u>Frank Film.</u> 16mm., vc. Frank Films. Direct Cinema Limited. 1973. 9 min. sound. color. order by title. buy: $250. rent: $30. prev. CA, SUCB, SY.

Using multiple assemblages of cut-out magazine photographs and an innovative dual soundtrack, this film summarizes filmmaker Frank Mouris's whole life. Considers his surroundings, influences upon his work, interests, and dreams and details his quest for self-knowledge in his development as an artist.

MULHOLLAND, BOB

M036 An Interview with Bob Mulholland. vc:3/4. Les Levine. Ronald Feldman Fine Arts, Inc. 1975. 30 min. sound. color. order by title. buy: $300. rent: $150. prev. on premises only.

> The artist is interviewed and questioned about his artistic position and his involvement with videotape production.

MYERS, JEROME

M037 Artist in Manhattan. 16mm., vc:3/4, vc:v. Barry Downes and Linda Marmelstein. Gini International. 1968. 10 min. sound. color. order by title. buy: 16mm./$175, vc:v/$60, vc:3/4/$75. rent: $15. prev.

> A portrait, narrated by David Wayne, of the city of New York and its people during the first part of the twentieth century, as recorded in the paintings by Jerome Myers, who documented street life of the poor and the working classes of the city. An award-winning film.

NNN

NEEL, ALICE

N001 Alice Neel. Rhodes/Murphy Venture. 16mm. New Day Films. 1978. 52 min. (Part III, 19 min.) sound. color. order by title. buy: 3 parts/$675, each part/$250. rent: 3 parts/$85, each part/$35. prev. with intent to purchase. series: They Are Their Own Gifts.

> This film, Part III of a three-part series on prominent women artists, chronicles Neel's career from an early marriage to a Cuban painter, through the Depression and her work with the Works Projects Administration, to her long residence in Spanish Harlem. Calling herself a "collector of souls," she is known for her ability to see straight to the essence of her subjects, producing startling, alive and honest images. In 1979 President Carter honored her as being one of the five great women artists of the 20th century. (Other subjects of the series are Muriel Rukeyser, and Anna Sokolow).

NEVELSON, LOUISE

N002 Nevelson In Process. 16mm., vc:3/4, vc:v. WNET. Films

Incorporated. 1977. 30 min. sound. color. order #405-0027.
buy: 16mm./$490, vc/$245. rent: $65. prev. series: The
Originals: Women in Art Series.

> Louise Nevelson was in her forties before she sold a
> work to anyone other than a fellow artist, and in
> her sixties before the art press acknowledged her
> stature as a sculptor. As a result of her lack of
> money, she developed her art mostly from discarded
> wood. In the film her "process" is demonstrated on
> camera as she creates two new sculptures, one of
> wood, and one of metal.

NEWMAN, BARNETT

N003 Artists: Barnett Newman. 16mm. WNET/13, New York.
Indiana University Audiovisual Center. 1966. 30 min. sound.
b&w. order #RS-666. buy: $250. rent: $9.50. prev. series:
Artists. CA.

> An introduction to Barnett Newman, his surroundings,
> his personal philosophies, the meaning of painting
> to him and his works. Newman's paintings, "The
> Stations of the Cross," are shown while the artist
> explains how he came to create them and what their
> meaning is for him.

NITSCH, HERMANN

N004 Hermann Nitsch. ac. Audio Arts. 1975. 45? min. sound.
order #Volume 2 Number 4. buy: Ь4 (plus Ь1.10 handling).
series: Audio Arts Magazine.

> In this recording made at the Basle art fair in June
> 1975, Nitsch talks generally about his work, its
> sources and influences on his thinking including
> Jung, Eastern philosophy and Nietzche. He then
> describes a new work being planned: a twenty-four
> hour feast.

NOGUCHI, ISAMU

N005 Isamu Noguchi. 16mm., allv. Blackwood Productions.
1973. 28 min. sound. color. order by title. buy: $550. rent:
$60. prev. with intent to purchase.

> Narrated by the artist, this documentary spans over
> forty years. The Japanese-American sculptor Noguchi
> returns to Paris to visit Brancusi's workshop where
> he apprenticed. He also speaks with Buckminster
> Fuller and Ezra Pound, long-standing friends. The
> artist discusses his sets and costumes for Martha
> Graham.

N006 Isamu Noguchi. vc:3/4. The Buffalo Fine Arts Acade-
my/Albright-Knox Art Gallery. SUCB Film Library. 1977. 40
min. sound. b&w. order by title. buy: $100. rent: $40. prev.
tape with excerpts from several programs avail. on request.

Noguchi sees the vital utilitarianism of abstract
art whether as his Akari lamp sculptures or as an
environmental plaza in Detroit. The artist
discusses formal and expressive concerns which have
persisted in his art from the thirties to the
present day.

N007 Noguchi: A Sculptor's World. 16mm. Arnold Eagle. Mu-
seum at Large. 1973. 27.5 min. sound. color. order by title.
buy: $600 (plus handling). rent: $60 (plus handling). prev.
CA.

Isamu Noguchi speaks directly to the audience about
his philosophy of art. Examines works in the
Whitney Museum, the UNESCO garden in Paris, the
Billy Rose Sculpture Garden in Jerusalem, the rock
garden of the Chase Manhattan building in New York,
and a monumental fountain designed for the 1970
exposition at Osaka, Japan.

OO

OBREGON, ALEJANDRO

O001 Alejandro Obregon Paints a Fresco. 16mm., allv. Museum
of Modern Art of Latin America. 1965. 21 min. sound. color.
order #3. buy: 16mm./$210, vc/$63. prev. on premises only.

The Colombian painter demonstrates fresco techniques.

OESTERLE, LEONARD

O002 Leonard Oesterle. 16mm., allv. Film Arts. Kinetic Film
Enterprises. 1981. 28 min. sound. color. order #4436/0625.
buy: $425. rent: $75. prev.

A film profile of Toronto sculptor and teacher
Leonard Oesterle. The film explores two
relationships, the relationship between the artist
and his materials as the creative process unfolds,
and the "relationship of volumes and spaces" that
Oesterle tries to achieve in each piece of
sculpture.

O'KEEFFE, GEORGIA

0003 Georgia O'Keeffe. 16mm., vc:3/4, vc:v. WNET/13, New York. Films Incorporated. 1977. 60 min. sound. color. order #405-0024. buy: 16mm./$780, vc/$390. rent: $95. prev. series: The Originals: Women in Art Series. CA.

For the first time the painter appears on camera to talk about her work and life and of her marriage and devotion to the legendary photographer Alfred Stieglitz. O'Keeffe's paintings are seen together with the scenes of nature (the mountains and desert of New Mexico, flowers, shells, stones and bone) that have served as her inspiration.

OLDENBURG, CLAES

0004 Claes Oldenburg. 16mm., allv. Blackwood Productions. 1975. 52 min. sound. color. order by title. buy: $690. rent: $90. prev. with intent to purchase.

This film portrait, narrated by the artist, shows the use of a first-baseman's glove as a model for a twelve-foot high sculpture of lead and steel, grasping a huge wooden baseball. "Mitt" is typical of many of Oldenburg's sculptures for it transforms a commonplace item into something original by altering vastly its scale and by changing the materials from which it is constructed. The Connecticut factory which fabricates the huge sculpture is shown.

0005 Claes Oldenburg. 16mm. WNET/13, New York. Indiana University Audiovisual Center. 1966. 30 min. sound. b&w. order #RS-663. buy: $250. rent: $9.50. prev. CA.

An introduction to Claes Oldenburg, his studio, his personality, his reasons for doing what he does, and his works. Oldenburg is shown working and preparing for a major exhibition of his new works. He discusses the means he uses to motivate himself to plan for an exhibition, mentions the reasons that he became an artist, and explains his daily routine. Many examples of his work are shown.

0006 Claes Oldenburg. ac. Pacifica Tape Library. 1969. 35 min. sound. order #BB3573. buy: $15. series: Great Artists in America Today.

Sculptor Claes Oldenburg talks with Jeanne Siegel.

0007 <u>Giant</u> <u>Writhing</u> <u>Icebag.</u> ac. Pacifica Tape Library. 1971.
48 min. sound. order #BB4458.06. buy: $15. series: Art and
Technology.

 Claes Oldenburg is interviewed at the Los Angeles
County Museum of Art.

0008 <u>Sort</u> <u>of</u> a <u>Commercial</u> <u>for</u> an <u>Icebag.</u> 16mm. Gemini Films,
Inc. Benchmark Films, Inc. 1972. 16 min. sound. color. buy:
$305. rent: $30. prev. SY.

 Claes Oldenburg takes us with him in a visual way as
he creates an outdoor sculpture for the World's Fair
in Osaka. With wit and virtuosity he explores
familiar objects for combinations of hard and soft,
form and texture, and movement under tension and
release. His considerations of color, lighting,
scale, settings, and climatic conditions finally
lead him to construct a giant metal-capped, pink,
motorized icebag which is able to transform the way
that people see icebags.

OLIVIERA, NATHAN

0009 <u>Nathan</u> <u>Oliviera.</u> vc:3/4. The Buffalo Fine Arts Acade-
my/<u>Albright-Knox</u> Art Gallery. SUCB Film Library. 1977. 40
min. sound. b&w. order by title. buy: $100. rent: $40. prev.
tape with excerpts from several programs avail. on request.

 Oliviera, like so many other California artists, has
remained somewhat apart from the succession of
stylistic trends emanating from New York since World
War II. He speaks openly of his feelings about the
independence and the isolation of working on the
West Coast.

OLSEN, HERB

0010 <u>The</u> <u>Marine</u> <u>Scene</u> <u>with</u> <u>Herb</u> <u>Olsen.</u> 16mm., allv.
Electrographic Corporation. Perspective Films. 1973. 19 min.
sound. color. order #3566/16mm., #3566V/vc. (specify
format). buy: 16mm./$389, vc/$233. prev. (16mm. only).
series: Watercolor Painting. SY.

 Olsen shows techniques for creating images of fog
and solid forms in space as he interprets the moods
of the sea.

ONO, YOKO

0011 <u>Yoko</u> <u>Ono</u> <u>Interview.</u> ac. Liza Cowan and Jan Albert.
Pacifica Tape Library. 1971. 47 min. sound. order #BC0339.

buy: $20.

> Yoko Ono Lennon talks about her life as an artist in
> New York during the early sixties. Her discussion
> touches on conceptual art, "acting-out therapy," the
> loft concerts which she helped to organize, and
> discrimination against the female artist. Recorded
> at the Hotel St. Regis.

OPPENHEIM, DENNIS

0012 Dennis Oppenheim. ac. Audio Arts. 1983?. 40? min.
sound. order by title. buy: ₤4.00 (plus ₤1.10 handling).
series: Audio Arts Magazine Supplement.

> "The Diamond Cutter's Wedding." An interview with
> Oppenheim on the occasion of his exhibitions at the
> Ikon and Lewis/Johnstone Galleries.

0013 Dennis Oppenheim. vc:3/4. Jaime Davidovich. Artists
Television Network. 1980. sound. color. order by title. buy:
request price. rent: request price. prev. series: Conversa-
tions.

> Steven Poser interviews Dennis Oppenheim, sculptor
> and maker of earthworks and video art.

ORTIZ, RALPH

0014 The Art of Destruction. ac. Pacifica Tape Library.
1966. 24 min. sound. order #BB5294. buy: $15.

> Ralph Ortiz discusses his second piano destruction
> concerto in D major. Recorded in London.

OTERO, ALEJANDRO

0015 Vibrant Mirror in the Sun. 16mm., allv. Museum of
Modern Art of Latin America. 1973. 10 min. sound. color.
order #20. buy: 16mm./$100, vc/$30. prev. on premises only.

> This film shows the kinetic sculpture of Alejandro
> Otero, the Venezuelan artist. The work is an open
> metal framework with stainless steel sails or wings
> inside the structure. The sails move with the wind
> and rain and act as a mirror to the sun,
> representing the change and flux in nature and in
> life. English and Spanish narration.

OVERSTREET, JOE

0016 <u>The</u> <u>Black</u> <u>Artist.</u> ac. Pacifica Tape Library. 1969. 53 min. sound. order #BB2816. buy: $13.

Novelist and poet Ishmael Reed, abstract painter Joe Overstreet, and musician Ortiz Walton talk about the traditions and aspirations of black artists.

PP

PALEY, ALBERT

P001 <u>Behind</u> <u>the</u> <u>Fence:</u> <u>Albert</u> <u>Paley,</u> <u>Metalsmith.</u> 16mm. David Darby. David Darby Productions. 1976. 28:30 min. sound. color. order by title. buy: $400. rent: $55 (plus shipping).

A documentary of the attitudes and work of Albert Paley. A metalsmith, Paley executes his largest work to date, an ornamental iron fence for the Hunter Museum of Art in Chattanooga, Tennessee. The film follows the year-long construction of the eight-foot, twelve-thousand-pound fence. Paley also discusses two earlier phases of his work: gates for the Renwick Gallery and his jewelry. An award-winning film.

PARKS, GORDON

P002 <u>Black</u> <u>Wealth.</u> 16mm., allv. WETA-TV, Washington, D.C. Agency for Instructional Television. 1973. 19:56 min. sound. b&w. order by title. buy: 16mm./$300, vc/$150. rent: $30. prev. series: A Matter of Fact.

This program illustrates the spiritual richness of black artists involved in the struggle for freedom and recognition, spotlighting writer-photographer Gordon Parks and actress Margo Barnett.

P003 <u>The</u> <u>Weapons</u> <u>of</u> <u>Gordon</u> <u>Parks.</u> 16mm. Forma Art Associates. 1967. 28 min. sound. color. order #8306. buy: $450. rent: $55. (per 3 days, $15 per additional day. rental fee applicable to purchase price if used for preview). series: Artists at Work.

A revealing study of Gordon Parks, the <u>LIFE</u> photographer, author and musician, told by Parks as he works. "My mother freed me from the curse of inferiority long before she died by not allowing me to take refuge in the excuse that I had been born black."

PARRISH, MAXFIELD

P004 Parrish Blue. 16mm. Ronald S. Marquisse. Indiana University Audiovisual Center. 1967. 27 min. sound. color. order #RSC-1047. rent: $17.75.

Explores the work of Maxfield Parrish in his Cornish, New Hampshire studio. His son discusses his father's work as a painter and illustrator.

PATTISON, ABBOTT

P005 Iron Horse. 16mm., allv. William VanDerKloot. Education Through Visual Works, Inc. 1981. 28 min. sound. color. order by title. buy: 16mm./$450, vc/$350. rent: $50 per showing. prev.

Concerns a piece of sculpture by Chicago sculptor, Abbott Pattison which created a riot on a college campus in 1954. Over one thousand students defaced the piece and set it on fire. In addition to dealing with public sculpture and its impact on society, the film contains an interview with Pattison and shows him at work in his studio. An award-winning film.

PFAFF, JUDY

P006 Judy Pfaff. vc:3/4. Sharon Blume and Susan Krane for The Buffalo Fine Arts Academy/Albright-Knox Art Gallery. SUCB Film Library. 1982. 12 min. sound. color. order by title. buy: $100. rent: $40. prev. tape with excerpts from several programs avail. on request.

An interview with Judy Pfaff by Susan Krane, Curator, Albright-Knox Art Gallery on the occasion of Pfaff's installation at the Albright-Knox, "Rock/Paper/Scissors," 1982. The program includes views of the installation process while Pfaff describes her working method and esthetic concerns. As noted by Krane, "Her works are related metaphorically to the specific psychological states and sensations evoked by particular places. They are often diaristic, whether describing the seemingly urban confusion of her early figurative work, fluid aquatic environs, or craggy haunts filled with stalactite-like forms."

PICASSO, PABLO

P007 <u>The Formative Years.</u> 16mm., allv. Perry Miller Adato
for <u>Perspective Films.</u> 1981. 35 min. sound. color. order
#4181/16mm., #4181V/vc. (specify format). buy: 16mm./$575,
vc/$345. prev. (16mm. only). series: Picasso--A Painter's
Diary.

> Illustrates the artist's lifestyle in Spain and
> France with drawings, paintings and sculptures.
> Picasso's own analysis of his works, as well as the
> observations of friends and family, offer insights
> into Picasso's life. This film, including comments
> from Joan Miro, Gertrude Stein, Jean Cocteau, Jaime
> Sabartes, and other friends and the intimate
> remembrances of his daughter Paloma and son Claude,
> traces Picasso's creative growth from the earliest
> traditional works through the influence of the Post-
> Impressionists. Uses re-enacted voice-overs.

P008 <u>From Cubism To Guernica.</u> 16mm., allv. Perry Miller
Adato for <u>WNET/13.</u> Perspective Films. 1981. 34:30 min.
sound. color. order #4182/16mm., #4182V/vc. (specify
format). buy: 16mm./$560, vc/$336. prev. (16mm. only).
series: Picasso--A Painter's Diary.

> Discusses how, influenced by African sculpture,
> Picasso commenced in 1907 using the collage
> technique and began his Cubist era with "Les
> Demoiselles d'Avignon." Considers the effect upon
> his work of the various women in his life. The film
> also discusses how the Spanish Civil War's
> atrocities impelled Picasso to comment through his
> painting "Guernica." Uses re-enacted voice-overs.

P009 <u>Pablo Picasso: The Legacy of a Genius.</u> 16mm., allv.
Blackwood Productions. 1982. 44 min. sound. color. order by
title. buy: $690. rent: $90. prev. with intent to purchase.

> Interviews Henry Moore, Picasso's son Claude, and
> Francoise Gilot on the subject of Picasso's life and
> art. Considers his works over eighty years in
> exhibitions in the Museum of Modern Art, in Paris
> and in Minneapolis.

P010 <u>Picasso is 90.</u> 16mm. allv. Columbia Broadcasting Sys-
tem News. Carousel Films, Inc. 1972. 51 min. sound. color
buy: 16mm./$750, vc/$575. prev.

> This production is a retrospective biography, filmed
> on the occasion of Picasso's 90th birthday. This
> program shows highlights from his life, his
> paintings and sculpture.

P011 Picasso: War, Peace, and Love. 16mm., allv. UEVA.
1971. 55 min. sound. color. order #6261. buy: $585. rent:
$59 (3 day rental). prev. series: Museum Without Walls.

 This documentary covers the career of the artist
 from "Guernica" to 1970. Picasso talks about his
 work as he is photographed inside his studios near
 Cannes. Works from twenty-two museums, seven
 galleries, and eleven private collections are shown,
 photographed by Lucien Clergue.

P012 A Unity of Variety. 16mm., allv. Perry Miller Adato for
WNET/13, New York. Perspective Films. 1981. 21:30 min.
sound. color. order #4183/16mm., #4183V/vc. (specify for-
mat). buy: 16mm./$410, vc/$246. prev. (16mm. only). series:
Picasso--A Painter's Diary.

 Focuses on Picasso's transformation of the concept
 of sculpture after France's liberation at the close
 of World War II. His use of different media such as
 ceramics and multiple styles made his work
 constantly innovative and original. This award-
 winning series uses re-enacted voice overs.

PIERCE, ELIJAH

P013 Sermons in Wood. 16mm. Carolyn Jones Allport. Center
for Southern Folklore. 1979. 27 min. sound. color. order by
title. buy: $400. prev.

 Examines the life and art of Elijah Pierce, a
 craftsman who carves relief sculptures in wood.
 Pierce, a native Mississippian now living in Ohio,
 has spent half his life preserving episodes from his
 life and from the Bible in brightly-painted
 sculptures. The film reveals the importance of
 Pierce's faith in his artwork. An award-winning
 film.

PINDELL, HOWARDINA

P014 Black Woman Artist: Howardina Pindell. ac. Pacifica
Tape Library. 1974. 102 min. sound. order #BC1986. buy: $27.

 Howardina Pindell is interviewed by Clare Spark.
 Also includes a recorded speech by Linda Nochlin.

POLEO

P015 <u>Poleo</u> and <u>Poetic</u> <u>Figuration.</u> 16mm., allv. CONAC and the
Museum of Modern Art of Latin America. Museum of Modern Art
of Latin America. 1977. 28 min. sound. color. order #23.
buy: 16mm./$280, vc/$84. prev. on premises only.

Discusses the life and works of the Venezuelan
painter Poleo. Spanish, French and English versions
of the film are available.

POLICE, JOE

P016 <u>Wire</u> <u>Sculpture.</u> 16mm., allv. Richard A. Sanderson.
Perspective Films. 1974. 13 min. sound. color. order
#33676/16mm., #3676V/vc. (specify format). buy: 16mm./$269,
prev. (16mm. only). IU, SY.

The life and work of kinetic sculptor Joe Police are
explored. Stresses the importance of allowing the
materials with which one works to express themselves
in the work of art. An award-winning film.

POLLACK, REGINALD

P017 <u>Painting:</u> <u>The</u> <u>Creative</u> <u>Process.</u> 16mm. Film Associates
of California, BFA Educational Media. Indiana University
Audiovisual Center. 1967. 15 min. sound. color. order #RSC-
723. rent: $8.50.

Shows the process of a painting from beginning to
completion, as the painter explains his inspiration.

POLLOCK, JACKSON

P018 <u>Jackson</u> <u>Pollock.</u> 16mm. Paul Falkenberg and Hans Namuth.
Museum at Large. 1951. 11 min. sound. color. order by title.
buy: $400 (plus handling). rent: $50 (plus handling). prev.
CA, SY.

Shot during the late summer and fall of 1950, this
film shows Pollock working out of doors, first on
canvas, then on glass, discussing his technique as
he works. Photographed in one sequence through the
glass, the viewer sees Pollock failing as well as
succeeding. He admits at one point to "losing con-
tact" with the painting. A document of Pollock at
work.

POZZATTI, RUDY

P019 <u>Pozzatti.</u> 16mm. WTIU, Bloomington, Indiana for Public
Television Library. Indiana University Audiovisual Center.

1971. 30 min. sound. color. order #RS-779. rent: $12.50.
series: Artists in America.

> Examines the work and philosophy of Rudy Pozzatti, a
> printmaker living in Bloomington, Indiana.
> Illustrates Pozzatti's versatility in using as
> subjects both classical and contemporary themes.

PRISBREY, TRESSA

P020 Grandma's Bottle Village. 16mm. Allie Light and Irving
Saraf. Light-Saraf Films. 1982. 28:30 min. sound. color.
order by title. buy: $370. rent: $40. prev. with intent to
purchase. series: Visions of Paradise.

> This film explores Grandma Prisbrey's creativity and
> sense of the absurd. Documents the interiors of
> fifteen houses, all examples of the assemblage art
> filled with objects scavenged from the county dump
> by this folk artist.

PRITCHARD, MARY

P021 Mary Pritchard. 16mm. KVZK, Pago Pago. Indiana
University Audiovisual Center. 1971. 30 min. sound. color.
order #RSC-781. rent: $12.50. series: Artists in America.

> Considers the work and philosophy of Pritchard who
> is exploring tapa, a cloth material made from bark,
> as an artistic medium. Shows her at work on
> location in Samoa.

RR

RAPOPORT, SONYA

R001 Sonya Rapoport at Her Studio in Berkeley With Stephen
Moore. ac. Stephen Moore for Union Gallery. Sonya Rapoport.
1978. 60 min. sound. order by title. buy: $10. series:
Contemporary Art Interviews by Stephen Moore/Sonya Rapoport.

> Sonya Rapoport, an artist working in an
> interdisciplinary computer format, is interviewed by
> Stephen Moore, then Director of the Union Gallery of
> San Jose State University, California. The
> interview considers the difficulties that Rapoport
> experiences in presenting her work to an art
> audience that has preconceptions about art. She
> discusses her search for ways to make her art more
> accessible to audiences.

RAUSCHENBERG, ROBERT

R002 Mud Muse. ac. Pacifica Tape Library. 1971. 34 min.
sound. order #BC0069. buy: $15.

 Robert Rauschenberg is interviewed by Clare Loeb on
 his sound activated Louisiana mud project.

R003 Robert Rauschenberg. 16mm. WNET/13, New York. Indiana
University Audiovisual Center. 1966. 30 min. sound. b&w.
order #RS-664. buy: $250. rent: $9.50. prev. series:
Artists.

 At the peak of his greatest fame as a painter,
 Robert Rauschenberg stopped painting completely; in
 the film Rauschenberg discusses his reasons for the
 decision and explains where he hoped to go in his
 art. The film also presents a sample of
 Rauschenberg's works which now include sculpture,
 theatrical works, and films as well as paintings.

R004 Robert Rauschenberg: Retrospective. 16mm., allv.
Blackwood Productions. 1979. 45 min. sound. color. order by
title. buy: $690. rent: $90. prev. with intent to purchase.

 Narrated by the artist, this film presents
 important examples of Rauschenberg's use of diverse
 media and techniques, tracing his development from
 his student years and his earliest experiments to
 the retrospective of his work held in 1977 at the
 Museum of Modern Art in New York. The film includes
 the participation of John Cage and Merce Cunningham,
 both influential in Rauchenberg's development.

REID, BILL

R005 Bill Reid. 16mm., allv. National Film Board of Canada.
1979. 27:50 min. sound. color. order #106C 0179 094. buy:
16mm./$500, vc/$300. rent: $50. prev.

 Bill Reid is a jeweler and wood carver from British
 Columbia. He carves a cedar trunk into a totem pole
 in the tradition of the Haida Indians in this film.
 It is his gift to the people of Skidigate, Queen
 Charlotte Islands. Produced with the support of the
 National Museum of Man, National Museums of Canada
 and the Province of British Columbia.

REINHARDT, AD

R006 Ad Reinhardt. ac. Pacifica Tape Library. 1967. 28 min. sound. order #BC0424.01. buy: $13. series: Great Artists in America Today.

Ad Reinhardt speaks with Jeanne Siegel.

R007 Art as Art Dogma. ac. Pacifica Tape Library. 1965. 96 min. sound. order #BB3391. buy: $19. series: Art Forum.

Ad Reinhardt is interviewed by Bruce Glazer.

REVERON

R008 The Magic Workshop of Reveron. 16mm., allv. Museum of Modern Art of Latin America. 1980. 23 min. sound. color. order #31. buy: 16mm./$230, vc/$69. prev. on premises only.

This film shows the life of the Venezuelan painter through the objects and dolls at his studio. Produced with the National Gallery of Venezuela. Spanish and English versions available.

RICHTER, HANS

R009 Hans Richter: Artist and Filmmaker. 16mm., allv. Erwin Leiser. International Film Bureau, Inc. 1976. 45.5 min. sound. color. order by title. buy: 16mm./$645, vc/$475. rent: $45 (16mm. only). prev. SY.

This exploration of Richter's work focuses primarily on his studies in film, his place in the Dadaist movement, and his collaboration with other artists. Richter speaks about his philosophy of image and creativity, his films, and his art. Shortly after beginning the Dadaist movement, he turned to film as a way to examine rhythm in painting. Richter assisted with the production of the film until his death in 1976.

RICKEY, GEORGE

R010 George Rickey, Sculptor. ac. Pacifica Tape Library. 1971. 60 min. sound. order #BB5214. buy: $15.

George Rickey is interviewed by Clare Loeb.

RILEY, BRIDGET

R011 Bridget Riley. vc:3/4. The Buffalo Fine Arts

Academy/Albright-Knox Art Gallery. SUCB Film Library. 1978.
16 min. sound. color. order by title. buy: $100. rent: $40.
prev. tape with excerpts from several programs avail. on
request.

Op artist Bridget Riley has extended visual language
toward new and unexplored frontiers of painting.
This British artist is interviewed in Buffalo, New
York by esthetician, Robert Kudielka. Riley
describes several of her paintings in the
exhibition, "Bridget Riley: 1959-78."

RIVERS, LARRY

R012 Larry Rivers. 16mm., allv. Blackwood Productions. 1973.
28 min. sound. color. order by title. buy: $550. rent: $60.
prev. with intent to purchase.

Throughout his career Rivers has revised popular
themes and cliches, embracing and exploiting the
characters and material things that surround him.
In this film, narrated by Rivers, he examines a
series of his "Dutch Masters" paintings, inspired by
the standard cigar-box image that recalls Rembrandt,
as well as several of his iconoclastic portraits,
among them a naked rendition of art critic Frank
O'Hara.

ROCKWELL, NORMAN

R013 Norman Rockwell's World: An American Dream. 16mm.
Concepts Unlimited. Indiana University Audiovisual Center.
1972. 25 min. sound. color. order #RSC-992. rent: $12.50.
prev.

Presents painter Norman Rockwell at work in his
studio. The famous illustrator of the Saturday
Evening Post reflects upon his life and his
artistic and philosophical point of view. Includes
archival film footage and re-enactments.

ROGOVIN, MILTON

R014 Milton Rogovin. vc:3/4. The Buffalo Fine Arts Acade-
my/Albright-Knox Art Gallery. SUCB Film Library. 1975. 29
min. sound. b&w. order by title. buy: $100. rent: $40. prev.
tape with excerpts from several programs avail. on request.

Social Realist photographer Milton Rogovin speaks of
the esthetic and ethical concerns of his work which
have to do with people, dignity and survival in
modern society.

ROSS, ALEX

R015 Imaginative Designs with Alex Ross. 16mm., allv.
Electrographic Corporation. Perspective Films. 1973. 20 min.
sound. color. order #3568/16mm., #3568V/vc. (specify
format). buy: 16mm./$389, vc/$233. prev. (16mm. only).
series: Watercolor Painting. IU, SY.

Illustrator-painter Alex Ross discusses his
philosophy and approach to his work. He tells how
he takes inspiration from old photographs and from
the works of other painters. He demonstrates his
painting with acrylic on textured media board.

ROTHSCHILD, AMALIE
R016 Nana, Mom & Me. 16mm. Amalie R. Rothschild. New Day
Films. 1974. 47 min. sound. color. order by title. buy:
$600. rent: $60. prev.

A portrait of the three generations of women in the
filmmaker's family, and the differing motivations,
philosophies and rivalries that shape their
interaction. The production features interviews
with the filmmaker's mother who, as an artist
herself, discusses her transition from commercial
artist to her present status as painter and
sculptor. She also comments on the difficulties she
faced balancing her art career with raising a
family.

RUSCHA, EDWARD

R017 Edward Ruscha: A Conversation. allv. Joyce Cutler Shaw
and Palomar College. Independents Network. 198?. 30 min.
sound. color. order by title. buy: $100. prev. for libraries
only.

In a dialog between Ruscha and artist/educator,
Joyce Cutler Shaw, Ruscha clarifies many of his
viewpoints, offering some opinions of art and
education. Well known for his paintings, prints and
films, he prefers his work on non-traditional
artist's books.

RUSHFORD, PETER

R018 Heart, Head, and Hand. 16mm., allv. Crafts Resource
Productions. Tasmanian Film Corporation. 1979. 23 min.
sound. color. order by title. buy: 16mm./Australian $506,
vc/Australian $322. rent: Australian $50 per screening,

plus freight. prev.

The film shows potter and teacher Peter Rushford at work with his pottery. Rushford's early mentor, Bernard Leach, originated the words from which the title of the film are taken, "Heart, head and hand in proper balance." In the film, director and longstanding friend, Peter Weir observes Rushford at a point when he is moving from his teaching career back into his own creative life as a full-time potter.

RYAN, ANNE

R019 Anne Ryan (Discussed by Elizabeth McFadden). vc:3/4. Sharon Blume, Susan Krane and Catherine Green for the Buffalo Fine Arts Academy/Albright-Knox Art Gallery. SUCB Film Library. 1980. 14 min. sound. color. order by title. buy: $100. rent: $40. prev. tape with excerpts from several programs avail. on request.

Elizabeth McFadden, daughter of Anne Ryan, recalls her mother's work including some of the personal references found in the artist's intimate collages. Ryan's work, though abstract, suggests the poetry of everyday occurrences.

SSS

SAAR, BETYE

S001 Spirit Catcher: The Art of Betye Saar. 16mm., vc:3/4, vc:v. WNET. Films Incorporated. 1977. 30 min. sound. color. order #405-0029. buy: 16mm./$490, vc/$245. rent: $65. prev. series: The Originals: Women in Art Series. CA, SY.

Assemblage artist Betye Saar's fascination with the mystical merges with social concerns of significance to her as a black American. Often using the discards of our civilization, she creates provocative and powerful images. In some of the works shown she liberates stereotyped black images from derogatory contexts, thus creating new levels of awareness.

ST. CLAIR, STONEY

S002 Stoney Knows How. 16mm., vc:3/4. Alan Govenar. Folklore Media Center. 1980. 29 min. sound. color. order by title. buy: $450 (16mm.). rent: $50. prev. (From

University of Texas Film Library).

> Stoney St. Clair, a handicapped tattoo artist, talks about his life and demonstrates his art. Through Stoney's words and stories, the viewer comes to realize how he has used tattooing as a means to come to terms with his own handicaps, and to achieve his individualization.

SANCHEZ, JUAN FELIX

S003 Juan Felix Sanchez. 16mm. Dennis Schmeichler and Calogero Salvo. Calogero Salvo. 1982. 27 min. sound. color. order by title. buy: $450. rent: $50. prev.

> Juan Felix Sachez is a folk artist who for the past forty years has lived and worked in a remote valley 12,000 feet up in the Venezuelan Andes. In this documentary, filmed in Venezuela, the 82 year old artist speaks passionately of his life and works which include weaving, sculpture and architecture. In Spanish with English or French subtitles. An award-winning film.

SANCHEZ, MARIO

S004 Mario Sanchez: Painter of Memories. 16mm. Jack Ofield. Bowling Green Films, Inc. 1978. 17 min. sound. color. order #MS20. buy: $265. rent: $30. (for two days). prev. with intent to purchase. series: Three American Folk Painters.

> Documents the art and life of the Cuban-American self-taught artist Mario Sanchez. He has seen the island society change and has depicted his memories of daily life in a continuing series of painted, hand-chiseled wood reliefs. Sanchez is seen at work, discussing techniques and the influences on his work of his life events.

SANDERS, CHRIS

S005 Chris Sanders: Apprentice Potter. allv. Film Victoria. Tasmanian Film Corporation. 1979. 5 min. sound. color. order by title. buy: (series) Australian $813. rent: Australian $50 per screening, plus freight. prev. series: Craft as a Livelihood.

> Part of a series produced for the Victorian Crafts Council, these productions cover a wide range of craft occupations and are intended for teaching appreciation of the skills required in the various careers. In this segment the craftsman discusses

his interaction with the master potter to whom he is apprenticed.

SCARPONI, BARBARA

S006 The World and Work of Barbara Scarponi. 16mm. Public Television Library for PBS Video. Indiana University Audiovisual Center. 1970. 28 min. sound. color. order #RSC-760. buy: $360. rent: $12.50. prev. series: World of the American Craftsman.

One does not see organiziation, neatness, or slickness in the art of Barbara Scarponi. Her creations reflect the personalities of people. People, she feels, cannot be fully organized. Scarponi, who works in wax and metal, is shown casting a ring, the most personal of jewelry items.

SCHAPIRO, MIRIAM

S007 A Conversation With Miriam Shapiro. (sic) ac. Pacifica Tape Library. 1974. 55 min. sound. order #BC1924. buy: $15.

The painter Miriam Schapiro relates her art to the women's movement in this interview by Clare Spark.

SCHINDEL, MORTON

S008 Morton Schindel: From Page to Screen. 16mm. Morton Schindel. Weston Woods. 1981. 27 min. sound. color. order #MP431. buy: $325. rent: $25. prev. SY.

Interviews Morton Schindel, the founder and president of Weston Woods, a studio which adapts children's literature for presentation via audiovisual media. Presents a guided tour of the Weston Woods Studios for the purpose of showing how books are chosen for screen adaptation, how artists work with the studio, and how the artwork from the books is reproduced.

SCHOEFFER, NICOLAS

S009 Nicolas Schoeffer. vc:3/4. The Buffalo Fine Arts Academy/Albright-Knox Art Gallery. SUCB Film Library. 1977. 40 min. sound. b&w. order by title. buy: $100. rent: $40. prev. tape with excerpts from several programs avail. on request.

Exploring the edges of technological civilization, Schoeffer's sound-light-motion sculpture evokes the

mystery and beauty of machines. From his Paris
studio, Schoeffer explains and demonstrates some of
his most spectacular creations. Available in French
with English transcript.

SCHUTZ, ROBERT

S010 Education of an Architect. ac. Pacifica Tape Library.
1962. 67 min. sound. order #BB1976. buy: $17.

 In this tape, recorded in 1953 or 1954, Bernard
 Maybeck talks with Robert Schutz.

S011 Men and Issues. ac. Pacifica Tape Library. 1953. 31
min. sound. order #BB1975. buy: $15.

 Bernard Maybeck talks with Robert Schutz.

SCOTT, JOYCE

S012 A Woman Artist Speaks: Joyce Scott. ac. Elaine Heff-
ernan and Naomi Eftis. Pacifica Tape Library. 1977. 30 min.
sound. order #WZ0109. buy: $13. series: Survival
Clearinghouse for the Arts.

 Elaine Heffernan and Naomi Eftis interview Joyce
 Scott about creating and selling art.

SCOTT, WILLIAM

S013 William Scott. vc:3/4. The Buffalo Fine Arts
Academy/Albright-Knox Art Gallery. SUCB Film Library. 1976.
40 min. sound. b&w. order by title. buy: $100. rent: $40.
prev. tape with excerpts from several programs avail. on
request.

 Scott recalls moments of an extraordinary career,
 including painting an old Breton peasant woman who,
 as a girl, posed for Paul Gauguin; and on other
 occasions, strolling through British museums with
 his close friend, Dylan Thomas. Taped at Scott's
 cottage near Bath, England.

SCWANCK, TOR

S014 Tor Scwanck: Gold and Silversmith. allv. Film Victoria.
Tasmanian Film Corporation. 1979. 5 min. sound. color. order
by title. buy: (series) Australian $813. rent: Australian
$50 per screening, plus freight. prev. series: Craft as a
Livelihood.

Part of a series produced for the Victorian Crafts
Council, these productions cover a wide range of
craft occupations and are intended for teaching
appreciation of the skills required in the various
crafts occupations. In this production Tor discus-
ses the difficulties of building up a regular clien-
tele after five years of apprenticeship.

SEGAL, GEORGE

S015 The Artist's Studio: Meyer Schapiro Visits George
Segal. 16mm., allv. Blackwood Productions. 1983. 28 min.
sound. color. order by title. buy: $550. rent: $60. prev.
with intent to purchase.

George Segal was a student of Meyer Schapiro at
Columbia University. Now as friends, they often
visit in Segal's studio. In this film, they discuss
Segal's departure from conventional sculpture by
creating plaster figures and their environments.

S016 George Segal. 16mm., allv. Blackwood Productions. 1979.
58 min. sound. color. order by title. buy: $690. rent: $90.
prev. with intent to purchase.

Narrated by the artist, the film looks back over two
decades of Segal's achievements, reassembled for a
retrospective exhibition at the Walker Art Center in
Minneapolis. Segal helps to install the environ-
ments and wall reliefs, talking about key works and
the artistic issues that they embody; among these
pieces are "Cinema," "The Butcher Shop," "To All
Gates," and "Costume Party."

S017 George Segal. vc:3/4. The Buffalo Fine Arts Academy/Al-
bright-Knox Art Gallery. SUCB Film Library. 1977. 28 min.
sound. b&w. order by title. buy: $100. rent: $40. prev. tape
with excerpts from several programs avail. on request.

"I want to wake up a fantasy within you. I want you
dreaming about what is going on without telling a
story with beginning, middle, or end...." Excerpts
from four interviews with Segal over the period of
conception, execution and installation of his first
outdoor public commission entitled, "Restaurant,"
for the Federal Building, Buffalo, New York.

SENDAK, MAURICE

S018 Maurice Sendak. 16mm. Morton Schindel. Weston Woods.

1965. 14 min. sound. color. order #MP404. buy: $225. rent: $15. prev. SY.

A visit in Maurice Sendak's studio where he discusses his favorite artists of the past and how they have influenced his work today.

SHAFER, ANNA

S019 Anna Shafer and Her Art. 16mm. Georgiana and William Jungels. Applied Media Associates. 1972. 10 min. sound. color. order by title. buy: $225. SUCB.

Animates the drawings of folk-artist Anna Shafer while she speaks about her experiences from birth through old age. Shows her to be a vibrant Jewish woman of 85 years.

SHAPIRO, JOEL

S020 Joel Shapiro. vc:3/4. The Buffalo Fine Arts Academy/Albright-Knox Art Gallery. SUCB Film Library. 1976. 20 min. sound. b&w. order by title. buy: $100. rent: $40. prev. tape with excerpts from several programs avail. on request.

Installation views of the exhibition, "Joel Shapiro: Recent Works," shown at the Albright-Knox Art Gallery. The tape also includes excerpts from an informal discussion by the artist at HALLWALLS Gallery. The exhibition was jointly sponsored by the Albright-Knox Art Gallery and HALLWALLS. Exhibition Curator, Linda L. Cathcart.

SHILLING, ARTHUR

S021 The Beauty of My People. National Film Board of Canada. 16mm. allv. 1977. 29 min. sound. color. order #106C 0177526. buy: 16mm./$550, vc/$350. rent: $60. prev.

Arthur Shilling, Ojibway artist from the Rama Reserve on Lake Conchiching, Ontario is shown during an artistic journey that took him from his home to Toronto and then back again. Paintings are juxtaposed with interviews to round out the story of the artists. Commissioned to Nova Productions by the National Film Board for Indian and Northern Affairs Canada. An award-winning film.

SIMS, PATTERSON

S022 The Whitney Biennial. allv. Inner-Tube Video. 1981?. 30

min. sound. color. order #6. buy: $125. series: ART/New
York: 1980-1 Art Season.

This tape offers a comprehensive survey of the
painting and sculpture in this exhibition. Includes
a four-minute interview with Whitney curator,
Patterson Sims.

SIQUEIROS, DAVID ALFARO

S023 America Tropical. 16mm. Indiana University Audiovisual
Center. 1971. 30 min. sound. color. order #CSC-2198. rent:
$12.50. CA.

Considers the mural "America Tropical" painted by
Mexican artist David Alfaro Siqueiros. This
painting, which was cause for the failure of the
United States government to renew Siqueiros' visa,
showed a man crucified under the American eagle.
The mural was recently restored after having been
painted over with whitewash.

S024 Siqueiros: "El Maestro." (The March of Humanity in
Latin America.) 16mm. allv. Encyclopaedia Britannica Educa-
tion Corporation. 1969. 14 min. sound. color. order #2818.
buy: $225. rent: $22.50 prev. CA.

A documentary, collaborated upon by Misch Kohn, of
the largest mural ever created: "The March of
Humanity in Latin America" by David Siqueiros in
Mexico City. The film focuses on the complex
technique he employs, a combination of sculpture and
painting which is called "esculpto-pintura." With a
team of students, painters, welders, architects, and
artisans, the artist involves a whole community of
people. Throughout this award-winning film,
Siqueiros supervises, paints, and discusses his
techniques and philosophy, reflected in the theme of
the mural. A Spanish version of the film is
available.

SISCHY, INGRID

S025 Ingrid Sischy. vc:3/4. Robin White & Jaime Davidovich.
Artists Television Network. 1979. 28 min. sound. color.
order by title. buy: request price. rent: request price.
prev. series: Conversations.

In this segment of Conversations, Steven Poser
interviews Ingrid Sischy, who is the editor of
Artforum.

SISKIND, AARON

S026 Aaron Siskind. 16mm. Checkerboard Foundation, Inc. 1981. 17 min. sound. color. order by title. buy: request price. rent: request price.

In the early 1940's Siskind broke with the traditions of documentary photography and began making personal, abstract pictures. This portrait of Siskind was shot on location in Martha's Vineyard and Lima, Peru.

SMITH, TONY

S027 Tony Smith. vc:3/4. The Buffalo Fine Arts Academy/Albright-Knox Art Gallery. SUCB Film Library. 1977. 30 min. sound. b&w. order by title. buy: $100. rent: $40. prev. tape with excerpts from several programs avail. on request.

"Minimal" artist Tony Smith explains the technical means and esthetic aims of his sculpture which has earned him the misleading sobriquet as the "artist who orders sculpture by telephone."

SNELSON, KENNETH

S028 Kenneth Snelson. vc:3/4. Sharon Blume and Catherine Green for The Buffalo Fine Arts Academy/Albright-Knox Art Gallery. SUCB Film Library. 1981. 12 min. sound. color. order by title. buy: $100. rent: $40. prev. tape with excerpts from several programs avail. on request.

Although Snelson's soaring sculpture composed of stainless steel cylinders and wire stays do not merely illustrate principles of mathematics and physics, they achieve the same elegance and purity of design. Snelson believes that, "...artists are the last of the speculative philosophers," and clearly his work, unmistakably modern as it is, harks back to a medieval synthesis of art and science. The tape includes views of Snelson supervising installation of large outdoor sculptures and an interview with the artist by Catherine Green of the Albright-Knox in conjunction with the exhibition, "Kenneth Snelson."

SOLDNER, PAUL

S029 A Potter's Song: The Art and Philosophy of Paul Soldner. 16mm., allv. Crystal Productions. 1976. 16 min.

sound. color. order #F-101/16mm., V-101/vc. buy: 16mm./$240, 'vc/$150. rent: $25. (for three days). prev.

The artist is seen working in his studio. He discusses his lifestyle, as well as his theories of education for the potter. Some of these theories are seen in practice at the Anderson Ranch Art School. Soldner also demonstrates the techniques which he has developed to create his non-functional raku pottery. An award-winning film.

SOLERI, PAOLO

S030 How to Change the World: Inspired by the Thought of Teilhard de Chardin. 16mm. allv. Hartley Film Foundation, Inc. 1982. 28 min. sound. color. buy:16mm./$350. vc:b/$58.40. vc:v/$58.40. vc:3/4/$245. rent: (16mm. only) $40 plus $5 shipping. prev.

Paolo Soleri is interviewed in this film concerning his ideas about Arcosanti and Teilhard. Soleri was so inspired by Teilhard that he went out into the desert near Phoenix and began building Arcosanti, a city of the future. Recently, a celebration, "Teilhard and Metamorphosis," was held there. A host of artists, philosophers, and scientists came to perform, to talk about, and to celebrate Teilhard's ideas about evolution and the future. The film is both serious thought and joyful celebration.

S031 Paolo Soleri: On Becoming Spirit. ac. Pacifica Tape Library. 1975. 55 min. sound. order #BL2176.01. buy: $13.

An interview with Paolo Soleri, an Italian-born architect who proposes that "archologies," three-dimensional cities built on nominal land areas as high as they are wide, are necessary to further humankind's material and spiritual evolution. Through this application of complexification-miniaturization to the urban environment, conveniently located services and cultural facilities are maximized.

S032 The Spirit of Arcosanti. ac. Pacifica Tape Library. 1975. 49 min. sound. order #BC2176.02. buy: $13.

Paolo Soleri disagrees with conservationists who insist that the balance of nature is sacred. He suggests that humanity is engaged in a three-billion-year struggle into consciousness. "Alteration is sacred, too, and mankind must now

take up the burden of the future."

SONFIST, ALAN

S033 Alan Sonfist. vc:3/4. Sharon Blume and Charlotta Kotik for The Buffalo Fine Arts Academy/Albright-Knox Art Gallery. SUCB Film Library. 1980. 10 min. sound. color. order by title. buy: $100. rent: $40. prev. tape with excerpts from several programs avail. on request.

> This tape documents Sonfist's "Monument for Buffalo" including an outdoor sculpture and other site-related works exploring the ecology of the Niagara Frontier region of upstate New York. Although rooted in the ecology-oriented art of recent years, Sonfist is essentially interested in the mysteries of time, geologic and human, macrocosm and micro-cosm, as well as the reaction and interaction of people with his work. Sonfist discusses these and other concerns with Albright-Knox Curator, Charlotta Kotik.

SOTO, JESUS RAPHAEL

S034 Soto. 16mm., allv. CONAC and the Museum of Modern Art of Latin America. 1972. 15 min. sound. color. order #18. buy: 16mm./$150, vc/$45. prev. on premises only.

> This award-winning film documents the work of Venezuelan kinetic artist Jesus Raphael Soto. The artist created environments of nylon threads through which the spectator walked and optical art of superimposed planes of dots. His next works were elliptical spirals and metal forms which held vertical and horizontal rods. English and Spanish narration.

SOYER, RAPHAEL

S035 Beauty in Disarray. ac. Pacifica Tape Library. 1975. 90 min. sound. order #BC2260. buy: $17.

> Raphael Soyer, who paints scenes of New York's streets and people, is interviewed by Jan Aubert.

SPIELBERG, STEVEN

S036 The Making of Raiders of the Lost Ark. 16mm., vc. Howard Von Kazanjian for Lucasfilm, Ltd. Direct Cinema Limited. 1982. 58 min. sound. color. order by title. buy: $895. rent: $100. prev.

Documents the personalities of Steven Spielberg and
George Lucas in the making of "Raiders of the Lost
Ark." Illustrates the processes needed to create a
film: story boards, set buildings, work with actors
and crew, stunts, and special technical effects
through documentary footage.

STAMPER, I.D.

S037 Sourwood Mountain Dulcimers. 16mm., allv. Gene DuBey
and Alan Bennett. Appalshop, Inc. 1976. 28 min. sound.
color. order by title. buy: 16mm./$500, vc/request price.
rent: $55 (16mm. only). prev. with intent to purchase ($10
handling).

Shows I.D. Stamper teaching the building and playing
of the dulcimer, a folk instrument, to John
McCutcheon, who shares his special knowledge of the
hammered dulcimer.

STELLA, FRANK

S038 Frank Stella. vc:3/4. The Buffalo Fine Arts
Academy/Albright-Knox Art Gallery. SUCB Film Library. 1976.
30 min. sound. b&w. order by title. buy: $100. rent: $40.
prev. tape with excerpts from several programs avail. on
request.

"If you don't have a sense of the past, it's
sad...the thing about history is that it's
unavoidable..." Stella talks about his work and
contemporary American painting in general as it
relates and refers to numerous sources from past
history and present culture. Available subject to
Mr. Stella's permission.

STIEGLITZ, ALFRED

S039 Alfred Stieglitz, Photographer. 16mm. Paul Falkenberg
and Hans Namuth. Museum at Large. 1982. 26 min. sound.
color. order by title. buy: $750 (plus handling). rent: $75
(plus handling). prev.

Drawn from Stieglitz's own observations and the
reminiscences of various people who knew him well--
among others: Ansel Adams, Mary Steichen Calderone,
Harold Clurman, Aaron Copland, Arnold Newman, Isamu
Noguchi, Dorothy Norman, and Mary Rapp. The
narrative underlines the powerful and multi-faceted
personality of the photographer and the man.

STOVALL, QUEENA

S040 Queena Stovall: Life's Narrow Space. 16mm. Jack
Ofield. Bowling Green Films, Inc. 1980. 18.5 min. sound.
color. order #QS22. buy: $270. rent: $30 (for two days).
prev. with intent to purchase. series: Three American Folk
Painters.

> Documents the art and life of Queena Dillard
> Stovall, a self-taught painter from Virginia. She
> discusses her life and its evocation through her
> detailed paintings, showing daily chores, births and
> deaths, raising children, and the changing seasons.

SUTHERLAND, GRAHAM

S041 Graham Sutherland. vc:3/4. The Buffalo Fine Arts Aca-
demy/Albright-Knox Art Gallery. SUCB Film Library. 1976. 30
min. sound. b&w. order by title. buy: $100. rent: $40. prev.
tape with excerpts from several programs avail. on request.

> Taped at the new Graham Sutherland Gallery at Picton
> Castle, Wales, near some of Sutherland's favorite
> sources of landscape imagery, Sutherland describes
> the intertwining of nature and abstraction which is
> important to him as a painter.

SZYSZLO, FERNANDO DE

S042 Fernando de Szyszlo of Peru Paints a Picture. 16mm.,
allv. Museum of Modern Art of Latin America. 1965. 22 min.
sound. color. order #4. buy: 16mm./$220, vc/$66. prev. on
premises only.

> De Szyszlo is shown working in his studio in Lima.
> This film is available in Spanish only.

TTT

TACHA, ATHENA

T001 Athena Tacha, Sculptor. vc:3/4. Ron Giles. Warner
Cable Corporation of Pittsburgh. 1982. 10 min. sound.
color. order by title. buy: request price. rent: request
price.

> This interview with Tacha was taped during the
> "Rainforest" tape installation at Mattress Factory
> Gallery, Pittsburgh, 1982.

TAMAYO, RUFINO

T002 Rufino Tamayo: The Sources of His Art. 16mm. Gary Conklin. Arthur Cantor Films, Inc. 1973. 27 min. sound. color. buy: $400. rent: $75. prev.

> Mexico's culture is epitomized by the painter Rufino Tamayo. Like his fellow countryman, poet and commentator, Octavio Paz, Tamayo's art could not exist without Mexico, a homeland providing a constant frame of reference and source of inspiration. John Huston reads Paz's poetry as the camera lingers over Tamayo's canvases; the two great Mexicans talk in their garden as images of their country are juxtaposed with images of their art.

THOMAS, HOWARD

T003 Earth Red: Howard Thomas Paints a Gouache. 16mm., allv. Mr. and Mrs. Howard Thomas. UEVA. 1969. 20 min. sound. color. order #5804. buy: $312. rent: $31. (for three days). prev.

> Shows Mr. Thomas, a native of North Carolina, obtaining natural pigments, blending them in his studio, and creating one of his works. The artist's rhythmic approach to painting is evident as Thomas blends elements of music and nature with his philosophy of art.

THOMPSON, CONWAY

T004 Conway Thompson: Sculptor From Dry Bridge. 16mm. Charlotte Schrader. Available for free loan only in the state of Virginia from the Virginia State Library Film Collection. Purchase or rental from the producer. 1976. 20 min. sound. b&w. and color. order by title. buy: $350. rent: $35.

> Although Conway Thompson was trained at Cooper Union in New York City and in Italy, she has returned to rural Virginia to work with agrarian themes. She uses such old tools as the pitchfork, hay cradle, bullyoke, and singletree in her sculptures, as well as creating marble abstractions. An award-winning film.

THOMPSON, DEWEY

T005 Chairmaker. 16mm., allv. Rick DiClemente. Appalshop, Inc. 1975. 22 min. sound. color. order by title. buy: $350.

(16mm. only. video for purchase only. request prices). rent: $40. prev. with intent to purchase (plus $10 handling).

Eighty-year-old Dewey Thompson discusses and demonstrates his craft of furniture building as a rough-hewn rocking chair takes form under his experienced hands and well-worn knife.

THUNDER, CHIEF ROLLING MOUNTAIN

T006 The Monument of Chief Rolling Mountain Thunder. 16mm. Allie Light and Irving Saraf. Light-Saraf Films. 1983. 28:30 min. sound. color. order by title. buy: $370. rent: $40. prev. with intent to purchase. series: Visions of Paradise.

This film considers the creative process as it is shown in the work of seventy-one-year-old Chief Thunder. The Chief has created a monumental dwelling decorated with overwhelming sculptures which portray Indian heroes, family and friends in the Nevada desert.

TOBEY, MARK

T007 Mark Tobey. 16mm. Orbit Films, Brandon Films, Inc. Indiana University Audiovisual Center. 196?. 18 min. sound. color. order #RSC-367. rent: $9.75.

Considers the world of the commonplace through the artistic vision of Mark Tobey. Illustrates the elements of design through poetic visual montages.

TORRES-GARCIA, JOAQUIN

T008 Torres Garcia and the Universal Constructivism. 16mm., allv. Museum of Modern Art of Latin America. 1974. 30 min. sound. color. order #21. buy: 16mm./$300, vc/$90. prev. on premises only.

The life and works of the Uruguayan artist, Joaquin Torres-Garcia are depicted in this film. A founder of the constructivist movement, Torres-Garcia became interested in pre-Hispanic art, especially the decorative motifs used in the weaving and pottery of Tiahuanaco and the patterns used by the Incas. His works appear on canvas, wood constructions, and stone. Spanish and English narration.

TURNBULL, WILLIAM

T009 <u>William</u> <u>Turnbull.</u> vc:3/4. The Buffalo Fine Arts Acade-
my/Albright-Knox Art Gallery. SUCB Film Library. 1976. 50
min. sound. b&w. order by title. buy: $100. rent: $40. prev.
tape with excerpts from several programs avail. on request.

British artist William Turnbull is both a painter
and a sculptor. When asked which he would prefer to
visit: the British Museum or the National Gallery,
Turnbull replied, "The British Museum." This
interview was taped at Turnbull's London home and
studio.

TWORKOV, JACK

T010 <u>Jack</u> <u>Tworkov.</u> 16mm. WNET/13, New York. Indiana Univer-
sity Audiovisual Center. 1966. 30 min. sound. b&w. order
#RS-667. buy: $250. rent: $9.50. prev. series: Artists.

An introduction to the abstraction of Jack Tworkov.
He offers his thoughts about the meaning of his
work, considering biographical aspects of his life
as he is shown working on a large painting which
uses organic forms, rather than his earlier
expressionistic style.

UU

UNGERER, TOMI

U001 <u>Tomi</u> <u>Ungerer:</u> <u>Storyteller.</u> 16mm. Morton Schindel.
Weston Woods. 1982. 21 min. sound. color. order #MP432. buy:
$325. rent: $25. prev.

In this interview by Gene Deitch, animation director
for the filmed adaptations of Tomi Ungerer's books,
Ungerer reveals why his books are filled with
violence and satire as well as with humor and
moments of loneliness. Ungerer admits to creating
books "to please myself."

VV

VACA, VACLAV

V001 <u>Vaclav</u> <u>Vaca:</u> <u>Fantastic</u> <u>Visions.</u> 16mm., allv. Kristina
Vaca and P. de Silva. Kinetic Film Enterprises. 1982. 27
min. sound. color. order by title. buy: $495. rent: $75.
prev.

A musician and dancer of international calibre before coming from Czechoslovakia to Canada, Vaclav Vaca is inspired by his faith. Including interviews and superb details of his works, the film centers around the hanging of a giant commissioned canvas by Mr. Vaca in Toronto's Roman Catholic Cathedral.

VALES, GORDON

V002 The Silhouettes of Gordon Vales. 16mm., allv. Robin DuCrest. The Media Project. 1980. 26 min. sound. color. order by title. buy: 16mm./$384, vc/$288. rent: $45.

This is a portrait of an artist who tears silhouettes from paper. It traces Vale's journey from his life in a facility for the mentally handicapped to his subsequent artistic and personal freedom. Animated sequences bring his silhouettes of butterflies, flying horses, and cowboys to life.

VAN DYKE, WILLARD

V003 Conversations with Willard Van Dyke. 16mm. Amalie R. Rothschild. New Day Films. 1981. 59 min. sound. color. order by title. buy: 16mm./$895, vc/$500 (plus $10 handling). rent: $100 (plus $5 handling). prev.

This film is a portrait of the well-known documentary photographer and filmmaker, who also served as the director of the Museum of Modern Art's Film Department. It explores the dilemma of the artist with a social conscience. Van Dyke faced the harsh realities of earning a living while retaining his artistic integrity.

VAN DERZEE, JAMES

V004 Black Has Always Been Beautiful. 16mm. WNET/13. Indiana University Audiovisual Center. 1971. 17 min. sound. b&w. order #KS-401. buy: $165. rent: $7.50. prev. CA.

Black photographer James Van DerZee worked in relative obscurity for six decades, documenting the black experience in Harlem. As the self-taught Van DerZee photographs a young woman, he discusses how he gets the camera to record the subject as he sees it. Van DerZee's photographs of Harlem school children, the Black Yankees, Marcus Garvey, Bill "Bojangles" Robinson, and many others are presented.

V005 Uncommon Images: James Van DerZee. 16mm. Evelyn Bar-

ron. Filmakers Library, Inc. 1977. 22 min. sound. color.
order by title. buy: $390. rent: $40. prev. to large film
libraries with intent to purchase.

 A portrait of the photographer James Van DerZee and
 his work. Mr. Van DerZee photographed Harlem from
 the early years of this century. His work provides a
 record of public and private life in the black
 community. The film includes interviews with him at
 the age of 92, in which he reminisces about his life
 and work.

VAN FLEET, ELLEN

V006 Ellen Van Fleet Gallops Off...... vc:3/4. Richard
Osborne. University Media Services, California State
University at Sacramento. 1981. 27:08 min. sound. color.
order by title. buy: request price. rent: request price.
prev.

 A videotape that deals with an artist who represents
 ideas in many different materials and art forms.
 This artist is also depicting her role in the
 community.

VASARELY, VICTOR

V007 Victor Vasarely. vc:3/4. The Buffalo Fine Arts Acade-
my/Albright-Knox Art Gallery. SUCB Film Library. 1977. 40
min. sound. b&w. order by title. buy: $100. rent: $40. prev.
tape with excerpts from several programs avail. on request.

 From the era of Impressionism to the present day,
 artists have continued to explore problems of
 perception. Vasarely extends this concern to his
 paintings. Taped at Vasarely's studio outside
 Paris, Vasarely is interviewed by Jean Hubert-
 Martin, Curator of the Centre Georges Pompidou,
 Paris. Available in French with English transcript.

V008 Who is: Victor Vasarely. 16mm. NET. Indiana University
Audiovisual Center. 1968. 30 min. sound. color. order #RSC-
754. rent: $12.50. CA.

 Discusses with Vasarely his philosophy and point of
 view about art. Stressing the value of owning works
 of art, the artist has designed many of his works
 for unlimited reproduction. Vasarely, a founder of
 Op Art, speaks about his ideas regarding relativity
 and the speed of light in art.

VELASQUEZ, J. A.

V009 The World of a Primitive Painter. 16mm., allv. Museum of Modern Art of Latin America. 1972. 20 min. sound. color. order #16. buy: 16mm./$200, vc/$60. prev. on premises only.

This award-winning film documents the work of Honduran primitive painter J.A. Velasquez in the villages of San Antonio and Tegucigalpa. English and Spanish narration.

VINTON, WILL

V010 Claymation. 16mm. Susan Shadburne. The Media Project. 1978. 17 min. sound. color. order by title. rent: $30. CA, SY.

Considers the process of clay animation, an art form partially developed by Will Vinton Productions. Utilizing both live action and clay animation, the film shows Vinton and his crew of animators and sculptors as well as their creations.

VISSER, CAREL

V011 Carel Visser, Sculptor. 16mm. Jonne Severijn and Hans Locher. Consulate General of the Netherlands. 1972. 23 min. sound. color. order by title. rent: free loan. prev.

A portrait of Visser, who received the 1972 State Prize for Arts and Architecture, showing the successive stages in the evolution of his work. He emphasizes the stylistic affinity between his sculptures and his work in graphic art. The artist gives his own commentary on the film.

VON RINGELHEIM, PAUL

V012 Talking I. ac. Pacifica Tape Library. 197?. 52 min. sound. order #BC2611. buy: $15.

Sculptor Paul von Ringelheim is interviewed by Barbara Londin.

WW

WAIN, GREG

W001 Greg Wain: Potter. allv. Film Victoria. Tasmanian Film Corporation. 1979. 5 min. sound. color. order by title. buy: (series) Australian $813. rent: Australian $50 per screening, plus freight. prev. series: Craft as a Liveli-

hood.

Part of a series produced for the Victorian Crafts
Council, these productions cover a wide range of
craft occupations and are intended for teaching
appreciation of the skills required in the various
careers. In this production, the viewer sees Greg
hand-building plates while he discusses his life-
style.

WAISLER, LEE

W002 Art Reviewed. ac. Paul Lion. Pacifica Tape Library.
1981. 30 min. sound. order #KZ1050. buy: $15. series: Media
Rare.

Lee Waisler, a painter who dumped a truckload of
manure in front of the Los Angeles Times in reaction
to an unfavorable review of his paintings, discusses
art reviews with Paul Lion.

WARHOL, ANDY

W003 Andy Warhol. 16mm., allv. Blackwood Productions. 1973.
53 min. sound. color. order by title. buy: $690. rent: $90.
prev. with intent to purchase.

Narrated by the artist and others, this film
portrait focuses on Warhol and his repertoire of
activities. One of the major innovators of the Pop
Art movement of the 1960's, Warhol took his
inspiration direct from the world of commerce. He
turned out works factory-style, even having others
sign his name to paintings. His innovation has not
stopped there, since he is shown also to be a
filmmaker and the creator of a magazine Interview.

W004 Andy Warhol. 16mm. Canyon Cinema. 197?. 18 min. silent.
b&w. order by title. rent: $15.

This silent film documents Andy Warhol's work.

W005 Super Artist, Andy Warhol. 16mm. Canyon Cinema. 1967.
22 min. sound. color. order by title. rent: $30.

This award-winning film documents the world of pop
culture of which Warhol is a part. Henry
Geldzahler, curator of American painting and
sculpture of New York's Metropolitan Museum of Art
discusses the artist's work.

WEED, WALKER

W006 The World and Work of Walker Weed. 16mm. Public Television Library. Indiana University Audiovisual Center. 1970. 28 min. sound. color. order #RSC-759. buy: $360. rent: $12.50. prev.

> The art of Walker Weed reflects the harmony found between himself and his environment. The medium through which Weed communicates is wood, making everything from skis to furniture. He also teaches at Dartmouth College where he invites students to his home as part of the educational experience. Weed's style is influenced by the "sympathetic" designs of the Scandinavian wood-workers.

WEINER, EGO

W007 Ego Weiner. 16mm., vc:3/4. Peter Weiner. 1983?. 60 min. sound. color. order by title. buy: $800. rent: $75.

> The main focus of this production is the Austrian-born sculptor, Weiner. Several generations of the sculptor's family are traced, illustrating the influences upon him by his family and by others. Scheduled for 1983 release.

WESTON, EDWARD

W008 How Young I Was. 16mm. WNET/13. Indiana University Audiovisual Center. 1965. 30 min. sound. b&w. order #RS-643. buy: $250. rent: $9.50. prev. series: Photography: The Daybooks of Edward Weston. CA.

> The philosophy of Edward Weston, his doubts, his beliefs, and above all his constant growth are reflected in his writings, which he called his "Daybooks." Quotes from these writings are utilized to explain the feelings of the photographer as the viewer examines works from his soft-focus portrait period, his abstract motifs, and his work done in Mexico. Family members and a former student discuss and evaluate the artist and their relationships to him.

W009 The Strongest Way of Seeing. 16mm. WNET/13. Indiana University Audiovisual Center. 1965. 30 min. sound. b&w. order #RS-664. buy: $250. rent: $9.50. prev. series: Photography: The Daybooks of Edward Weston. CA.

> To Edward Weston, the strongest way of seeing was the minimal way. He never tried to express his personal views through photography; he looked at the

world with no preconceived ideas. The quality of
his work is a reflection of this simplicity, seen in
his study of Point Lobos, California, his record of
the United States West, his cat-portraits, and his
civil defense series.

WHEELER, DENNIS

W010 Revolve. vc:3/4. Nancy Holt. Art Metropole. 1977. 75
min. sound. b&w. order by title. buy: $600. rent: $75.
single play, $400. multiple play.

An intimate and haunting interview with Canadian
artist, Dennis Wheeler, discussing his fight with
remissive leukemia and his proximity to death.
Wheeler died on November 8, 1977.

WHITMAN, ROBERT

W011 LACMA Art and Technology Project. ac. Pacifica Tape
Library. 1971. 80 min. sound. order #BB4458.07. buy: $17.
series: Art and Technology.

Performance artist Robert Whitman and John Fonkner
are interviewed.

WHITNEY, JOHN

W012 Experiments in Motion Graphics. 16mm. John Whitney.
Pyramid Film & Video. 1968. 13 min. sound. color. order by
title. buy: $275. rent: $35. prev. by arrangement. CA, SY.

John Whitney narrates and explains the processes
involved in programming and animating his designs.
He discusses his methods of creating images that
"impinge upon emotions and feelings directly," and
predicts that one day the art of computer graphics
will be a regular part of television programming.
Whitney's informal explanation makes an instructive
introduction to the abstract or kinetic film.

WHITE, CHARLES

W013 A Black Artist Speaks. ac. Pacifica Tape Library. 1969.
48 min. sound. order #BB2132. buy: $13.

Charles White, black graphic artist, spoke at
Merritt College in Oakland, California, in 1968.
White considered the reality of "paying dues" in
America, the black struggle and the black artist in
relation to ideological unity and a sense of worth.

A question and answer period follows the address.

WIEGHORST, OLAF

W014 Olaf Wieghorst: Painter of the American West. 16mm.,
allv. OW Productions. The Nostalgia Merchant. 1978. 53 min.
sound. color. order by title. buy: 16mm./$575, vc:3/4/$450,
vc:b or vc:v/$39.95.

An autobiographical film by Western artist, Olaf
Wieghorst. Alive during America's expansionist
period, Wieghorst recalls his days with the U.S.
Cavalry chasing Pancho Villa, his career as a
mounted policeman, and his rugged life on the
frontier. A self-taught artist, Wieghorst paints
from his memories of these episodes.

WILCHUSKY, LE ANN BARTOK

W015 Skyworks, The Red Mile. 16mm. Canyon Cinema. 1973. 9.5
min. sound. color. order by title. rent: $15.

Documentary of conceptual artist Le Ann Bartok
Wilchusky's "Skyworks, The Red Mile," dropped from
a seventy-five hundred foot altitude with skydivers
over the Pennsylvania countryside. This "Dropped
Object" unrolled in free fall creating a line one
mile long.

W016 Skyworks, Wind & Fire. 16mm. Canyon Cinema. 1975. 8
min. sound. color. order by title. rent: $15.

This film of a conceptual artist's work is a
document of Skyworks but is also intended to be
expressive as an art film. Shows "Dropped Objects"
falling at the rate of 120 to 135 miles per hour
from eight-thousand feet of altitude.

WILKE, HANNAH

W017 Hannah Wilke Interview. vc:3/4. ARTDOC/NY, Queens Col-
lege. Ronald Feldman Fine Arts, Inc. 1975. 22 min. sound.
color. order by title. buy: $175. rent: $50. prev. on
premises only.

This tape is a part of a video project documenting
New York art trends. Hannah Wilke is interviewed in
the Ronald Feldman Gallery. Her exhibition of latex
pieces and gum sculpture is shown as is the artist
working in her studio.

WILLIAMS, GERRY

W018 <u>American Potter</u>. 16mm. Charles Musser. Daniel Clark
Film Library. 1976. 36 min. sound. color. order by title.
buy: $440. rent: $49. (plus $5 handling). prev.

This film discusses the development of Gerry
Williams' psyche and work, showing the increased
interest in American crafts and considering the
implications of this increased interest. It is built
around four themes: Williams' roots, his mastery of
traditional techniques, his expansion using modern
technology, and his social and ecological concerns.

WILLINK, CAREL

W019 <u>Carel Willink, an Imaginative Realist</u>. 16mm. Paul Huf.
Consulate General of the Netherlands. 1976. 30 min. sound.
color. order by title. rent: free loan. prev.

Willink, then a student of architecture, decided to
become a painter in 1919. In the early twenties he
painted abstract, somewhat cubist compostions, later
developing a highly personal style, an interplay of
symbols and reality. Willink is now considered to
be an imaginative realist.

WILSON, MAY

W020 <u>Woo Who? May Wilson</u>. 16mm. Amalie R. Rothschild. New
Day Films. 1969. 33 min. sound. color. order by title. buy:
$400. rent: $40 + $4 handling. prev. CA.

When her husband informs her that his future plans
no longer include her, May Wilson, a sixty-year-old
housewife and grandmother, moves to New York City
and begins the painful process of working out a new
life in which her artwork, once a hobby, becomes
central. With humor and insight the film shows her
acquiring new friends and a self-image in which she
can accept herself as an artist, and we watch her
gain success as "Grandma Moses of the Underground
Artworld."

WITKIN, ISAAC

W021 <u>Sculpture by Isaac Witkin</u>. 16mm. vc:3/4. Cinetudes
Films. 1977. 25 min. sound. color. buy: $350. rent:
16mm./$50, vc/$60. prev. on premises only.

This production is a portrait of the sculptor and
his work. In it we see Witkin in each phase of his
process: from the purchase of materials through

various stages of construction; to exhibitions, where the camera explores his sculptures as the eye of the viewer; to the final installation of a large piece at the home of a private collector. Throughout the film runs an interview with Witkin and several other interviews with museum officials and private collectors.

WRIGHT, DAVID

W022 David Wright: Stained Glass Worker. allv. Film Victoria. Tasmanian Film Corporation. 1979. 5 min. sound. color. order by title. buy: (series) Australian $813. rent: Australian $50 per screening, plus freight. prev. series: Craft as a Livelihood.

Part of a series produced for the Victorian Crafts Council, these productions cover a wide range of craft occupations and are intended for teaching appreciation of the skills required in the various crafts fields. Here, David Wright explains that he does everything himself from design, to production, to installation of the finished glass works. This level of involvement gives him great control over the quality of the finished work.

WRIGHT, FRANK LLOYD

W023 Chicago Dynamic. ac. Pacifica Tape Library. 1957. 39 min. sound. order #BB1974. buy: $15.

A dialogue between Frank Lloyd Wright and Carl Sandburg, moderated by Alistaire Cooke. Recorded at the Chicago School of Architecture.

W024 Frank Lloyd Wright at Berkeley. ac. Pacifica Tape Library. 1957. 80 min. sound. order #BB1972. buy: $17.

In a dialogue with other architects, Wright proclaims the mediocrity of most architecture which he claims is based on quantitative concerns and which lacks inspiration. He makes many critical comments regarding the outside structuralism of 19th century buildings, the works of such architects as Le Courboisier and Van der Rohe, urbanism, the educational process, and building codes. He also discusses his refusal to join the American Institute of Architects.

W025 Wright's Legacy. ac. Pacifica Tape Library. 1969. 59 min. sound. order #BB2794.06. buy: $15.

Wright's one-man show at the Ecole des Beaux-Arts in Paris received official recognition from the American Institute of Architects in the form of a gold medal. His acceptance speech before the AIA is heard in its entirety.

W026 An Address to Students at Berkeley. ac. Pacifica Tape Library. 1957. 39 min. sound. order #BB1973. buy: $15.

The architect discusses the future and the function of architecture in society. He stresses the importance of nature and of "organic" architecture. The sound quality on this tape is suitable for research only.

WYETH, ANDREW

W027 The Real World of Andrew Wyeth. 16mm., allv. London Weekend Television. Films for the Humanities. 1981. 63 min. sound. color. order #FFH 178. buy: 16mm./$975, vc/$299. rent: $65. prev.

Explores the work of the American painter, Andrew Wyeth. He discusses his life and philosophy in interviews at his homes in Pennsylvania and Maine. The artist explains how events in his childhood shaped his life and his art. The production also interviews several people who have been the subjects of his paintings. An award-winning film.

W028 The Wyeth Phenomenon. 16mm. Columbia Broadcasting System, BFA Educational Media. Indiana University Audiovisual Center. 1967. 25 min. sound. color. order #RSC-764. rent: $12. prev.

Considers the reactions of the public and the critics to the works of Andrew Wyeth and his family members, N.C. and Jamie. Interviews his son and sister at the family home in Pennsylvania, where works of the three Wyeths are shown and discussed.

YY

YOUNG, DOROTHY

Y001 The World and Work of Dorothy Young. 16mm. PTL. Indiana University Audiovisual Center. 1970. 30 min. sound. color. order #RSC-752. buy: $360. rent: $12.50. prev. series: World of the American Craftsman. CA.

Dorothy Young is a weaver. Throughout this film she discusses the role that weaving has played in her life and in the life of her husband, Dr. Lloyd Young. She started weaving while at Keene State College in New Hampshire where Dr. Young was president. Dorothy Young likes using natural reeds and grasses in her work and is seen gathering and using these materials. After retirement Dr. Young also began weaving, the couple living in harmony with each other and with nature.

YOUNGERMAN, JACK

Y002 Jack Youngerman. vc:3/4. Sharon Blume and Mary Wayne Fritzsche for The Buffalo Fine Arts Academy/Albright-Knox Art Gallery. SUCB Film Library. 1980. 10 min. sound. color. order by title. buy: $100. rent: $40. prev. tape with excerpts from several programs avail. on request.

Often associated with the Color Field painters of the sixties including Frank Stella, Kenneth Noland, Morris Louis, Ellsworth Kelly and others, Youngerman combines European and American sources in work that is highly original. Youngerman's large scale canvases evoke a kind of lyrical romanticism based on intuitively derived relationships of shape, surface, color and edge. Taped at Youngerman's New York studio and including views of recent paintings and sculpture. This interview, by Mary Wayne Fitzsche and Sharon Blume is scheduled for 1984 release.

ZZ

ZAIR, AZGUR

Z001 Azgur Zair Interview: Part 1, Part 2, Part 3. ac. Pacifica Tape Library. 1981. Part 1, 60 min.; Part 2, 60 min.; Part 3, 45 min. sound. order #AZ0549, #AZ0570, #AZ0571. buy: $15. each. series: The Soviet Union: A Closer Look.

The seventy-three year old sculptor Azgur Zair discusses Communism, his models, and events in his life. In Russian and English.

ZAKANITCH, ROBERT S.

Z002 Robert S. Zakanitch. 16mm., vc:3/4. Elliot Caplan. Filmmakers' Cooperative. 1982. 20 min. sound. color. order

by title. buy: 16mm./$1000, vc/$500. rent: $100.

The film features recent compositions characterized
by bold decorative floral patterns, bravura
painting, and daring color combinations. The energy
in Zakanitch's work is disciplined by visual
cadences, subtle intricacies of pattern and a sense
of proportion. Included in the film are interviews
with the artist as well as a portrait of the painter
at work.

ZUCKER, JOE

Z003 Joe Zucker. vc:3/4. Sharon Blume and Susan Krane for
The Buffalo Fine Arts Academy/Albright-Knox Art Gallery.
SUCB Film Library. 1982. 14 min. sound. color. order by
title. buy: $100. rent: $40. prev. tape with excerpts from
several programs avail. on request.

In the teeth of then prevailing winds of austere,
intellectual formalism, Joe Zucker in 1969 began
making paintings which in the words of Albright-Knox
Curator, Susan Krane, "appeared to have crossed over
from the wrong side of the tracks." His raucous
color, idiosyncratic imagery and unothodox method of
using paint-soaked balls of cotton like mosaic tes-
serae all signalled a presence to be reckoned with
on the contemporay American art scene. This tape
includes scenes of Zucker's unique process shot in
the artist's studio and an interview by Susan Krane.

ENTRIES FOR MULTIPLE ARTISTS

11

1001 <u>American Art in the Sixties.</u> 16mm., allv. Blackwood
Productions. 1973. 57 min. sound. color. order by title.
buy: $875. rent: $125. prev. with intent to purchase.

Through interviews with several critics and through
visits and discussions with the artists themselves
this film reflects the tone of the affluent 1960's
when the practitioners of art had no pretensions of
transcending everyday life; they intensified what
was already familiar. Interviewed are Carl Andre,
Ron Davis, Dan Flavin, Sam Francis, Helen
Frankenthaler, Ed Kienholz, Robert Irwin, Jasper
Johns, Donald Judd, Ellsworth Kelly, Roy
Lichtenstein, Morris Louis, Kenneth Noland, Claes
Oldenburg, Jules Olitski, Robert Rauschenberg, Larry
Rivers, Ed Ruscha, George Segal, Frank Stella, Andy
Warhol, Jack Youngerman and John Cage, Leo Castelli
and Clement Greenberg.

1002 <u>American Songfest.</u> 16mm. Morton Schindel in association
with C.B. Wismar. 1976. 42 min. sound. color. order #MP425.
buy: $500. rent: $40. prev. SY.

Host Robert McCloskey escorts viewers through this
songfest of folklore and history based on films
adapted from four outstanding American picture
books. The viewer visits the homes and studios of
folksinger Pete Seeger and illustrators Steven
Kellogg, Robert Quackenbush and Peter Spier. Films
adapted from their books are presented in portions
or in their entirety.

1003 <u>The Americans: 3 East Coast Artists.</u> 16mm. Forma Art Associates. 1963. 19 min. sound. color. order #8303. buy: $450. Rent: $55 per 3 days, $15 per addl. day. (rental fee may be applied toward purchase if used for preview). series: Artists at Work.

Hans Hofmann, Milton Avery, Jack Tworkov, at work, explain their art. In this documentary the viewer has a rare opportunity to see and hear Hofmann's explosive method of painting. Milton Avery explains his method of "simplifying," while Jack Tworkov solves the problem of uniting twin canvases by painting a thin line down the divide, making the joint invisible. He tells of his use of a rag for painting to bring him even closer to the canvas than is possible with a brush.

1004 <u>Anatomy of a Mural.</u> 16mm. Rick Goldsmith. 1982. 15 min. sound. color. order by title. buy: request price. rent: request price. prev.

Set against the sounds of Salsa music, these artists transform two blank walls into a vibrant mural reflecting the Latino art and culture of their San Francisco neighborhood. The artists, Carlos Loarca, Betsie Miller-Kusz, and Manuel Villamor, discuss the mural process, the design, and their philosophies about this community-based art form.

1005 <u>Andy Warhol and Roy Lichtenstein.</u> 16mm. WNET/13, New York. Indiana University Audiovisual Center. 1966. 30 min. sound. b&w. order #RS-654. rent: $9.50. series: Artists.

Shows Warhol and Lichtenstein as they discuss their use of everyday objects as subjects for art. Lichtenstein creates a painting and a sculpture which he discusses as he works. Warhol explains his silk-screen prints, his "floating sculpture," and discusses Pop Art in general.

1006 <u>The Animators.</u> 16mm. David S. Weinkauf. 1984?. 60? min. sound. color. order by title. buy: request price. rent: request price. prev.

Deals with animation techniques and the people responsible for developing and using those techniques. The film also concentrates on the lives and interests of the animators George Nicholas and Joan Orbison and the story person Ralph Wright. Scheduled for 1984 release.

1007 Anthology 1980. vc:3/4. Al Razutis. Video Out. 1980. 25 min. sound. color. buy: $350 for life of tape. rent: $50 single play; $200 multiple play. prev.

This tape is a collection of interview fragments, flashbacks and excerpts from film, videotapes and holographic work. It was created for the Canadian Film-Makers Distribution Center as a "Portrait of the Artist and His Work."

1008 Architecture vs. Non-architecture. ac. Bonnie Bellow. Pacifica Tape Library. 1971. 61 min. sound. order #BC0288. buy: $15.

Panel discussion by architects and architectural students. Recorded at Emanu-el Midtown in New York.

1009 Art & The Prison Crisis. allv. Mark Schwartz and Eric Thiermann. Impact Productions. 1981. 27 min. sound. color. order by title. buy: vc3/4:$100, vcl/2:$50. rent: $33. prev.

Photographed in penal institutions throughout the State of California, this production depicts the activities, perspectives, and artwork of inmates whose lives have been changed by art projects in prison. State officials, program directors, and prison administrators verify the statements made in interviews with the artist-inmates, which assert that the experience of punishment can also be an experience of the restoration of humanness.

1010 Art as Social Criticism. ac. Pacifica Tape Library. 1970. 90 min. sound. order #BC0068. buy: $17.

Artists Claes Oldenburg and David Kaprow talk with David Kunzle and Clare Loeb.

1011 Art Careers. 16mm. Irene Zmurkevych. Handel Film Corporation. 1978. 30 min. sound. color. order #A-24. buy: $400. rent: $40. prev. when purchase is considered.

This film interviews commercial artists, sculptors, painters, graphic and industrial designers, photographers, those in museum work, teaching, costume design and crafts. Artists discuss how their training was acomplished, special demands of the various disciplines, and how their work is marketed. CINE Golden Eagle finalist.

1012 <u>Art in Taos: The Early Years</u>. 16mm. Danamar Films.
1979. 28 min. sound. color. order by title. buy: $425.
rent: $58.50. prev.

> Since the 1890's when the first artists arrived in
> Taos, New Mexico, there has been a tradition of
> artists immigrating to this "la Boheme of the
> Rockies." This film presents the history and the
> art of this American art colony in the first half of
> the 20th century. Included are candid interviews
> with Brett and Dasburg.

1013 <u>Art is the Magic.</u> 16mm., allv. Detrick Lawrence. 1979.
29 min. sound. color. order by title. buy: $225. rent: $35.

> This film interviews artists and craftspersons
> participating in New England artists' festivals.
> Concentrates on how they view their art, why they
> have become artists, and the role of the artist in
> modern society.

1014 <u>Art of Central America and Panama.</u> 16mm., allv. Museum
of Modern Art of Latin America. 197?. 29 min. sound. color.
order #8. buy: 16mm./$290, vc/$87. prev. on premises only.
16mm.

> Central American artists are shown with their
> paintings in their native environment. English and
> Spanish narration.

1015 <u>The Art Scene.</u> ac. Pacifica Tape Library. 1969. 49 min.
sound. order #BB2758.03. buy: $15. series: Exploring the
Arts in the Bay Area.

> Knute Stiles, Joe Costello, Henry Sultan, Mark
> Green, and Robert Johnson discuss the San Francisco
> art scene.

1016 <u>Art Since 1945.</u> ac. Pacifica Tape Library. 1961. 42
min. sound. order #BB076. buy: $15.

> Painter Gene Besser and professor Stephen Pepper
> discuss Abstract Expressionism.

1017 <u>Artists and Galleries.</u> ac. Pacifica Tape Library. 1971.
29 min. sound. order #BC172. buy: $13.

> Painters Michael Bowen and Arthur Moore and gallery
> owners Muldoon Elder and Larry Devers discuss
> concerns with Bob Sitton.

1018 Artists at Work: A Film on the New Deal Art Projects.
16mm. Mary Lance. New Day Films. 1981. 35 min. sound. color.
buy: $500 (plus $7 handling). rent: $60 (plus $7 handling).
prev. with intent to purchase from distributor. Other pre-
views on videocassette can be arranged by contacting the
producer.

This award-winning film focuses on the visual arts
programs of the New Deal era. Through historical
footage and present-day interviews with surviving
artists, the film presents a picture of the life and
times of the Depression. Considers the political
and social aspects of the New Deal's "art to the
millions" program. Among the artists interviewed
are Alice Neel, Chaim Gross, Jacob Lawrence, Lee
Krasner, James Brooks, Ilya Bolotowsky, Edward
Laning, Joseph Delaney, Harry Gottlieb, and Joseph
Solman.

1019 Artists Europe. ac. Pacifica Tape Library. 1968. 55
min. sound. order #BB3776. buy: $13.

In Part Two, Marisol is interviewed by Jeanne Siegel
at the Venice Biennial (26 min.), while in Part
Three Antonio Tapies is interviewed in Barcelona (29
min.).

1020 Artists in Residence. ac. Audio Arts. 198?. 60 min.
sound. order by title. buy: ₤4. (plus ₤1.50 handling).
series: Audio Arts Magazine Supplement.

A discussion with Helen Chadwick, Maggi Hambling,
and Ian McKeever with Lesley Greene and Anthony
Reynolds.

1021 Artpark People. 16mm., allv. Blackwood Productions.
1977. 53 min. sound. color. order by title. buy: $690. rent:
$90. prev. with intent to purchase.

Produced during a summer season at the arts-oriented
State Park near Niagara Falls, New York, this film
focuses on the projects created by thirteen artists
working in varying media. The film explores not only
the artworks and their creators, but also the the
natural setting of the park and reaction of the
public to the works created. Includes Lynda
Benglis, Charles Fahlen, Richard Fleischner, Lloyd
Hamrol, Mary Miss, Ree Morton, Pat Oleszko, Sig
Rennels, Jim Roche, Abe Rothblatt, James Surls,
George Trakas and Connie Zehr.

1022 Arts and Crafts. 16mm. Irene Zmurkevych. Handel Film

Corporation. 1979. 28 min. sound. color. order #A-29. buy:
$400. rent: $40. prev. when purchase is considered.

This film interviews artists, both amateur and
professionals, working in the various crafts
disciplines: pottery, basket making, weaving,
spinning, blacksmithing, silversmithing, and others.
Among those interviewed are: Mary Witkop, Jonathan
Krout, Pam Strawn, Liaila Kuchma, Mova Lowe, Elidio
Gonzalez, Ken Anderson, Linda Lasater, Leon Smith,
Jim McNary, Walter Day, Jack Hall, Jack Campbell,
Zenovia Wrzesniewski, Arlene Shemizu, and Dorine
Yoder.

1023 Aspects of Pattern and Decoration. allv. Inner-Tube
Video. 1981?. 30 min. sound. color. order #10. buy: $125.
series: ART/New York: 1981-2 Art Season.

This tape visits the following exhibitions:
"Homework" at the Henry Street Settlement and
"Useable Art" at the Queens Museum, and interviews
the following artists: Miriam Schapiro (4.5 min.),
John Perreault (3.5 min.) and Holly Solomon (3.5
min.).

1024 Ben Heller, Donald Factor, Walter Hopps, Peter Selz,
and Alfred Frankenstein. ac. Pacifica Tape Library. 1966.
118 min. sound. order #B0919.04. buy: $27. series: The
Current Movement in Art, Part 4.

Recorded in San Francisco, this tape is a discussion
with Ben Heller, Donald Factor, Walter Hoops, Peter
Selz, and Alfred Frankenstein.

1025 Beyond Cubism. 16mm., allv. Blackwood Productions.
1978. 58 min. sound. color. order by title. buy: $875.
rent: $125. prev. with intent to purchase. series: Masters
of Modern Sculpture, Part II.

This film shows Henry Moore in his studio near
London, Joan Miro in Paris as well as the
performance artists Gilbert and George in their
Dada-like "living sculptures." Other artists
considered in this second film of a three-part
series include Vladimir Tatlin, Naum Gabo, Antoine
Pevsner, Man Ray, Jean Arp, Max Ernst, Alberto
Giacometti, Barbara Hepworth, Germaine Richier,
Cesar, Gunther Uecker, Heinz Mack, Otto Piene,
Joseph Beuys, Arman, Yves Klein, Daniel Spoerri,
Jean Tinguely, and Anthony Caro.

1026 Bob Irwin and Ed Wirtz on Art and Technology. ac.

Pacifica Tape Library. 1971. 63 min. sound. order #BB4458.01. buy: $15. series: Art and Technology.

Interview by Clare Loeb.

1027 British and American Art: View from the Museum. ac. Pacifica Tape Library. 1968. 39 min. order #BB3427. buy: $13. prev.

Sir John Rothenstein, former director of the Tate Gallery in London, and Thomas Hoving, director of New York City's Metropolitan Museum of Art, discuss the challenge of relating art to practical living, what criteria to use in acquiring work, cooperation between rival museums, and how the museum can and cannot benefit struggling artists.

1028 The Challenge: A Tribute to Modern Art. 16mm. Herbert Kline. New Line Cinema Corporation. 1976. 104 min. sound. color. order by title. buy: $1200 subject to change pending laboratory increases. rent: contact distributor. prev. (subject to availability).

The viewer visits with such artists as Chagall, Henry Moore, Lipchitz, Calder, Nevelson, Oldenburg, Di Chirico, Dali, de Kooning, Soulages, and Motherwell, while other artists are seen in historical footage which shows them at work. Visits are provided to several major collections including the Louvre, The Guggenheim, and the Museum of Modern Art. An Academy Award nominee.

1029 Children of the Northlights. 16mm. Jane Morrison. Weston Woods. 1977. 20 min. sound. color. order #MP426. buy: $275. rent: $20. prev. SY.

Author-illustrators Ingri and Edgar Parin d'Aulaire discuss the philosophy behind their work and the unique process of creating illustrations by using lithographic stones. Animated sequences of their illustrations and excerpts from their own home movies are incorporated into this portrait.

1030 Clay: Living with the Process. Eric Thiermann and Joel Magen. Impact Productions. 1982. 28 min. sound. color. order by title. buy: vc3/4:$100, vc1/2:$50. rent: $33. prev.

This production is a documentary portrait of four coastal California potters: Bruce and Marcia McDougal, Bruce Anderson, Al Johnsen, and Daniel Rhodes. It is the story of these artists' lives and

their medium. Shot in a unique part of the Monterey
Bay with sculpted coastlines and serene forests, the
production demonstrates the interaction between the
artists and their environment.

1031 Click. ac. David Selvin. NPR Publishing. 1979. 59 min.
sound. order #OP-79-08-23. buy: $10. series: Options.

Looks at photography as an important medium for
understanding ourselves and our environment.
Interviews professional photographers, photography
curators, photo-editors, and amateur photo buffs.

1032 Conversations with Creative People Over 70. ac. Connie
Goldman. NPR Publishing. 1980. 59 min. sound. order #OP-80-
06-20. buy: $10. series: Options.

Some well-known personalities discuss their creative
energies and the importance of the artistic
experience to older persons. Among those
interviewed are Josh Logan, Eugene Van Gima, Ethel
Merman, Agnes DeMille, Steve Sacklarian, and Isaac
Bashevis Singer.

1033 Courage to Create. ac. Carolyn Jensen and Tom Steward.
NPR Publishing. 1978. 118 min. sound. order #SP-78-04-29.
buy: $20. series: Special.

Dr. Rollo May discusses the discipline and the
inspiration behind the creativity shown by artists,
actresses, musicians, and photographers.
Participants include Jeanne Moreau, Lorin Hollander,
Henri Cartier-Bresson, Jean-Pierre Rampal, George
Shearing, and Ernest Nysvestni.

1034 The Crisis in Professionalism. ac. Audio Arts. 1978.
60? min. sound. order by title. buy: ₤40 for series of 16
tapes (plus ₤1.10 each for handling). series: The State of
British Art: A Debate.

The series of which this tape is a part is a
complete unedited recording of the debates that took
place at the Institute of Contemporary Art in
February 1978. This tape, documenting British
contemporary art of the late 1970's, features
Richard Cork, Peter Fuller, Robyn Denny, Mary Kelly
and Rene Gimpel.

1035 Cross-Overs: Series on Photographers. vc:3/4. Carole
Ann Klonaraides and Michael Owen. Artists Television Net-
work. 1981-82. 22.5 min. (segments can be viewed separately

or as one program.) sound. color. order by title. buy: re-
quest price. rent: request price. prev.

> This is a set of three segments with artists who
> work in media other than video or television. The
> subject for the tapes is the artists themselves.
> Designed for a television-viewing audience, the
> production uses recognized televion formats, such as
> the talk-show interview, sixty-minute editions, the
> commercial, the film teaser, and the public service
> announcement. In this way art ideas are made more
> accessible to a larger public than through
> galleries, museums and art periodicals. Includes:
> Laurie Simmons--A Teaser (5 min.), Richard Prince--
> Editions (7.5 min.), and Cindy Sherman--An Interview
> (10 min.).

1036 Culture as Nature. 16mm., allv. BBC. Time-Life Video.
1980. 62 min. sound. color. order 16mm./#F2341,
3/4vc./#V2066, 1/2vc./#V9615. buy: 16mm./$850, 3/4vc/$200,
1/2vc/$150. rent: $100. prev. series: The Shock of the New.

> Considers the use of the man-made world, as opposed
> to the natural world, as the subject for art. The
> production focuses in particular on Pop Art, but
> also explores the Dadaists and the Surrealists in
> this context. Discusses Johns, Rauschenberg,
> Warhol, Lichtenstein, Rosenquist, Oldenburg and
> others.

1037 Dada. 16mm., allv. Procine for the Ministry of National
Education of Belgium. International Film Bureau, Inc. 1969.
31 min. sound. b&w. order by title. buy: $16mm./$375,
vc/$285. rent: $25 (16mm. only). prev. SY.

> Max Ernst, Gabriel Buffet, Marcel Duchamp, and Man
> Ray appear in live interviews to explain the meaning
> and origin of the Dadaist movement. Duchamp
> discusses the 1913 Armory Show and the subsequent
> uproar over his "Nude Descending a Staircase."

1038 Declarations of Independents. vc:3/4. Robin Reidy and
Bill Thompson. CCTV, Georgia State University. 1983. 28.5
min. sound. color. rent: contact distributor.

> Nine independents (Joan Churchill, Karen Cooper,
> Kathleen Dowdey, Gayla Jamison, Chip Lord, Mark
> Rappaport, John Sanborn, Bill VanDerKloot and Gene
> Youngblood) describe their community of film and
> video artists who work with tools of the mass media
> to create very personal visions. Examples of their
> work illustrate those visions.

1039 <u>Directions</u> <u>in</u> <u>Painting.</u> allv. Inner-Tube Video. 1982?. 30 min. sound. color. order #12. buy: $125. series: ART/New York: 1981-2 Art Season.

This tape visits the following exhibitions: Frank Stella at Knoedler Gallery, David Salle at Mary Boone and Leo Castelli galleries and Leon Golub at Susan Caldwell Gallery. It provides interviews with David Salle (3.5 min.) and Leon Golub (4 min.).

1040 <u>An Eames Celebration:</u> <u>Several</u> <u>Worlds</u> <u>of</u> <u>Charles</u> <u>and</u> <u>Ray</u> <u>Eames.</u> 16mm. WNET/13, New York. Indiana University Audiovisual Center. 1975. 90 min. sound. color. order #RSC-977. buy: $770. rent: $27. prev. CA.

This film profiles Charles and Ray Eames, a creative couple renowned for their design work. Their design efforts are broad in scope, including: architecture, filmmaking, science, communications, painting, and furniture design--most notably "The Eames Chair." Included are excerpts from a number of their films, views of major exhibits, a visit to their home, and comments from colleagues. A Red Ribbon Winner, 1977 American Film Festival. Produced and directed by Perry Miller Adato.

1041 <u>Educating</u> <u>Women</u> <u>Artists.</u> ac. Pacifica Tape Library. 1971. 57 min. sound. order #BC0260. buy: $15.

Judy Chicago and Miriam Schapiro talk with Clare Loeb.

1042 <u>Encre.</u> 16mm. Jean Cleinge. International Film Bureau, Inc. 1972. 20 min. sound. color. order by title. buy: $265. rent: $15. SY.

Without narration, this film visits a lithographer's shop in Paris where Appel, Ting, and Alechinsky demonstrate their own unique approaches to the same medium, lithography.

1043 <u>End</u> <u>of</u> <u>the</u> <u>Art</u> <u>World.</u> 16mm. vc:3/4. Alexis Krasilovsky. Canyon Cinema, Film-Makers' Cooperative, video direct from producer only. 1971. 35 min. sound. color. order by title. buy: 16mm./$1200, vc/$500. rent: $60.

Provides a look at the contemporary art scene in a style characteristic of the artists whose esthetics it explores. Interviews Jo Baer, Jasper Johns, Joseph Kosuth, Roy Lichtenstein, Robert Rauschenberg and others.

1044 Erotic Art by Women. ac. Pacifica Tape Library. 1975.
43 min. sound. order #BC2255. buy: $15.

 A panel discussion by sculptors Hannah Wilke and
Louise Bourgeois, photographer Irene Stern, collage
maker Ann Sharp, and artist Judith Bernstein;
moderated by Judith Vivel.

1045 Esso Salon of Young Artists. 16mm., allv. Museum of
Modern Art of Latin America. 1965. 16 min. sound. color.
order #6. buy: 16mm./$160, vc/$48. prev. on premises only.

 A selection of the works of prize-winning artists at
the Esso Salon of Young Artists, filmed at the
Organization of American States in Washington, DC.
The narration is in Spanish.

1046 Feminist Art Workshop. ac. Pacifica Tape Library.
1975?. 46 min. sound. order #BC1429. buy: $15.

 A discussion with Judy Chicago, Sheila de
Brettville, and Arlene Raven.

1047 Feminist Issues in Contemporary Art. ac. Audio Arts.
1978?. 60? min. sound. order #Volume 4 Number 1. buy: ₺4.00.
(plus ₺1.10 handling). series: Audio Arts Magazine.

 American writer Lucy Lippard and British artist
Margaret Harrison compare, analyze and discusss what
it means to be an artist and a woman in British and
American society today. An informative background
is also given of women artists' groups in both
countries.

1048 Fibrecrafts of Aurukun. allv. National Museum of Victo-
ria. Tasmanian Film Corporation. 1980. 18 min. sound.
color. order by title. buy: 16mm./Australian $360,
vc/Australian $225. rent: Australian $50 per screening,
plus freight. prev.

 Annie Kalkeyorta and her sister-in-law Neeym
Yunkaporta, two highly skilled artisans, demonstrate
the collecting and dyeing of Livistona fibre and the
making of two-ply string from the fibre. The
manufacture of the four kinds of string bags made at
Aurukun is also shown.

1049 Fire and Ice and Visions of Light: The Crafting of Art
Glass. ac. Mary Lou Finnegan. NPR Publishing. 1980. 29 min.

sound. order #SP-80-11-20. buy: $9. series: Special.

The program includes interviews with expert designers and craftsmen, who examine each step of the glassmaking process, discuss the relationship of art to craft, and describe the feeling collectors of fine glassware have for this highly technical, enduring art form.

1050 First Look. 16mm. Kavery Dutta. River Films. 1983. 60 min. sound. color. order by title. buy: $900. rent: $130. prev.

Tells the story of young painters in Cuba and follows two as they travel to the United States. Artists included in Cuba are Wilfredo Lam, Mariano Rodriguez, Antonia Eiriz, Aldo Menendez, Nelson Dominguez, Eduardo Roca, Tomas Sanchez, Adelaida Herrera, Flora Fong, Manuel Mendive, Flavio Garciandia, Jose Bedia, and Pedro Pablo Oliva. American artists included are Ana Mendieta, James Rosenquist, Alice Neel; Latin artists Rene Castro, Patricia Rodriguez in San Francisco; black artists Al Loving, Tyrone Mitchell, Charles Abramson in New York. The production shows an important cultural exchange between the artists of these two countries.

1051 Five Artists Billbobbillbillbob. 16mm. Dorothy Wiley and Gunvor Nelson. Canyon Cinema. 1971. 70 min. sound. color. order by title. rent: $60.

This film of five California artists, Bill Wiley, Bob Nelson, Bill Allan, Bill Geis, and Bob Hudson, is a personal look at the lives of these close friends at home with their families, at work in the studio, teaching, fishing, drawing together, at parties and openings. The sound track is a sound-montage of comments and music by the artists mixed with personal impressions by friends and others.

1052 5 British Sculptors Work & Talk. 16mm. Forma Art Associates. 1965. 28 min. sound. color. order #8304. buy: $450. rent: $55 (per 3 days, $15 per addl. day; rental may be applied to purchase).

Reg Butler, Lynn Chadwick, Kenneth Armitage, Barbara Hepworth, and Henry Moore are shown at work. Armitage is seen in his London studio, Chadwick in his castle, Hepworth by the sea, Moore at his studio/home, Hoglands, and Butler near Oxford, "still my playpen." This film is the winner of several major awards.

1053 <u>Five</u> <u>Young</u> <u>Artists</u> <u>From</u> <u>L.A.</u> ac. Pacifica Tape Library.
1970. 59 min. sound. order #BB5220. buy: $15.

 Doug Edge, Jeff Card, Greg Card, Terry O'Shea, and
 Bob Marcks discuss problems of young artists.

1054 <u>Four</u> <u>Women</u> <u>Artists.</u> 16mm. Center for Southern Folklore.
1978. 25 min. sound. color. order by title. buy: $350. rent:
$35. prev.

 A look at the memories, traditions and visions
 guiding the art and lives of four Southern women.
 The film examines novelist Eudora Welty, quilter
 Pecolia Warner, embroiderer Ethel Mohamed and
 painter Theora Hamblett. These women discuss the
 creative spirit that drives all artists. Award-
 winning film.

1055 <u>Fourteen</u> <u>Americans:</u> <u>Directions</u> <u>of</u> <u>the</u> <u>1970's.</u> 16mm.,
allv. Blackwood Productions. 1980. 44 min. (each of 2
parts). sound. color. order by title. buy: $975. rent: $150.
prev. with intent to purchase.

 This film shows the degree of interest in freedom
 and variety which characterizes the Soho artists.
 These young artists are drawn together from across
 the country to live and work in New York's Soho
 district. They live their beliefs in the concept of
 the maximum exploration of their media and their
 techniques. Interviewed are Vito Acconci, Laurie
 Anderson, Alice Aycock, Scott Burton, Peter Campus,
 Chuck Close, Nancy Graves, Joseph Kosuth, Gordon
 Matta-Clark, Mary Miss, Elizabeth Murray, Dennis
 Oppenheim, Dorothea Rockburne and Joel Shapiro.

1056 <u>Frank</u> <u>Stella</u> <u>and</u> <u>Larry</u> <u>Poons:</u> <u>The</u> <u>New</u> <u>Abstraction.</u>
16mm. WNET/13, New York. Indiana University Audiovisual
Center. 1966. 30 min. sound. b&w. order #RS-657. buy: $250.
rent: $9.50 prev. series: Artists.

 These two abstractionist painters are shown in their
 studios painting and discussing their work.
 Instituting innovation by exploiting repetition,
 emptiness and monotony to produce their abstract
 works, Mr. Stella renounced his famous striped
 paintings and is shown producing huge geometric
 polygons which employ sculptural elements, while
 Poons is shown working on his contrapuntal dot
 paintings.

1057 <u>Frank</u> <u>Stella</u> and <u>Phillip</u> <u>Leider</u> <u>with</u> <u>John</u> <u>Fitzgibbon.</u>
ac. Pacifica Tape Library. 1966. 104 min. sound. order
#B0919.06. buy: $27. series: The Current Movement in Art,
Part 6.

> Recorded in San Francisco, this tape is a discussion
> with Frank Stella and Phillip Leider with John
> Fitzgibbon.

1058 <u>From</u> <u>One</u> <u>Struggle</u> <u>to</u> <u>Another.</u> ac. Pacifica Tape
Library. 1972. 71 min. sound. order #BC0605. buy: $17.

> Judy Chicago talks to painter Miriam Schapiro about
> women's participation in the New York art world of
> the 1950's. They refer to their experiences and to
> those of Helen Frankenthaler, Elaine de Kooning and
> Lee Krasner. Schapiro sees an expansion of the
> esthetic and social struggle of women artists.

1059 <u>From</u> <u>Renoir</u> <u>to</u> <u>Picasso.</u> 16mm. Brandon Films, Inc.
Indiana University Audiovisual Center. 1951. 32 min. sound.
b&w. order #RS-393. rent: $9.25. CA, SY.

> Describes characteristics of the work of Renoir,
> Seurat, and Picasso as representive of the schools
> of Sensualism, Intellectualism, and Emotionalism.
> Presents historical footage of Picasso and Renoir at
> work.

1060 <u>From</u> <u>the</u> <u>Heart.</u> allv. Gihon Foundation. 1982. 58 min.
sound. color. order by title. buy: request price. rent:
request price. prev.

> Portrays the feminine attitudes and strengths of
> women artists in America. Nine artists: Lynda
> Benglis, Nancy Chambers, Clyde Connell, Janet Fish,
> Hermine Ford, Dorothy Hood, Mary McCleary, Gael
> Stack and Dee Wolff provide the dialogue, which
> ranges from family background and philosophy of art,
> to expressions of self-criticism and success.

1061 <u>The</u> <u>Future</u> <u>That</u> <u>Was.</u> 16mm., allv. BBC. Time-Life Video.
1980. 52 min. sound. color. order 16mm./#F2340,
3/4vc/#V2059, 1/2vc./#V9608. buy: 16mm./$850, 3/4vc/$200,
1/2vc/$150. rent: $100. prev. series: The Shock of the New.

> Considers the death of the idea of the Modernist
> movement. Without the tension of the Academy versus
> the Avant-Garde, the production suggests that
> traditional struggles are fragmented. It becomes
> difficult to discern the direction of trends, if any
> do exist.

1062 <u>Geometric</u> <u>Abstraction.</u> allv. Inner-Tube Video. 1982?.
30 min. sound. color. order #17. buy: $125. series: ART/New
York: 1982-3 Art Season.

 This tape includes visits to the following
 exhibitions: Al Held at the Andre Emmerich Gallery,
 Sol LeWitt at the John Weber and Barbara Toll
 galleries, and Brice Marden at Pace Gallery, as well
 as interviews with Al Held (4 min.) and Brice
 Marden (4 min.).

1063 <u>The</u> <u>Gift.</u> 16mm. Chuck Olin. First National Bank of
Chicago. Indiana University Audiovisual Center. 1975?. 30
min. sound. color. order #RSC-880. rent: $6.

 Describes the collaboration between Marc Chagall and
 Michel Thurin to produce a mosaic which was
 presented as a gift to the people of Chicago.
 Includes a discussion by the curator of the Chagall
 Museum about how difficult it is to adapt works of
 art from one medium to another. The mosaic,
 entitled, "The Four Seasons," decorates the First
 National Bank of Chicago.

1064 <u>Hannah</u> <u>Wilke/Jackie</u> <u>Winsor.</u> vc:3/4. The Buffalo Fine
Arts Academy/Albright-Knox Art Gallery. SUCB Film Library.
1976. 8 min. sound. b&w. order by title. buy: $100. rent:
$40. prev. tape with excerpts from several programs avail.
on request.

 Installation-in-progress views of "Four for the
 Fourth," a bicentennial event at the Albright-Knox
 Art Gallery on July 4, 1976. Included are Wilke's
 chewing gum sculpture workshop and her
 reinterpretation of the Gallery's classical caryatid
 porch using photomannequins of herself. Winsor is
 seen constructing a modular sculpture out of wood.
 Videotaped by HALLWALLS staff. Exhibition Curator,
 Linda L. Cathcart.

1065 <u>Harold</u> <u>Rosenberg</u> and <u>Peter</u> <u>Voulkos</u> with <u>Fred</u> <u>Martin</u> and
<u>Charles</u> <u>Maddox.</u> ac. Pacifica Tape Library. 1966. 104 min.
sound. order #B0919.01. buy: $27. series: The Current Move-
ment in Art, Part 1.

 Recorded in San Francisco, this tape is a discussion
 with Harold Rosenberg and Peter Voulkos, Fred
 Martin and Charles Maddox.

1066 <u>The</u> <u>Idea</u> <u>of</u> <u>the</u> <u>Symposium.</u> ac. Pacifica Tape Library.

1966. 30 min. sound. order #B0919.07. buy: $13. series:
The Current Movement in Art, Part 7.

Recorded in San Francisco, this tape is an interview
of Fred Martin by Erik Bauersfeld.

1067 Ideology & Consciousness. ac. Audio Arts. 1977. 60?
min. sound. order #Volume 3 Number 3. buy: ₺4 (plus ₺1.10
handling). series: Audio Arts Magazine.

This issue of Audio Arts Magazine considers three
major topics: "Art and Politics," discussed by
Conrad Atkinson, the "Free International University
for Creativity and Interdisciplinary Research,"
founded by Joseph Beuys and activated in England by
Caroline Tisdall, and "Women's Practice in Art"
featuring discussion between Mary Kelly and Susan
Hiller.

1068 Images of People. ac. Audio Arts. 1978. 60? min. sound.
order by title. buy: ₺40 for series of 16 tapes (plus ₺1.10
each for handling). series: The State of British Art: A
Debate.

The series of which this tape is a part is a
complete unedited recording of the debates that took
place at the Institute of Contemporary Art in
February 1978. This tape, documenting British
contemporary art of the late 1970's, features
Richard Cork, Terry Atkinson, Reg Butler, Lisa
Tichner, Joseph Herman and Victor Burgin.

1069 Interstate 80 Art Gallery. ac. Pacifica Tape Library.
1975?. 57 min. sound. order #BC2694. buy: $15.

Bradford Graves, Linda Howard, and Steven Urry talk
with Paul von Ringelheim about their project to
produce sculpture for 2920 miles of highway.

1070 Italian Stone. vc:3/4. Appalshop, Inc. 1982. 28 min.
sound. color. order by title. buy: $150. prev. restricted
to segments of the program.

Italian immigrant stonemasons who spoke no English
on arrival, Francesca and Dominic Monjiardo, learned
the American ways of Eastern Kentucky and West
Virginia. The buildings constructed by these men
and their families, their tools, techniques and
their values are the subject of this production.

1071 It's a Lot Like Love. ac. Pacifica Tape Library. 197?.

25 min. sound. order #BC2322. buy: $13.

Artist Larry Rivers and poet Kenneth Koch discuss their collaboration.

1072 It's One Family: Knock on Wood. 16mm., allv. Tony De Nonno. De Nonno Pix, Inc. 1982. 23:30 min. sound. color. order by title. buy: $425. rent: $55. prev. 16mm. only.

In this film we meet puppeteers Mike and Ida Manteo, their children and grandchildren, a family bound together by a Sicilian folk tradition that dates back to the sixteenth century. At 72 Mike still builds marionettes, while his sister Ida sews capes and gowns.

1073 Japan: The New Art. 16mm., allv. Blackwood Productions. 1971. 28 min. sound. color. order by title. buy: $550. rent: $60. prev. with intent to purchase.

Japan's cultural and natural landscape pervade this documentary of some of that country's adventurous young artists, including sculptor Jiro Yoshihara and the Gutai group, Nobuo Sekine, critic Ree Woo Fon, and Katsuhiku Narita who uses sumi logs in a sculptural way. Edward Fry's comments in English help explain these esthetic explorations.

1074 Kinetic Art in Paris. 16mm., allv. Universal Education and Visual Arts. 1971. 27 min. sound. color. order #6266. buy: $325. rent: $33 (3 day rental). prev. series: Museum Without Walls.

This film presents the experiments of contemporary French artists who are exploring creative applications of new materials that alter and manipulate light and movement. The works of Le Parc, Yvaral, Vasarely and others are presented. Also included are interviews with artists in which they describe their artistic philosophies and objectives.

1075 Kinetic Sculpture. ac. Pacifica Tape Library. 1966. 97 min. sound. order #BB1981. buy: $19.

A panel discussion with Harry Kramer, Len Lye, and George Rickey: moderated by Peter Selz. Recorded at U.C., Berkeley.

1076 The Kinetic Sculpture of Gordon Barlow. 16mm. Rainbow Productions. Perspective Films. Indiana University

Audiovisual Center. 1974. 7 min. sound. color. order #RSC-908. rent: $5.75.

Barlow used his knowledge of the design and engineering of mechanical toys to design interesting moving sculptures. Shown in the film are a "Domino Machine" which creates shifting patterns, and and "Behavioral Sink" in which colored balls climb through plastic cubes.

1077 Kites. 16mm., allv. Compass Films. Lucerne Films, Inc. 1980. 28 min. sound. color. order by title. buy: 16mm./$450, vc/$350. rent: $45. 16mm. prev.

Considers the makers of kites as designers and artists in different historical and cultural contexts. Eastern cultures associate kites with ritual and ceremony, while in the West the emphasis has been on abstract shapes developed for scientific and aeronautical experiments.

1078 The Land of Enchantment: New Mexico Arts and Artists. ac. Connie Goldman and John Weber. NPR Publishing. 1981. 29 min. sound. order #NJ-81-11-08. buy: $9. series: NPR Journal.

Considers the cultural phenomenon of Santa Fe, with its opera, repertory theater, and dance company. Local artists talk about their art and how the region nourishes and shapes it. They also discuss the beauty and simplicity of the surrounding area, the diversity of its cultures, and the strong spiritual influence that seems to pervade the environment.

1079 The Landscape of Pleasure. 16mm., allv. BBC. Time-Life Video. 1980. 52 min. sound. color. order 16mm./#F2342, 3/4vc./#V2060, 1/2vc./#V9609. buy: 16mm./$850, 3/4vc/$200, 1/2vc/$150. rent: $100. prev. series: The Shock of the New.

This production focuses upon the representation by the artist of sensual pleasure in his work. Such pleasure is apparent in works by Braque, Picasso, Cezanne, Gauguin, Derain and Matisse, and is central to the works of the painters of the Impressionist School.

1080 Larry Poons, Roy Lichtenstein, and Frank Stella with Harry (sic) Geldzahler. ac. Pacifica Tape Library. 1966. 109 min. sound. order #B0919.05. buy: $27. series: The Current Movement in Art, Part 5.

Recorded in San Francisco, this tape is a discussion with Larry Poons, Roy Lichtenstein, and Frank Stella with Henry Geldzahler.

1081 Live to Air: Artist Sound Works. ac. Audio Arts. 1981?. 180? min. sound. order #Volume 5 Number 3 and 4. buy: Ƚ12 for set of 3 tapes (plus Ƚ3.60 for handling). series: Audio Arts Magazine.

Vito Acconci, Yura Adams, Jacki Appel, Art & Language, F. Uwe Laysiepen/Marina Abramovic, Connie Beckley, Ian Breakwell, Stuart Brisley, Hank Bull, John Carson, Helen Chadwick, David Cunningham, Barbara Ess, David Garland, Rose Garrard, Bob George, Jack Goldstein, Dan Graham, Roberta M. Graham, Adrian Hall, Julia Heyward, Charlie Hooker, Tina Keane, Richard Layzell, Les Levine, Bruce McLean, Tom Marioni, Ian Murray, Maurizio Nannucci, Gerald Newman, John Nixon/Anti Music, Hannah O'Shea, Clive Robertson, Dieter Roth, Arleen Schloss, Madelon Hooykaas/Elsa Stansfield, Rob Summers/VEC, Kerry Trengove, David Troostwyk, Peter Gordon/Lawrence Weiner, Steve Willats, Silvia C. Ziranek.

1082 The Lively Art of Picture Books. 16mm. Morton Schindel under the auspices of the Children's Division of the American Library Association. Weston Woods. 1964. 57 min. sound. color. order #MP405. buy: $500. rent: $40. prev. SY.

Author/singer John Langstaff hosts this filmed presentation that has heightened the enjoyment and appreciation of children's literature for a generation of audiences. Included are two Weston Woods films and interviews with Robert McCloskey, Maurice Sendak, and Barbara Cooney.

1083 The Los Angeles Fine Arts Squad. allv. Leonard Koren. Independents Network. 197?. 28 min. sound. color. order by title. buy: $100. prev. for libraries only.

Terry Schoonhaven, Vic Henderson and Leonard Koren, as the LA Fine Arts Squad are credited with extending the mural into the modern urban landscape. This program documents in detail a mural that they created on a familiar Hollywood landmark, "The Climax Club."

1084 Made in Mississippi: Black Folk Art and Crafts. 16mm. Center for Southern Folklore. 1977. 20 min. sound. color. order by title. buy: $300. rent: $30. prev. CA.

Interviews seven unique black folk artists who
discuss their work and recall how they learned their
crafts. The artists, who range from a quiltmaker to
a sculptor of clay, are unifed in their use of local
materials or discards to create something which is
rooted in tradition, yet personal to their styles.

1085 Making Offon. 16mm. Scott Bartlett. Canyon Cinema.
1981. 18 min. sound. color. order by title. rent: $25.

The creation of the film "Offon" is described and
illustrated in this video/film primer which shows
the standard functions of a studio switcher, then
demonstrates the use of the technique in the
production "Offon." "Offon" was made in 1967 by Mike
MacNamee, Glen McKay, Tom DeWitt and Scott Bartlett.

1086 Masters of Murano. 16mm., vc:3/4. Reuben Aaronson.
1982. 17 min. sound. color. order by title. buy: $300. rent:
$30. prev.

A portrait of three master glassblowers, filmed in
Murano, Italy. The film informs about the craft and
technique of glassmaking which follows a six-hundred
year old tradition. The three masters of Murano
pursue their craft, inspired by a sense of pride and
a love of beauty.

1087 The Mechanical Paradise. 16mm., allv. BBC. Time-Life
Video. 1980. 52 min. sound. color. order 16mm./#F2343,
3/4vc./#V2061, 1/2vc./#V9610. buy: 16mm./$850, 3/4vc/$200,
1/2vc/$150. rent: $100. prev. series: The Shock of the New.

Considers the influence of the machine age upon the
world of art. Cubism and Futurism were spawned by
this vision of art as seen from the viewpoint of the
inventor or the engineer. Works by Delaunay,
Duchamp and Francis Picabia, among others, are
discussed.

1088 Memorial Program for Barnett Newman. ac. Pacifica Tape
Library. 1970. 56 min. sound. order #BB5218. buy: $15.

Fred and Marsha Weisman, Frank Stella, and Max
Kozloff talk with Clare Loeb.

1089 Mendocino. 16mm. Michael Wallin. Canyon Cinema. 1968.
14 min. sound. color. order by title. rent: $20.

A personal documentary filmed during a summer spent
in Mendocino, California, featuring portraits of a
painter and a unicyclist.

1090 <u>Merce</u> <u>by</u> <u>Merce</u> <u>by</u> <u>Paik</u>. vc:3/4. WNET/Thirteen.
Cunningham Dance Foundation. 1975. 30 min. sound. color.
order by title. buy: $325. rent: $50 per screening.

A two-segment video piece. The first part, "Blue
Studio," is by Charles Atlas and Merce Cunningham,
the second part, "Merce and Marcel" is by Nam June
Paik and Sigeko Kubota and incorporates parts taken
from "Blue Studio." Part two includes material
taken from many sources; it is a tribute to Merce
Cunningham and Marcel Duchamp. Russell O'Connor
serves as the host in interviews with Marcel Duchamp
(1964) and Merce Cunningham. David Held and Earl
Howard created the sound score for the entire work.

1091 <u>Mick</u> <u>and</u> <u>the</u> <u>Moon</u>. 16mm., allv. Geoff Bardon.
Tasmanian Film Corporation. 1978. 20 min. sound. color.
order by title. buy: 16mm./Australian $400, vc/Australian
$250. rent: Australian $50 per screening, plus freight.
prev.

The art of the desert nomads of Central Australia in
the absence of bark or any other suitable materials
upon which to paint, took the form of elaborate
body decoration and sand paintings or mosaics
painted with ochre on the ground itself. This art
form has evolved many graphic symbols for various
desert motifs and has now been transposed onto
hardboard using acrylic and poster paints.

1092 <u>Morris</u> <u>Louis</u> <u>and</u> <u>Kenneth</u> <u>Noland</u>: <u>The</u> <u>New</u> <u>Abstraction</u>.
16mm. WNET/13, New York. Indiana University Audiovisual
Center. 1966. 30 min. sound. b&w. order #RS-656. buy: $250.
rent: $9.50. prev. series: Artists.

Morris Louis and Kenneth Noland are known as Color
Field painters. Both work exploring the potential
of pure color and symmetrical painting. Critic
Clement Greenberg, painters Helen Jacobson, and
Helen Frankenthaler along with Marcella Brenner,
Louis's widow, discuss their relationships with Mr.
Louis and his attitudes regarding his work. Mr.
Noland discusses the influence of Pollock and
Frankenthaler on his own work and on his innovative
technique of staining the raw canvas with color.

1093 <u>Motherwell/Alberti</u>: A <u>La</u> <u>Pintura</u>. 16mm., allv.
Blackwood. 1973. 15 min. sound. color. order by title. buy:

$400. rent: $50. prev. with intent to purchase.

Describes and illustrates the creation and
production of a special edition book, "A La
Pintura," the text of which is a poem cycle by
Rafael Alberti. The painter of the suite of images
in the book is Robert Motherwell, who narrates the
film. The paintings are transformed into aquatints
by Don Steward, who is shown in the film working on
the project. Tatyana Grosman, the founder of
Universal Limited Art Editions, is shown as the
artists consult on the production of this special
book.

1094 The Multinational Style. ac. Audio Arts. 1978. 60? min.
sound. order by title. buy: ₤40 for series of 16 tapes
(plus ₤1.10 each for handling). series: The State of British
Art: A Debate.

The series of which this tape is a part is a
complete unedited recording of the debates that took
place at the Institute of Contemporary Art in
February 1978. This tape, documenting British
contemporary art of the late 1970's, features John
Tagg, Caroline Tisdall whose paper is read, Patrick
Heron, Alan Bowness, and Rasheed Araeen.

1095 A New Heritage: Contemporary American Painting. vc:3/4.
The Buffalo Fine Arts Academy/Albright-Knox Art Gallery.
SUCB Film Library. 1976. 39 min. sound. b&w. order by title.
buy: $100. rent: $40. prev. tape with excerpts from several
programs avail. on request.

Comments on American painting since World War II.
Lee Krasner and Robert Motherwell talk about the
seminal years of Abstract Expressionism; Leo
Castelli, Roy Lichtenstein and Frank Stella discuss
the sixties and Richard Estes talks about current
Super-Realism.

1096 New Nihilism or New Art. ac. Pacifica Tape Library.
1964. 57 min. sound. order #BB3394. buy: $15. series: Art
Forum.

A panel discussion with Dan Flavin, Don Judd, and
Frank Stella; moderated by Bruce Glazer.

1097 New Public Art. allv. Inner-Tube Video. 1982?. 30 min.
sound. color. order #15. buy: $125. series: ART/New York:
1982-3 Art Season.

This tape visits the following exhibitions:

Joyce Kozloff at the Barbara Gladstone Gallery, Keith Haring at the Tony Shafrazi Gallery and in the New York City streets and subways, John Aherarn in the South Bronx and at the Shafrazi Gallery. Interviewed are Joyce Kozloff (4 min.), Keith Haring (3 min.), and New York City Cultural Affairs Commissioner Henry Geldzahler (1.5 min.), and a dedication speech by John Ahearn (3 min.) is heard.

1098 The New World. 16mm, allv. Blackwood Productions. 1978. 58 min. sound. color. order by title. buy: $875. rent: $125. prev. with intent to purchase. series: Masters of Modern Sculpture, Part III.

In this third film of a series which serves to introduce the major sculptors of this century, the viewer sees Robert Smithson running along his sculpture "Spiral Jetty," explores George Segal's plaster figures, and watches David Smith as he creates a sculpture and places it in the fields outside his studio in Bolton Landing, New York. Other artists included in this film are Louise Nevelson, David Hare, Ibram Lassaw, Theodore Roszak, Herbert Ferber, Louise Bourgeois, John Chamberlain, Mark Di Suvero, Isamu Noguchi, George Rickey, Barnett Newman, Tony Smith, Donald Judd, Claes Oldenburg, Robert Morris, Richard Serra, Carl Andre, Edward Kienholz, Christo, and Michael Heizer.

1099 New York/New Wave at P.S.1. allv. Inner-Tube Video. 1981?. 30 min. sound. color. order #5. buy: $125. series: ART/New York: 1980-1 Art Season.

This tape visits with Robert Mapplethorpe of "Punk Magazine," and with New York graffiti artists. Interviews are with Curt Hoppe (3 min.) and curator Diego Cortez (3 min.). Distributor cautions that this tape is for mature audiences.

1100 The New York School. 16mm., allv. Blackwood Productions. 1973. 55 min. sound. color. order by title. buy: $875. rent: $125. prev. with intent to purchase.

Narrated by Barbara Rose, this film brings together the works and personalities of post-war New York, when European models of painting seemed inadequate to express the freedom, impulse and instinct that favored larger-scale canvases and broad, improvisational brushwork. With artists Arshile Gorky, Adolph Gottlieb, Al Held, Hans Hofmann, Franz Kline, Willem de Kooning, Lee Krasner, Barnett Newman, Jackson Pollock, Ad Reinhardt, Mark Rothko, Clyfford Still, and Jack Tworkov as well as critics Clement

Greenberg and Harold Rosenberg.

1101 The New York Tapes. ac. Audio Arts. 1980. 60? min.
sound. order #Volume 4 Number 3. buy: ₤4 (plus ₤1.10 for
handling). series: Audio Arts Magazine.

These recordings were made in New York during one
week in 1980. Within that time the aim was to
examine the attitudes, concerns and opinions of
those centrally concerned with the practice,
support, and criticism of contemporary art in New
York. Featured are Ingrid Sischy, Les Levine,
Manhattan Project, Ronald Feldman, Helen Wiener, and
Willoughby Sharp. Includes commentary about
political artists, feminist artists, performance
artists, video artists and book artists.

1102 Nine Artists of Puerto Rico. 16mm. Museum of Modern Art
of Latin American Art. 1967. 16 min. sound. color. order
#12. buy: 16mm./$160, vc/$48. prev. on premises only.

This film provides visits to the studios of Puerto
Rico's most important artists. Narrations in
English and Spanish by Jose Ferrer.

1103 Northwest Visionaries. 16mm., allv. Ken Levine. The
Media Project. 1979. 58 min. sound. color. order by title.
buy: 16mm./$750, vc/$560. rent: $100.

This production is a documentary on the work of Mark
Tobey, Kenneth Callahan, Morris Graves, Margaret
Tomkins, Guy Anderson, Paul Horiuchi, Helmi Junoven
and George Tsutakawa. Considers the early
association of Graves, Tobey and Callahan as well as
the importance to these artists of nature and of
Indian culture.

1104 "Nuyoricans." ac. Elizabeth Perez-Luna. NPR Publishing.
1981. 29 min. sound. order #HO-81-05-27. buy: $9. series:
Horizons.

Called "Nuyoricans," the two million Puerto Ricans
living in New York City are a dynamic subculture.
Listeners visit Puerto Rican neighborhoods, stopping
at a new cultural center were Nuyorican artists
discuss their struggle to overcome familiar
stereotypes.

1105 Oregon Woodcarvers. 16mm., allv. Jan Baross. The Media
Project. Also Northwest Cultural Films. 1980. 24 min. sound.
color. order by title. buy: 16mm./$400, vc/$300. rent: $42.

This film explores the works, lives and philosophies of four very different Oregon wood artists. Ed Quigley, painter and sculptor of Western themes, carves and paints images of horses. Douglas MacGregor carves and repairs carousel animals. Gary Hauser lives by the sea and derives his inspiration and materials from the sea. Roy Setzoil, carves logs into abstract works.

1106 Ourselves and That Promise. 16mm., allv. Joe Gray, Gene DuBey and Scott Faulkner. Appalshop Films. 1977. 27 min. sound. color. order by title. buy: $425. rent: $40. prev. with intent to purchase (plus $10 handling).

Artists and writers James Still, Robert Penn Warren, Ronnie Criswell and photographer Billy Davis discuss their work and their relationships to the environment in which they work.

1107 Outline for the Next Wave: The New Performing Artist. ac. Bob Wisdom. NPR Publishing. 1982. 29 min. sound. order #NJ-82-01-25. buy: $9. series: NPR Journal.

Interviews four video/performance artists: Laurie Anderson, Melissa Fenley, John Sanborn and Kit Fitzgerald. They discuss their ideas on culture, perception, and art, and describe how they tap the imaginations of the observer to change how we see, hear, and respond to art.

1108 Outreach: The Changing Role of the Art Museum. vc:3/4. Jaime Davidovich. 1978. 28 min. sound. color. order by title. buy: request price. rent: request price. prev.

This tape presents insightful institutional responses to problems and challenges facing art museums in the rapidly changing art of our time. Gregory Battcock, host, leads the discussion with Marcia Tucker, Judith Van Baron and Chuck Hovland.

1109 Painters in the Modern World. 16mm., allv. D.C. Chipperfield and R.A. Campbell. International Film Bureau, Inc. 1970. 20 min. sound. color. order by title. buy: 16mm./$350, vc/$275. rent: $25. (16mm. only). prev. SY.

Shows the work of three artists who paint as an avocation. A government inspector, an art teacher, and a printer express their reaction to the environment in ways that are entirely personal.

1110 <u>Painters Painting.</u> 16mm. Emile de Antonio. New Yorker Films. 1972. 116 min. sound. color. order by title. buy: $1795. for five-year lease. rent: $125. prev.

The subject of this film is the artists' milieu. Not only the artists, but also the art critics, dealers, and owners. The production treats art as a living thing in attempting to convey how the artist actually functions. Using direct interviews illustrated by paintings, de Antonio brings us closer to de Kooning, Johns, Pollock, Rauschenberg, Motherwell, Poons, Stella, and Warhol.

1111 <u>Painting Alternatives.</u> allv. Inner-Tube Video. 1981?. 30 min. sound. color. order #8. buy: $125. series: ART/New York: 1980-1 Art Season.

This tape visits the following exhibitions: Ellsworth Kelly at the Leo Castelli Gallery, Chuck Close at the Whitney Museum, and Julian Schnabel at the Mary Boone and Leo Castelli galleries. It features interviews with Chuck Close (4 min.) and Julian Schnabel (4.5 min.).

1112 <u>Paul Mills and Roy Lichtenstein with John Fitzgibbon.</u> ac. Pacifica Tape Library. 1966. 117 min. sound. order #B0919.03. buy: $27. series: The Current Movement in Art, Part 3.

Recorded in San Francisco, this tape is a discussion with Paul Mills and Roy Lichtenstein with John Fitzibbon.

1113 <u>Performance Art.</u> allv. Inner-Tube Video. 1982?. 30 min. sound. color. order #13. buy: $125. series: ART/New York: 1981-2 Art Season.

This tape explores the following performances: "Street Piece" by Sam Hsieh, Robert Longo at the Kitchen and Colette at the Armageddon night club. It featues interviews with Sam Hsieh (3.5 min.), Robert Longo (3.5 min.) and Colette (3.5 min.).

1114 <u>Perspectives on the Avant Garde.</u> vc: 3/4. Jaime Davidovich. Artists Television Network. 1981. 58 min. sound. color. order by title. buy: request price. rent: request price. prev.

The term "avant garde" has been applied to new movements in art for many decades. But now, with no easily defined predominent group of artists who have created an entirely new way of making art, the avant

garde is more difficult to locate. The Artists
Television Network videotaped seven members of the
art community discussing the question, "Is the avant
garde dead?" ATN interviewed Marcia Tucker, the
Director of the New Museum, Robert Longo, artist,
Helen Winer, Director of Metro Pictures Gallery,
Walter Robinson, artist, Michael Smith, comedian and
performance artist, and Roselee Goldberg, curator
and critic.

1115 Photography Exhibitions. allv. Inner-Tube Video.
1981?. 30 min. sound. color. order #11. buy: $50 (this tape
only). series: ART/New York: 1981-2 Art Season.

This tape visits the following exhibitions: Hans
Namuth at Leo Castelli Gallery, Cindy Sherman at
Metro Pictures, and Robert Rauschenberg at Sonnabend
Gallery. Provides interviews with Hans Namuth (4
min.), Cindy Sherman (4 min.), and Robert
Rauschenberg (2.5 min.).

1116 Photography: Masters of the Twentieth Century. 16mm.
Irene Zmurkevych. Handel Film Corporation. 1981. 25 min.
sound. color. order #A-33. buy: $400. rent: $40. prev. with
intent to purchase.

Personal interviews with traditionalists and some of
today's younger artist-photographers create an
overview of this art form. Various techniques are
presented and explained by Ansel Adams, Barbara
Morgan, Harry Callahan, Eliot Porter, Gordon Parks,
Patrick Nagatani, Betty Hahn, Robert Heinecken and
Joel Meyerowitz. An award-winning film.

1117 The Pioneers. 16mm., allv. Blackwood Productions.
1978. 58 min. sound. color. order by title. buy: $875. rent:
$125. prev. with intent to purchase. series: Masters of
Modern Sculpture, Part I.

Narrated by George Segal, this film includes
historic film footage of many of the early creators
of twentieth-century sculpture. Shown are Auguste
Rodin, Edgar Degas, Medardo Rosso, Antoine
Bourdelle, Ariste Maillol, Wilhelm Lehmbruck, Henri
Matisse, Pablo Picasso, Jacques Lipchitz, Henri
Laurens, Jacob Epstein, Umberto Boccioni, Raymond
Duchamp-Villon, Julio Gonzales, and Constantin
Brancusi.

1118 Pop & Neo-Pop. allv. Inner-Tube Video. 1981?. 30 min.
sound. color. order #9. buy: $125. series: ART/New York:
1981-2 Art Season.

This tape visits the following exhibitions: Andy
Warhol at the Ronald Feldman Gallery, Roy
Lichtenstein at the Whitney Museum and Jack
Goldstein at Metro Pictures. Includes interviews
with Roy Lichtenstein (5 min.) and Jack Goldstein (4
min.).

1119 Possibilities in Clay. 16mm. Indiana University Audio-
visual Center. 1975. 25 min. sound. color. order #RSC-893.
buy: $360. rent: $12.50. prev.

In this film, scenes of ceramists at work illustrate
that today's approach to ceramics is characterized
by change and creativity. Pottery-making today
allows the ceramist to create pieces that are
traditional and functional or purely artistic.
Artists who discuss their work are Tom and Ginny
Marsh, Kathy Salchow, John Goodhart and Karl Martz.

1120 The Powers That Be. 16mm., allv. British Broadcasting
Company. Time-Life Video. 1980. 52 min. sound. color. order
#16mm./F2344, 3/4:V2062, 1/2:V9611. buy: 16mm./$850,
3/4vc:$200, 1/2vc:$150. rent: $100. prev. series: Shock of
the New.

Explores the political implications of the Dadaists
(Ernst, Schwitters, Hoch, and Baader) down to their
last major exponent Ed Kienholz, and those of the
German Expressionists after World War I. Some such
artists saw political art as a way of pressing art
into the service of political revolution.

1121 Public Sculpture. allv. Inner-Tube Video. 1982?. 30
min. sound. color. order #14. buy: $125. series: ART/New
York: 1981-2 Art Season.

This tape visits works by the following sculptors:
Owen Morrel at the McGraw-Hill building, Louise
Nevelson at Citicorp Center and Maiden Lane, Richard
Serra at Federal Plaza, and interviews both Serra
and Nevelson (4 min. each).

1122 Quilting Women. 16mm., allv. Elizabeth Barret. Appal-
shop Films. 1976. 28 min. sound. color. order by title. buy:
$500 (plus $10 handling; video avail. for sale only;
request prices). rent: $55 (plus $10 handling). prev. with
intent to purchase.

This film documents the women artists who, with
gentle modesty, create works of art in textile. The
film traces the entire process of quiltmaking from

piecing to the finale of a quilting bee.

1123 Quilts in Women's Lives. 16mm. Pat Ferrero. New Day
Films. 1980. 28.5 min. sound. color. order by title. buy:
$450. (plus $7 handling). rent: $50. (plus $7 handling:
classroom use, single screening; other uses request price).
prev. to qualified libraries only.

> Presents a series of portraits of traditional
> quiltmakers from various cultural entities, and
> provides insight into the spirit of these women who
> talk about their art and the influences of their
> lives upon it. They describe the inspirations for
> their work, the creative process, and the challenge
> of design. Winner of several major awards.

1124 Raymond Parker, Claes Oldenburg, and Larry Rivers with
Thomas Hess. ac. Pacifica Tape Library. 1966. 83 min.
sound. order #B0919.02. buy: $17. series: The Current
Movement in Art, Part 2.

> Recorded in San Francisco, this tape is a discussion
> with Raymond Parker, Claes Oldenburg, with Larry
> Rivers and Thomas Hess.

1125 Rockne Krebs and Boyd Mefferd: Two Interviews. ac.
Pacifica Tape Library. 1971. 59 min. sound. order #BB4458.03
and BB4458.04. buy: $28. series: Art and Technology.

> Clare Loeb interviews Rockne Krebs and Boyd Mefferd
> about their projects. Krebs describes how he uses a
> laser apparatus to create non-material sculptures
> which are configurations of color in space. Focuses
> on Art and Technology Project installation at LACA,
> 1971. Boyd Mefferd describes the evolvement of his
> work from landscape painting to electrical light art
> such as the one exhibited in this show.

1126 Ron and Mandy Heath: Weavers. allv. Film Victoria.
Tasmanian Film Corporation. 1979. 5 min. sound. color. order
by title. buy: (series) Australian $813. rent: Australian
$50 per screening, plus freight. prev. series: Craft as a
Livelihood.

> Part of a series produced for the Victorian Crafts
> Council, these productions cover a wide range of
> craft occupations and are intended for teaching
> appreciation of the skills required in the various
> careers. In this production the weavers show how
> they raise the sheep from which the wool for their
> rugs is obtained.

1127 Rubber Stamp Art. ac. Pacifica Tape Library. 1973. 59
min. sound. order #A20018. buy: $15. series: Ode to
Gravity.

 Artists Carol Law and Ken Friedman are interviewed
 by Charles Amirkhanian. Rubber stamp manufacturer
 Walter Ellis discusses his company.

1128 Los Santeros. 16mm., vc:3/4. Michael Earney. Blue Sky
Productions. 1978. 28 min. sound. color. order by title.
buy: 16mm./$450, vc/$275. rent: $50. prev. series:
Lifeways.

 This film documents New Mexican carvers of
 devotional images. It traces the history of the
 santeros' art and shows the woodcarving and painting
 techniques employed to realize these creations.
 Includes some of New Mexico's finest examples of
 such images, loaned from the collections of the
 Museum of International Folk Art as well as
 interviews with santeros: Orlando Romero, Luis
 Tapia, Horacio Valdez, George Lopez, Gloria Lopez,
 and Max Roybal.

1129 Somebody's Gotta Get Stoned. ac. Pacifica Tape
Library. 1966. 30 min. sound. order #B0919.08. buy: $13.
series: The Current Movement in Art, Part 8.

 Recorded in San Francisco, this tape is an interview
 by Erik Bauersfeld of Herbert Crehan.

1130 South Americans in Cordoba. 16mm., allv. Museum of
Modern Art of Latin America. 1966. 13 min. sound. color.
order #5. buy: 16mm./$130, vc/$39. prev. on premises only.

 Narrated in Spanish by Luis Vivas, this film shows
 works by the artists represented at the Cordoba
 Biennial in Argentina.

1131 Speaking of Tomlin. vc:3/4. The Buffalo Fine Arts
Academy/Albright-Knox Art Gallery. SUCB Film Library. 1975.
33 min. sound. b&w. order by title. buy: $100. rent: $40.
prev. tape with excerpts from several programs avail. on
request.

 Included on this tape are segments of interviews
 with friends of the late Bradley Walker Tomlin.
 James Brooks, Gwen Davies, Herbert Ferber, Ibram
 Lassaw, Robert Motherwell and Betty Parsons
 recall Tomlin as colleague and friend and discuss
 the artistic milieu of Abstract Expressionism during

the late forties and early fifties.

1132 Surviva. 16mm. Carol Clement and Ariel Dougherty. Women Make Movies. 1980. 35 min. sound. color. order by title. buy: $500. rent: $60. prev. with intent to purchase.

Centering on one artist in a group of rural women artists, this film combines animation and nature montage with documentary and narrative sequences which provide insights into the life and world of this artists' community.

1133 Los Tejedores. 16mm., vc:3/4. Blue Sky Productions. 1979. 28 min. sound. color. order by title. buy: 16mm./$450, vc/$275. rent: $50. prev. series: Lifeways.

A documentary on the art of traditional Hispanic weaving. This weaving tradition has continued in New Mexico since the Spanish first arrived. Historic examples are shown as well as modern Hispanic weavers illustrating traditional methods and techniques. Weavers in the film are Gus Martinez, Teresa Segal, Marcia Vergara-Wilson, Agueda Martinez, John Trujillo, and David Ortigo.

1134 Tense in Limbo. ac. Pacifica Tape Library. 1974. 62 min. sound. order #BC1923. buy: $17.

Political artists Leon Golub and Nancy Spero are interviewed by Clare Spark on political themes and attitudes in their art.

1135 Three Photographers. 16mm. Laurie Meeker. The Media Project. 1980. 20 min. sound. b&w. order by title. buy: $275. rent: $35.

A portrait of three women and their separate approaches to photography. A sports photographer describes the problems of catching the essential moments of action in a game. A fine arts photography student works at capturing the nuances of a drapery fold. An artist who is a university instructor helps students discover their own styles and define their ideas. Underlying each narrative is a commitment to the artform.

1136 The Threshold of Liberty. 16mm., allv. British Broadcasting Company. Time-Life Video. 1980. 52 min. sound. color. order #16mm./F2346, 3/4:V2064, 1/2:V9613. buy: 16mm./$850, 3/4vc:$200, 1/2vc:$150. rent: $100. prev. series: Shock of the New.

Considers Surrealism as expressed by the fantastic views of reality of Ernst, Miro, Dali, Magritte, Joseph Cornell and Jean Dubuffet. Shows how even such members of the New York School as Gorky, Motherwell, and Rothko were affected by Surrealism.

1137 Tinwork of Northern New Mexico. 16mm., vc:3/4. Blue Sky Productions. 1980. 14 min. sound. color. order by title. buy: 16mm./$250, vc/$150. rent: $30. prev. series: Lifeways.

This documentary film shows the traditional Hispanic craft of ornamental tinwork using contemporary and historical examples.

1138 Trouble in Utopia. 16mm., allv. British Broadcasting Company. Time-Life Video. 1980. 52 min. sound. color. order #16mm./F2357, 3/4:V2065, 1/2:V9614. buy: 16mm./$850, 3/4vc:$200, 1/2vc:$150. rent: $100. prev. series: Shock of the New.

Considers the work and the social implications of such architects as Scharoun, Finsterlin, Luckhardt, and Taut, the German Bauhaus school, Mies van der Rohe, Walter Gropius, and le Corbusier, and explores its culmination in the work of Buckminster Fuller in Brasilia.

1139 Ultimately, New York. vc:v, vc:b. John Stascak. 1983. 45 min. sound. color. order #U-NYC10083. buy: $650. rent: $225. prev. tape (10 min.) includes excerpts.

This tape is an autobiographical documentary of four artists living and working in New York City. They are Jane Ziegler, Steve Lemon, Steve Wood and Gina Wendkos. Edited by Doug Eisenstark.

1140 Video as Art. allv. Inner-Tube Video. 1982?. 30 min. sound. color. order #16. buy: $125. series: ART/New York: 1982-3 Art Season.

This tape visits the exhibition of Nam June Paik at the Whitney Museum, and the "New Imagery" exhibit at the Museum of Modern Art. Interviews are provided with Nam June Paik (4 min.) and with M.O.M.A. curator Barbara London (3 min.).

1141 The View From the Edge. 16mm., allv. British Broadcasting Company. Time-Life Video. 1980. 52 min. sound. color. order #16mm./F2345, 3/4:V2063, 1/2:V9612. buy:

16mm./$850, 3/4vc:$200, 1/2vc:$150. rent: $100. prev.
series: Shock of the New.

Explores the struggle of artists after World War II
to maintain a mythic-religious imagery in the face
of the increasing secularization of modern life.
Considers the work of Newman and Rothko in this
context.

1142 The Visual Arts in Tower Hamlets. ac. Audio Arts.
1981?. 60? min. sound. order #Volume 5 Number 1. buy:
Ƅ4 (plus Ƅ1.10 handling). series: Audio Arts Magazine.

This tape interviews a number of artists in the East
London neighborhoods which have served as homes for
many different ethnic groups over the years. Within
this environment, a unique range and level of
creativity can be found. Included on the tape are
Peter Dunn and Lorraine Leeson, Ray Walker, The
Basement Community Project, Dan Jones, Jeff Perks,
Chriss Orr, John Copnal, Eva Lockey, Half Moon
Photography Workshop and Liz Allen. On cassette
with: "Mario Merz at the Whitechapel Art Gallery."

1143 Viva Latinos: Latinos in the Creative Arts. ac.
Carlos Ganar. NPR Publishing. 1980. 29 min. sound. order
#SP-80-09-19. buy: $10. series: Special.

Looks at the traditions of Latino creative
expression through interviews with Hispanics in the
performing and fine arts.

1144 Wayne Thiebaud and Peter Voulkos. 16mm. WNET/13, New
York. Indiana University Audiovisual Center. 1967. 30 min.
sound. b&w. order #RS-705. buy: $250. rent: $9.50. prev.

This film contrasts the paintings of Pop-artist
Wayne Thiebaud with the Abstract Expressionistic
bronze sculpture created by Peter Voulkos. Thiebaud
is shown at work in his studio and teaching in the
classroom. Voulkos is shown working in his foundry
studio. Their philosophies as well as their art
works are contrasted by the program.

1145 We Are Still Alive. vc:3/4. Les Levine. Ronald Feldman
Fine Arts, Inc. 1975. 30 min. sound. color. order by title.
buy: $300. rent: $150. prev. on premises only.

A documentary of a society whose entire economy is
based on the production of art. This culture is
that of the Eskimos of the Canadian Northwest
Territories.

1146 We Work Alone. ac. Pacifica Tape Library. 1975. 56
min. sound. order #BC2355. buy: $15.

 Painters Jack Trickarico, Ruth Roberts, Carol
 Stronghelos, and Paul Rodonna discuss isolation with
 Barbara Londin.

1147 Who Needs Training? ac. Audio Arts. 1978. 60? min.
sound. order by title. buy: ฿40 for series of 16 tapes
(plus ฿1.10 each for handling). series: The State of British
Art: A Debate.

 The series of which this tape is a part is a
 complete unedited recording of the debates that took
 place at the Institute of Contemporary Art in
 February 1978. This tape, documenting British
 contemporary art of the late 1970's, features
 Andrew Brighton, Ray Watkinson, David Hockney,
 Michael Finn, and Peter de Francia.

1148 Why Not Popular? ac. Audio Arts. 1978. 60? min. sound.
order by title. buy: ฿40 for series of 16 tapes (plus ฿1.10
each for handling). series: The State of British Art: A
Debate.

 This tape, documenting British contemporary art of
 the late 1970's, is a recording of part of the
 debates that took place at the Institute of
 Contemporary Art in February 1978. It features
 Peter Fuller, Andrew Brighton, Naseem Khan, James
 Faure Walker, and Paul Waplington.

1149 With These Eyes You Shall Recover: The Navajo
Blanket. ac. Pacifica Tape Library. 1972?. 63 min. sound.
order #BC1000. buy: $17.

 Abstract artists Anthony Berlant and Mary Hunt
 Kahlenberg discuss their exhibition of Indian art
 with Clare Spark, the Curator of Textiles and
 Costumes at the LA County Museum of Art where this
 exhibit originated in August of 1972. It was
 subsequently shown at the Brooklyn Museum and
 abroad.

1150 Women in Art. ac. Pacifica Tape Library. 1971. 63 min.
sound. order #BC0290. buy: $15.

 This tape presents a panel discussion recorded in
 New York between women artists and art critics:
 Lucy Lippard, Cindy Nemser, Ruth Vodicka, Camille

Billops, Ce Roser, Amy Stromson, Therese Schwartz, and May Stevens.

1151 <u>Women in the Arts.</u> ac. Pacifica Tape Library. 1971. 29 min. order #BC0453.04. buy: $11.

Novelist and diarist Anais Nin and feminist artist Judy Chicago discuss the development of female consciousness in women's literature and art from the 18th century to the present. They explore the effects of the women's movement on art, and attempt to answer the question of whether or not there is a uniquely feminist art.

1152 <u>Women's Liberation and the Arts.</u> ac. Pacifica Tape Library. 1971. 66 min. sound. order #BC0289. buy: $17.

A panel of women artists and critics discuss whether feminist art exists, exchange ideas on women's liberation in general, and consider how to combine an art career with a family. With: Kate Millett, Louise Nevelson, Faith Ringold, Grace Paley, Lucy Lippard, Nancy Spero, Sylvia Stone, Jennifer Licht, and Annette Michelson. Recorded March 1971 at the Art Students League of New York.

1153 <u>Working in France.</u> vc:3/4. The Buffalo Fine Arts Academy/ Albright-Knox Gallery. SUCB Film Library. 1977. 60 min. sound. b&w. order by title. buy: $100. rent: $40. prev. tape with excerpts from several programs avail. on request.

Excerpts from interviews with Sonia Delaunay, Hans Hartung, Nicolas Schoeffer, and Victor Vasarely. Taped on location in France. Available in French with English transcript.

1154 <u>Working in Great Britain.</u> vc:3/4. The Buffalo Fine Arts Academy/Albright-Knox Art Gallery. SUCB Film Library. 1976. 60 min. sound. b&w. order by title. buy: $100. rent: $40. prev. tape with excerpts from several programs avail. on request.

Twelve British artists comment on their work, the art scene in Great Britain and attitudes toward post-war American art. Kenneth Armitage, Anthony Caro, Lynn Chadwick, Alan Green, John Hoyland, Phillip King, Allen Jones, Henry Moore, Bridget Riley, Graham Sutherland, William Scott and William Turnbull. Taped on location in England and Wales.

1155 <u>The World's Greatest Architect.</u> ac. Pacifica Tape

Library. 1969. 74 min. sound. order #BB2794.04. buy: $17.

Frank Lloyd Wright described himself as "the world's greatest architect." His partner, Aaron Green, insisted that Wright was not merely an egotist. Mies Van der Rohe and Buckminster Fuller are heard on this tape describing Wright. Van der Rohe states, "the dynamic impulse emanating from his work invigorated a whole generation."

1156 Young Graffiti Artists. ac. Renee Montagne. NPR Publishing. 1982. 29 min. sound. order #HO-82-10-13 buy: $9. series: Horizons.

Looks at the phenomenon of graffiti art and the young people who create it. Montagne talks to these artists about the techniques and style of their graffiti and how and why they go about painting it. City officials discuss their efforts to combat it, maintenance workers describe the chore of cleaning it up, and established gallery owners and art enthusiasts explain their desire to view it and sell it as art.

DIRECTORY

Reuben Aaronson
2024 R Street, NW
Washington, DC 20009
202-797-8547

Alison Abelson
see
National Museum of
American Art

Agency for Instructional
Television
Box A
Bloomington, IN 47402
800-457-4509 or
812-339-2203

University of Alabama
Department of Art
Box F
University, AL 35486
205-348-5967

Appalshop, Inc.
Box 743
306 Madison St.
Whitesburg, KY 41858
606-633-0108

Applied Media Associates
745 West Delavan Ave.

Buffalo, NY 14222
716-883-3636

Archives of American Art
Oral History Collection
Liza Kirwin
NMAA/NPG Building
F and 8th Street, N.W.
Washington, D.C. 20560
202-357-2781

Art Institute of Chicago
Video Data Bank
alphabetized under
Video Data Bank

Art Metropole
217 Richmond St. West
Toronto, Ontario
Canada M5V1W2

ART/New York
see
Inner-Tube Video

Artists Television
Network
152 Wooster St.
New York, NY 10012
212-254-4978

Artmusic, Inc.
248 Sackett St.
Brooklyn, NY 11231
212-624-3506

Audio Arts
6 Briarwood Road
London, SW4 9PX
England
01-720-9129

Benchmark Films, Inc.
145 Scarborough Rd.
Briarcliff Manor, NY
10510
914-762-3838

Susan P. Besemer
Learning Systems
75 Fordham Drive
Buffalo, NY 14216
716-878-6307

Blackwood Productions,
Inc.
251 West 57th St.
New York, NY 10019
212-247-4710

Blue Sky Productions
P.O. Box 548
Santa Fe, NM 87501
505-982-4757

see also
Public Media, Inc.

Bowling Green Films, Inc.
P.O. Box 12792
San Diego, CA 92112
619-462-8266

Buffalo State College
see
SUCB Film Library

CCTV
Georgia State University
Room 201, Student Center

Atlanta, GA 30303
404-658-2241

CSUS
University Media Services
6000 J. St.
Sacramento, CA 95819
916-454-6611

University of California
Extension Media Center
2223 Fulton St.
Berkeley, CA 94720
415-642-0460

Canadian Filmmakers
Distribution Centre
144 Front St. W. Ste 430
Toronto, Ontario
Canada M5J 2L7

Arthur Cantor Films, Inc.
33 W. 60 St.
New York, NY 10023
212-664-1298

Canyon Cinema
2325 3d St.
Suite 338
San Francisco, CA 94107

Carousel Films
241 E. 34th St.
New York, NY 10016
212-683-1600

Amon Carter Museum
3501 Camp Bowie Blvd.
P.O. Box 2365
Fort Worth, TX 76113
817-738-1933

Center for Southern
Folklore
Box 4081
1216 Peabody Ave.
Memphis, TN 38104
901-726-4205

Centron Films
65 East South Water St.
Chicago, IL 60601
312-977-4000

Doris Chase
222 West 23rd St.
New York, NY 10011
212-243-3700

Checkerboard Foundation, Inc.
c/o Edgar Howard
176 E. 77th St.
New York, NY 10021

Cinetudes Film
Productions
295 West 4th St.
New York, NY 10014
212-966-4600

Daniel Clark Film Library
P.O. Box 315
Franklin Lakes, NJ 07417
201-891-8240

Continuing Education
University of Mississippi
alphabetized under
University of Mississippi

Coronet Films
65 E. South Water Street
Chicago, IL 60601
312-977-4000

Consulate General of the
Netherlands
alphabetized under
Netherlands, Consulate
General

Crystal Productions
Box 12317
Aspen, CO 81612
303-925-8160

Cunningham Dance
Foundation
463 West St.
New York, NY 10014
212-255-3130

Danamar Films
106 Monte Vista Pl.
Santa Fe, NM 87501
505-983-5959

Rodger Darbonne
1835 O'Neill Place
Oxnard, CA 93033
805-483-0689

De Nonno Pix, Inc.
7119 Shore Road
Brooklyn, NY 11209
212-582-4240

Direct Cinema Limited
P.O. Box 69589
Los Angeles, CA 90069
213-656-4700

Education Through Visual
Works, Inc.
P.O. Box 7761
Atlanta, GA 30357
404-221-0236

Sheila Elias
443 South San Pedro St.
5th Floor
Los Angeles, CA 90013
213-689-9198

Encyclopaedia Britannica
Education Corp.
425 North Michigan Ave.
Chicago, IL 60611
312-321-7161

Extension Media Center
University of California
alphabetized under
California, University of

Ronald Feldman
Fine Arts, Inc.
31 Mercer St.
New York, NY 10013
212-226-3232

Film Rental Center
Syacuse University
alphabetized under
Syracuse University

FilmArts
461 Church St.
Toronto, Ontario
Canada M4Y 2C5

Filmart Productions
Business and Technology
Center
245 East Sixth St.
Suite 707
Saint Paul,MN 55101
612-291-2563

Film-Makers' Cooperative
175 Lexington Avenue
New York, NY 10016
212-889-3820

Filmakers Library, Inc.
133 East 58th St., Suite 703A
New York, NY 10022
212-355-6545

Films for the Humanities,
Inc.
P.O. Box 2053
Princeton, NJ 08540
800-257-5126

Films Incorporated
733 Green Bay Road
Wilmette, IL 60091
312-256-3200

The Folklore Media Center
Box 266

Cerrillos, NM 87010
505-982-6800

Forma Art Associates
433 Claflin Ave.
Mamaroneck, NY 10543
914-698-2598

Georgia State University
alphabetized under
CCTV

Gihon Foundation
1310 Annex, Suite 204
Dallas, TX 75204
214-821-9870

Ron Giles
Warner Cable Corporation
of Pittsburgh
1400 Penn Ave.
Pittsburgh, PA 1528
412-456-1111

Wendell Gilley Museum
P.O. Box 254
Southwest Harbor, MA
04679
207-244-7555

Gini International
269 West 72nd St.
New York, NY 10023
212-595-3533

Global Village
454 Broome St.
New York, NY 10012
212-966-7527

Glyn Group, Inc.
258 West Fourth Street
New York, NY 10014
212-255-5156

Rick Goldsmith
1315 Grove - #4

Berkeley, CA 94709
415-525-0916

Handel Film Corporation
8730 Sunset Blvd.
West Hollywoood, CA 90060
213-657-8990

Hartley Productions
Cat Rock Road
Cos Cob, CT 06807
203-869-1818

The High Museum of Art
Adult Extension Services
1280 Peachtree St.
Atlanta, GA 30309
404-892-3600, ext. 306

Impact Productions
1725-B Seabright Ave.
Santa Cruz, CA 95062
408-427-2624

Independents Network
12077 Wilshire Boulevard
Suite 533
Los Angeles, CA 90025

Indiana University
Audiovisual Center
Bloomington, IN 47405
812-335-2103

Inner-Tube Video
148 Greene St.
New York, NY 10012
212-966-7446

International Film Bureau
332 S. Michigan Ave.
Chicago, IL 60604
312-427-4545

International Film
Foundation, Inc.
200 W. 72d St.

New York, NY 10023
212-580-1111

Island Film Works
66 Garland
Oakland, CA 94611
415-465-1883

Kinetic Film
Enterprises Ltd.
781 Gerrard Street East
Toronto, Canada M4M IY5
416-469-4155

Kino International
Corporation
250 West 57th St.
Suite 314
New York, NY 10119
212-586-8720

Alexis Krasilovsky
424 Madison Ave.
Room 1406
New York, NY 10017
212-421-8787

Mary Lance
15 Sheridan Square
New York, NY 10014
212-929-3661

Detrick Lawrence
Box 1722
Duxbury, MA 02332
617-934-6156

Light-Saraf Films
131 Concord St.
San Francisco, CA 94112
415-469-0139

Loma Communications
P.O. Box 5233
Babylon, NY 11707
516-661-2430

Lucerne Films, Inc.
37 Ground Pine Road
Morris Plains, NJ 07950
201-538-1401

James E. Lyle
29 Wellesley St.
Rochester, NY 14607
716-244-1426

The Media Project
P.O. Box 4093
Portland, OR 97208
503-223-5335

University of Mississippi
Continuing Education
University, MS 38677
601-232-7282

Modern Talking Picture
Service
5000 Park Street North
St. Petersburg, FL
813-541-7571

Murphy Venture
alphabetized under
Rhodes/Murphy Venture

Museum at Large
P.O. Box 315
Franklin Lakes, NJ 07417
201-891-8240

Museum of Modern Art of
Latin America
18th St. and Constitution
Ave., NW
Washington, D.C. 20006
202-789-6021

NPR Publishing
2025 M Street N.W.
Washington, DC 20036
202-822-2670

National AudioVisual
Center
Washington, DC 20409
301-763-1850

National Film Board of
Canada
16th Floor
1251 Avenue of the
Americas
New York, NY 10020
212-586-5131

National Gallery of Art
Washington, DC 20565
202-737-4215

National Museum of
American Art
Alison Abelson
Smithsonian Institution
Washington, D.C. 20560
301-357-3095

National Park Service
Harpers Ferry,
WV 25425

National Public Radio
see
NPR Publishing

Consulate General of the
Netherlands
1 Rockefeller Plaza
New York, NY 10020
212-246-1429

New Dimension Films
see
Northwest Cultural Films

New Line Cinema
Corporation
575 Eighth Avenue
16th floor
New York, NY 10018
212-239-8880 or

800-221-5150

New Yorker Films
16 W. 61st St.
New York, NY 10023
212-247-6110

Northwest Cultural Films
85895 Lorane Highway
Eugene, OR 97405
503-484-7125

The Nostalgia Merchant
6255 Sunset Boulevard
Suite 1019
Hollywood, CA 90028
213-464-1406

Pacifica Program Service
see
Pacifica Tape Library

Pacifica Radio Archive
see
Pacifica Tape Library

Pacifica Tape Library
5316 Venice Blvd.
Los Angeles, CA 90019
213-931-1625

Perspective Films
65 East South Water St.
Chicago, IL 60601
312-977-4000

Phoenix Films & Video
468 Park Avenue South
New York, NY 10016
212-684-5910

Picture Start, Inc.
204 1/2 W. John St.
Champaion, IL 61820
217-352-7353

Port Washington
Public Library
Media Services
245 Main St.
Port Washington, NY 11050
516-883-4400

Public Media, Inc.
535 Cordova Rd.
Suite 200
Santa Fe, NM 87501
505-982-4757

Pyramid Films
P.O. Box 1048
Santa Monica, CA 90406
213-828-7577

Nancy V. Raine
23 Peverell St.
Dorchester, MA 02125
617-265-1923

Sonya Rapoport
6 Hillcrest Court
Berkeley, CA 94705
415-658-4741

The Rear Window
441 Washington St.
Brookline, MA 02146
617-277-4618

Rhodes/Murphy Venture
463 West St.#958
New York, NY 10014
212-691-2683

River Films
234 East 5 St.
New York, NY 10003
212-475-0132

S-L Film Productions
P.O. Box 41108
Los Angeles, CA 90041
213-254-8528

SUCB Film Library
Communications Center 102
1300 Elmwood Avenue
Buffalo, NY 14222
716-878-6821

St. Jude Chapel
1521 Main St.
Dallas, TX 75201
214-742-2508

John Stascak
20 Murray St.
New York, NY 10007
212-233-7827

State University College
at Buffalo
see listing under SUCB

Sheldon Sachs
488 Madison Ave.
New York, NY 10022
212-407-0368

Calogero Salvo
238 Shrader St. #4
San Francsico, CA 94117
415-752-4964

Saraf Films
alphabetized under
Light-Saraf Films

Charlotte Schrader
500 Court Square #704
Charlottesville, VA 22901
804-296-4888

Serious Business Co.
1145 Mandana Blvd.
Oakland, CA 94610
415-832-5600

Schindel, Morton
see
Weston Woods

Smithsonian Institution
see
National Museum of
American Art

Soho Television
see
Artists Television
Network

Southwest Alternate
Media Project
1506 1/2 Branard
Houston, TX 77006
713-522-8592

Film Rental Center
of Syracuse University
1455 E. Colvin St.
Syracuse, NY 13210

Katherine Deutch Tatlock
157 Naples Road
Brookline, MA 02146

Tasmanian Film Corporation
Pty. Limited
Suite 302, 107 Walker St.
North Sydney, N.S.W.2060
Australia
02-922-7761

University of Texas Film
Library
Drawer W
Austin, TX 78712

Time-Life Video
Time & Life Bldg.
New York, NY 10022
212-484-5930

UEVA
see
Universal Education and
Visual Arts

UMBC, Art Department
see
Vanderbeek, Stan

UT Film Library
alphabetized under
Texas, University of

Universal Education
and Visual Arts
100 Universal City Plaza
Universal City, CA 91608
213-508-4296

University of Alabama
alphabetized under
Alabama, University of

University of California
Extension Media Center
alphabetized under
California, University of

University of Mississippi
Continuing Education
alphabetized under
Mississippi, Univ. of

University, State of New York
College at Buffalo
see listing under
SUCB

Stan Vanderbeek
c/o Art Department
UMBC 5401 Wilkons Ave.
Baltimore, MD 21228

Video Data Bank
The School of the
Art Institute of Chicago
Columbus Drive
at Jackson Blvd.
Chicago, IL 60603

Video Gallery
P.O. Box 654

Northborough, MA 01532
617-393-8191

Video Out
540 Beatty St. Fifth
Floor
Vancouver, BC
Canada V5V 2L3
604-688-4336

Virginia State Library
Film Collection
Richmond, VA 23219
804-786-8929

WNET-TV
356 West 58th St.
New York, NY 10019
212-560-2000

Warner Cable Corporation
of Pittsburgh
see
Giles, Ron

Peter Weiner
835 Michigan Ave.
Evanston, IL 60202
312-475-7265

David S. Weinkauf
P.O. Box 145
Edinboro, PA 16412
814-587-3640

Weston Woods
Morton Schindel
389 Newtown Turnpike
Weston, CT 06883
800-243-5020

Wombat Productions, Inc.
P.O. Box 70
Glendale Road
Ossining, NY 10562
915-762-0011

Women Make Movies
Film Library
P.O. Box 315
Franklin Lakes, NJ 07417
212-929-6477

INDEX

About the Compilers

SUSAN P. BESEMER is Associate Director of Library Services at E. H. Butler Library, State University of New York College at Buffalo. She has published articles in *Previews, Curriculum Review,* and the *Journal of Creative Behavior.*

CHRISTOPHER CROSMAN is Curator of Education at the Albright-Knox Art Gallery in Buffalo, New York. He is the author of articles published in *Museum News, Art Journal, Audio-Visual Communications,* and *Art and Activities.*